Jean Haines
Atmospheric Flowers
in Watercolour

Dedication

To John, the gardener of my life who
helps me see beauty constantly.

Jean Haines
Atmospheric Flowers
in Watercolour

Painting with energy and life

Search Press

First published in 2018

Search Press Limited
Wellwood, North Farm Road,
Tunbridge Wells, Kent TN2 3DR

Text copyright © Jean Haines 2018

Photographs by Roddy Paine
Photographic Studios

Photographs and design copyright
© Search Press Ltd 2018

ISBN: 978-1-78221-545-5

The Publishers and author can
accept no responsibility for any
consequences arising from the
information, advice or instructions
given in this publication.

Suppliers
For details of suppliers, please
visit the Search Press website:
searchpress.com.

Publisher's note
All the step-by-step
photographs in this book
feature the author, Jean Haines,
demonstrating watercolour
painting. No models have
been used.

Printed in China by 1010
Printing International Ltd

Acknowledgements

There are so many people I need to thank for helping me to write this book. Firstly, Katie French from Search Press, who knew this book has been waiting to happen and who encouraged me to write it.

To the wonderful team at Search Press for supporting me in my literary career, and helping me see my dreams come true. Especially Juan, the head of the incredible design team, who takes such care to present my art so beautifully. Particularly Edward Ralph not only for his patience throughout this book's creation but also his expertise. My grateful appreciation goes to Gavin Sawyer for his fabulous photography throughout this book, which all took place in my own home and garden.

I must also pay my respects to Madame Blanche Odin, whose exquisite art inspired me in so many ways to paint flowers.

Most importantly, I need to thank my terrific husband John for being so supportive, wonderfully encouraging and extremely patient whilst I hid for days on end to write and paint.

My thanks go to you, the reader, because without you I could not be an author. You have helped me more than you will ever know.

I am also grateful to the best artist of all, Mother Nature, for providing me with such glorious subjects to paint in watercolour.

You all have my appreciation, my deepest thanks and my heart.

Page 1:
Delft Blue
32 x 38cm (12½ x 15in)

Page 2:
Sweetness and Light
32 x 38cm (12½ x 15in)

Opposite:
Gold of Spring
54 x 36cm (21¼ x 14¼in)

Contents

Author's welcome

"There is far more to enrich our lives than a finished piece of art when painting flowers."

I can't believe it. I am finally writing a book that I have dreamt of for so long. Ever since I was a child who believed in fairies at the foot of the garden, to now as an adult, I have been mesmerised by flowers and all that is nature. My spirit soars each time I see a plant come into bloom and my artist's soul springs to life as I imagine painting it.

Over the years, my painting style may have changed from the tight botanical artist I once was, to the more free and interpretative style I work with today to capture what I am seeing in my favourite medium: watercolour. But as an older and hopefully wiser woman, I know there is far more that can enrich my life when painting flowers rather than a finished painting. I absorb the positive energy of a new young plant. I have learned how to nurture weak plants to help them grow strong, in the way that I overcome obstacles in my paintings, or life,

when things don't go as smoothly as planned. I have become the kind of person who enjoys weeds rather than continually fighting to remove them from my garden. Just like enjoying the patterns and accidental 'blooms' created by watercolour when working with it.

I know there is more, much more, than simply admiring beauty from nature and painting it. We can grow as people and as artists if we take time to observe and learn from the best teacher in the world: nature itself.

I hope you enjoy this new publication as much as I enjoyed writing it. Each page was written with you, the reader, in my heart; no matter what level of artist you are or wish to become. Together we are going to go on an explorative journey, improving our life and art skills. Enjoy.

Jean Haines.

Simplicity
22 x 12cm (8¾ x 4¾in)

Introduction

"Learn from nature; absorbing as much information as possible until you find yourself breathing life into your art."

A T THE BEGINNING OF EACH new book that I write, I try to explain to the reader why I am writing and what they can expect from the following pages. You may believe you have purchased a book that will help you paint flowers in a loose style. While that is true, I am hoping that you gain far more from the chapters to come.

I want to take you on a journey that involves using watercolour materials to create beautiful paintings. I also want to share with you the joy I feel when painting flowers and how doing so has improved my life. More importantly, I want you to discover your true artist's soul. I hope to pull out of you the very best floral artist you can be; so that you surprise yourself not only with your art but by the peaceful way you feel when you have finished painting floral work. I want you to yearn to paint each day, every time you see a flower, a plant, or even an insect, as we are looking at all these fascinating subjects within this book.

For now I want to share how I first fell in love with flowers, long before I even started painting them. As a child I lived with my grandparents. One of the first things my Grandfather told me was that there were fairies at the foot of his garden. He told me I should never pick a flower, because I might disturb them. Crayons were placed in my child-sized hands and I played with colour as soon as I was able. I am thankful, because this is where my love of art began. All the gorgeous flowers in my Grandfather's garden were soon my favourite subjects. I learned about their colour, form, and about each special season when they would begin to appear. Over time I have found my life has been like seasons: my childhood and youth as the springtime of my life, followed by the beautiful summer as I grew, married and had children of my own. I would like to think I am now in the autumn rather than the winter of my lifetime – but oh, how much I have learned along the way.

In all of my international watercolour workshops I am asked how to paint flowers. Before you can paint them as a subject, I believe you have to absorb information about them: this will enable you to breathe life into your paintings. That is what I am hoping to do with this book: help you create more than just art. I want you to achieve a level where your paintings are stunningly unique and speak to the viewers of your finished pieces, so that they feel they can touch soft, silky petals or take in the heady perfume of each bloom you have completed in watercolour. Petal by petal, step by step, we are about to begin a journey together that, hopefully, will be totally memorable.

I can't wait to get started.

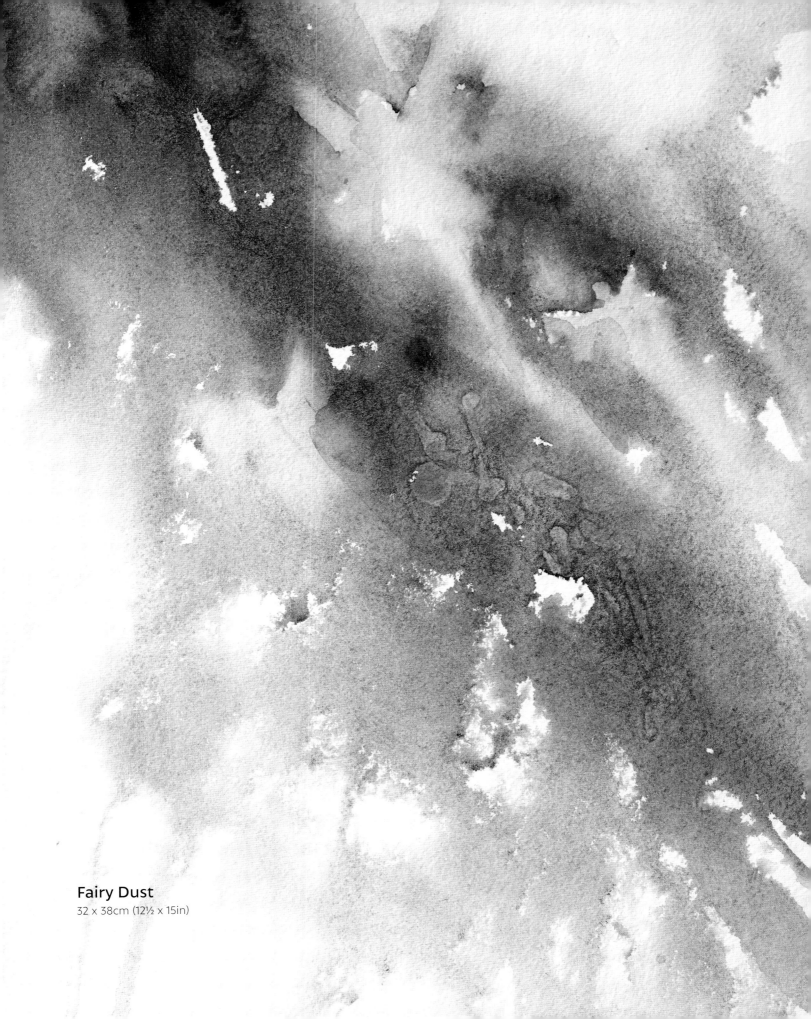

Fairy Dust
32 x 38cm (12½ x 15in)

Why paint flowers?

"Painting flowers lifts the artist's soul and brings joy to the heart."

Dancing Rudbeckia
20 x 38cm (8 x 15in)

Before we begin looking at the many wonderful ways to paint flowers, let us first consider why they make such an interesting subject. They have been painted over the years in so many styles, by artists of all levels, including very famous names which we all recognize – who could forget the sunflowers of Van Gogh, for example? There are many art societies full of members who love painting this incredibly popular area of art. There is even a language of flowers, with each particular plant carrying a meaning: roses, for example, are said to be the flower of love, so they are romantically linked to St Valentine's Day.

But why are flowers so popular? Is it just their beauty that appeals, or is there more to painting them? If we look at how flowers make us feel and how they are used, their popularity as a subject for artists really should come as no surprise. Firstly, they bring cheer which is why they are often used on greeting cards for events such as birthdays or other special occasions. When someone is ill, taking them flowers is a natural reaction for many people. Placing flowers in a reception area of a hotel welcomes guests instantly. Certain parts of flowers have been used throughout history for medicinal purposes. Essentially, flowers make us feel good; and for that reason alone painting them should lift our spirits and make us feel at peace.

We can't dismiss the fact that flowers as a subject also aids sales in so many ways. Floral art is highly in demand and popular, whether on soft furnishings in homes, on fashion items or other objects of desire. Flowers sell – and they sell well.

Besides the sense of relaxation I gain by painting flowers, my main reason for doing so is that they help me grow as an artist. When I paint a particular bloom I always fall in love with it first. In my mind, I like to imagine that the viewer of my finished piece will feel the same pleasure I felt in creating it. This connection of feelings and emotions through art is indefinable, yet so incredible. By placing my focus solely on this area of art for a time, I can improve my artistic skills for when painting all of my other favourite subjects too. I learn about structure, colour, and form. Painting flowers led me to where I am in my career today. I started my art life as a very detailed botanical artist; so very different to the loose style I enjoy creating with today.

Painting flowers can be simple, easy and effective. From the beginning of a small flower centre, to adding petals followed by a quick background for foliage. As a garden grows, so can our art skills.

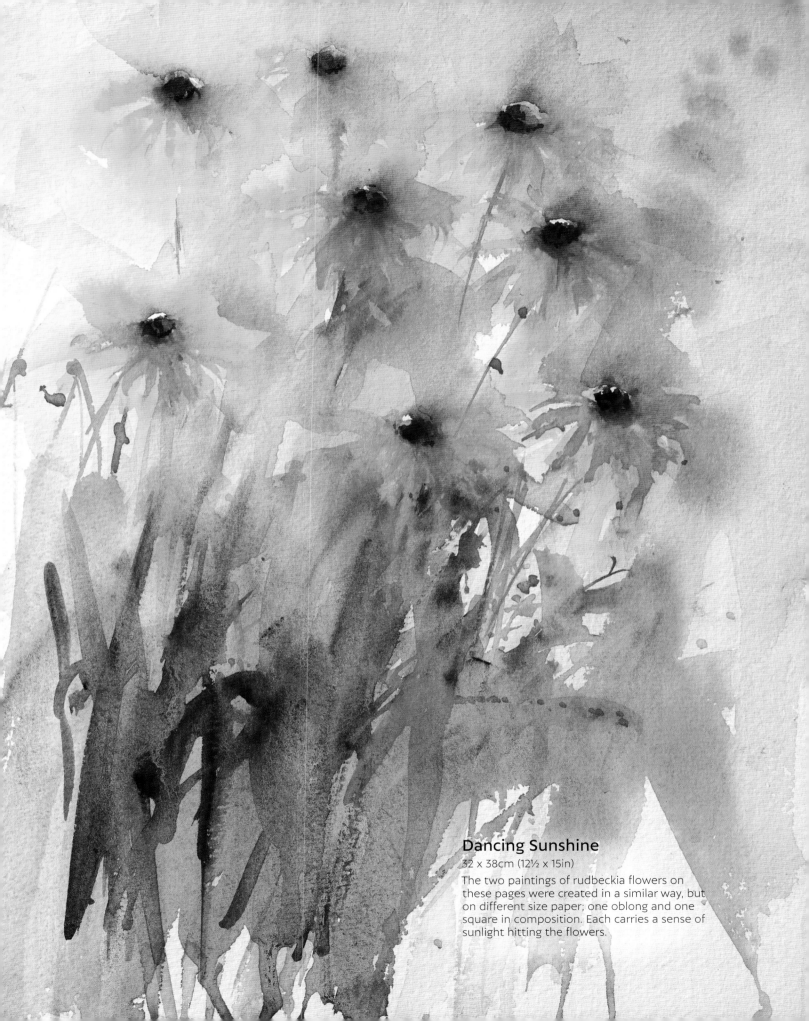

Dancing Sunshine
32 x 38cm (12½ x 15in)

The two paintings of rudbeckia flowers on these pages were created in a similar way, but on different size paper; one oblong and one square in composition. Each carries a sense of sunlight hitting the flowers.

In this book I want to show you why painting flowers has been such a wonderful and enriching part of my life for so long. There is no doubt that as a child I benefited from growing up surrounded by countryside, and influenced by my Grandfather, my guardian, a man who loved gardening and who taught me so much. I too now love gardening as he did, which in turn affects my art. It aids my choice of colour and shape, what to put where, when and how. This is the main connection between my planting and painting decisions.

Today, whenever I travel, I always make a point of looking for the flowers in the city or country I am visiting. I am inspired by famous gardens, parks and other places of botanical interest across the world, from the orchid gardens of Singapore to the desert in Arizona, USA, and – closer to my home – places like RHS Garden Wisley in the UK. Colour, landscape, and flowers from every part of the world enrich my life and my passion for working in this magical medium that we know as watercolour.

The techniques I use to paint flowers can be incorporated in any subject and improve your art skills. I adore painting flowers and I want you to as well. So as you read each chapter in my book I hope I open your eyes to the pleasure that is known to many artists already, past and present.

Painting flowers lifts the artist's soul, brings joy into your heart and can even be said to build confidence, not only in painting but in other ways too with a very positive outcome. Now it is time to look at painting, starting with what we need to create successful results and enjoy creating them.

Flower meaning: Orchid

I have visited orchid gardens all over the world; they are a favourite flower of mine. Deriving their name from the Ancient Greek god Orchis, orchids were associated with fertility due to the shape of the plant's tubers. Considered by some as symbols of love, these plants come in many colours, sizes and varieties.

Easy to grow, and likely to thrive, orchids were also once considered a sign of wealth, so these elegant flowers also represent luxury.

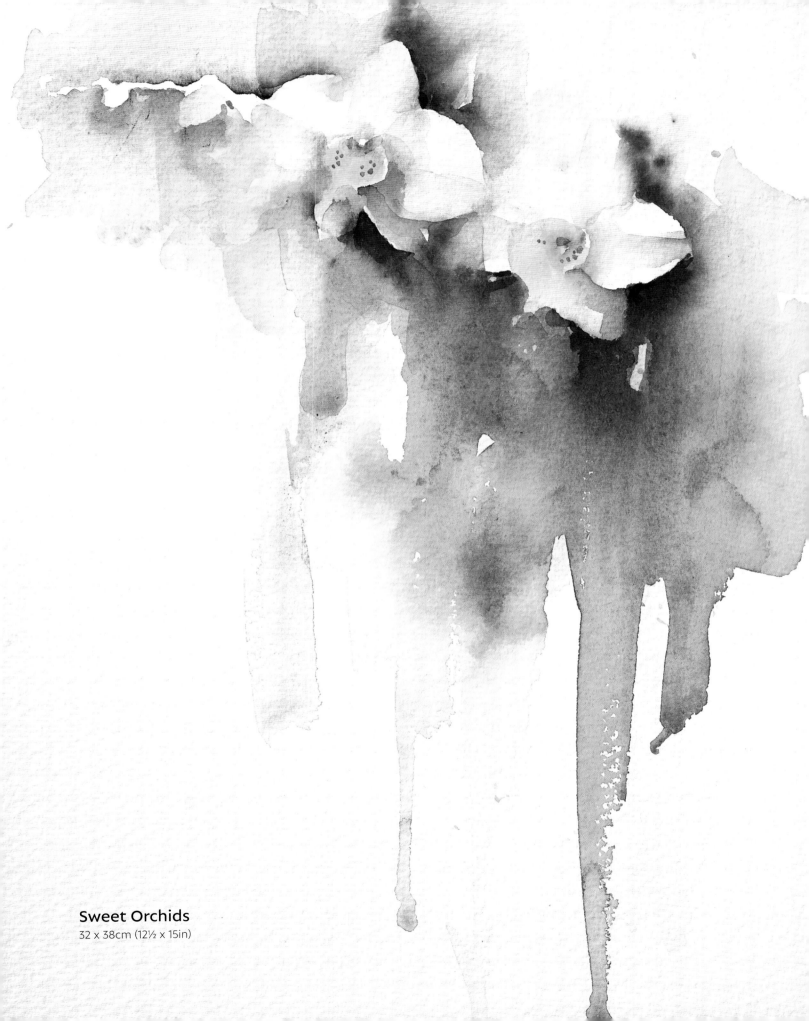

Sweet Orchids
32 x 38cm (12½ x 15in)

What we need

"Our time spent being creative is enriching rather than draining."

At this stage in writing a book, I usually share my art materials. The materials section is so important in any art book, letting the readers know what they need to enable them to follow the step-by-steps and demonstrations that are included.

From teaching workshops worldwide, I know there are other elements which are often forgotten, but that are really needed if we are serious about learning to paint a subject well, or even paint at all. These may not seem worth mentioning to you, but to me they are points we need to address. These elements are desperately important to us in gaining not only good results but a sense of relaxation when painting, so that our time spent being creative is enriching rather than draining.

The bare necessities:
What we need to achieve successful paintings

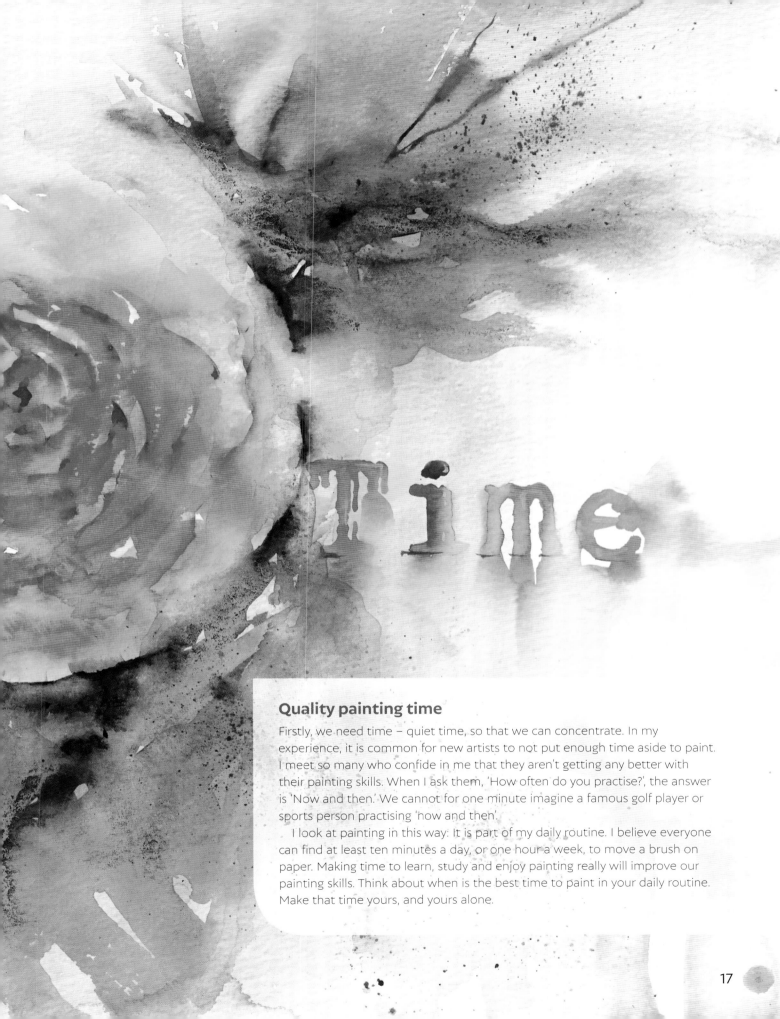

Quality painting time

Firstly, we need time – quiet time, so that we can concentrate. In my experience, it is common for new artists to not put enough time aside to paint. I meet so many who confide in me that they aren't getting any better with their painting skills. When I ask them, 'How often do you practise?', the answer is 'Now and then'. We cannot for one minute imagine a famous golf player or sports person practising 'now and then'.

I look at painting in this way: It is part of my daily routine. I believe everyone can find at least ten minutes a day, or one hour a week, to move a brush on paper. Making time to learn, study and enjoy painting really will improve our painting skills. Think about when is the best time to paint in your daily routine. Make that time yours, and yours alone.

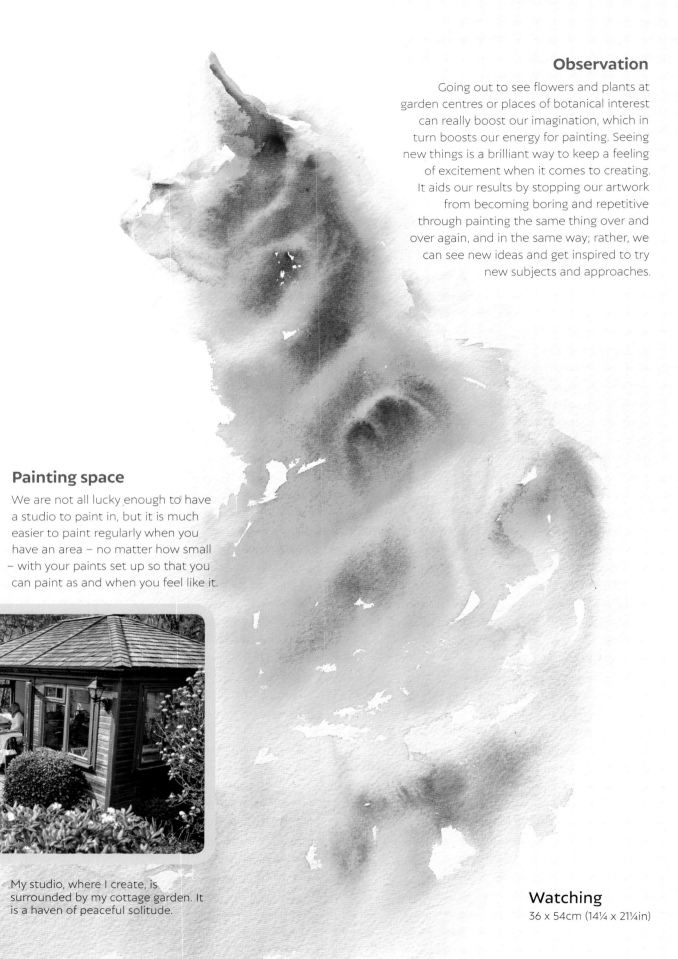

Observation

Going out to see flowers and plants at garden centres or places of botanical interest can really boost our imagination, which in turn boosts our energy for painting. Seeing new things is a brilliant way to keep a feeling of excitement when it comes to creating. It aids our results by stopping our artwork from becoming boring and repetitive through painting the same thing over and over again, and in the same way; rather, we can see new ideas and get inspired to try new subjects and approaches.

Painting space

We are not all lucky enough to have a studio to paint in, but it is much easier to paint regularly when you have an area – no matter how small – with your paints set up so that you can paint as and when you feel like it.

My studio, where I create, is surrounded by my cottage garden. It is a haven of peaceful solitude.

Watching
36 x 54cm (14¼ x 21¼in)

Enthusiasm and passion

Most of all we need enthusiasm. Painting should not be a chore. It should be something we look forward to with a passion. If you are not enjoying the process of creating, nothing you paint will ever have that magical feeling of being a success. If you love something enough, you will do it – and that means painting fabulous watercolours of your favourite flowers.

You can paint stunning floral artwork. If you feel you can't at the moment, I am going to show you how in the next few pages. I am also hoping to make you love painting flowers so much that by the end of this book you will be painting them at every opportunity.

Patience

"Practise, practise, practise."

As I grew up, my stepmother constantly told me 'patience is a virtue, possess it when you can.' I grew so tired of hearing that saying as a teenager who was always on the go, always wanting to do things quickly. How funny that now, as an older woman, I appreciate that slowing down often gets things done far more quickly.

When you race a painting, you often make mistakes that cannot be undone. By taking your time and working patiently and with thought, you learn far more. You understand why things go right and you can also learn why things go wrong – particularly in experimental work or new subject studies. The point is that practise makes perfect.

However, I am not really aiming for 'perfect' paintings. Instead, I aim to capture my favourite subjects and show them full of life, atmosphere and containing a terrific sense of energy or mystery. My goal is unique results.

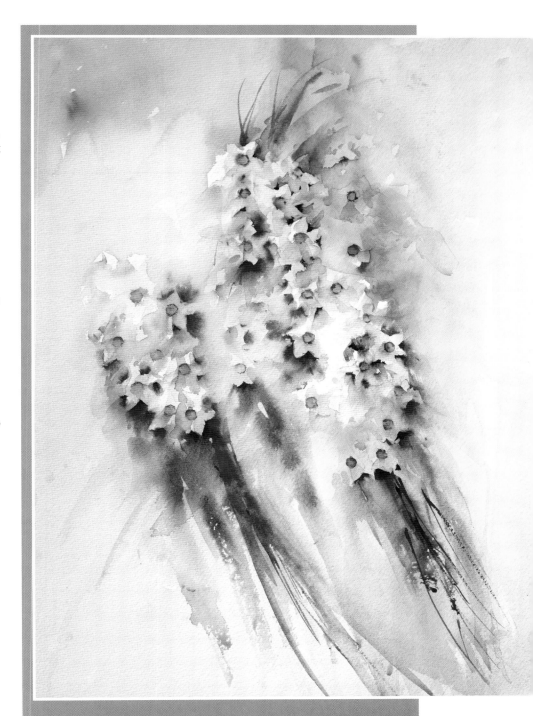

Patience
54 x 36cm (21¼ x 14¼in)

"I think we can all agree that you cannot buy any of the elements mentioned. But you can buy the materials in the pages to follow."

Materials

"You cannot garden without the right tools. It is the same when painting — you need the right equipment."

I always smile when I write the materials section in my books. Why? Because this is the chapter in any art book that I would once hastily skip through to get to the painting demonstrations. Now I completely understand that without this section, it is virtually impossible to follow the author's step-by-step projects later. We need to know what they have used to be able to match their results.

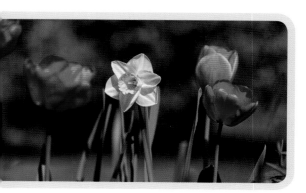

Flowers

Firstly we need subjects to paint. We don't all have magnificent, easily-accessible gardens full of flowers; but there are many wonderful public gardens and garden centres where we can see plants for inspiration in colourful displays throughout the year.

When I am travelling I visit anywhere that I can to see or buy flowers for my workshops. I constantly check out supermarkets, florists and markets, and also keep an eye out for any flower arrangements in restaurants or hotels. Anywhere that has flowers immediately attracts my attention. At home I have a cottage garden where I find an endless supply of interesting floral subjects. I work in the garden regularly and it is both a source of pleasure and a bonus for my artwork.

A really good tip is to paint from real flowers whenever possible. This is far better for your growth as an artist than always painting from photographs. Painting from the real thing is how we can genuinely gain a sense of life and energy in our work. However, because flowers are not always in season when I feel like painting them, I do work from photographs at times. In fact, it is for this reason that I have a collection of fabulous flower photographs as resource material, to be used when flowers are not possible to see or obtain. It is a good idea to start your own collection of floral resource photographs so that you always have something to fall back on when you are lost for something to paint.

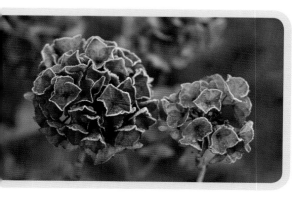

Flower borders in my garden through the seasons. From top to bottom, spring, summer and winter.

Paper

You need lots! Make sure you are using paper specifically designed for working with watercolour, and have a selection of different sizes. I use Saunders Waterford 640gsm (300lb) rough surface for most of my gallery paintings, but when I am experimenting or when painting a new subject for the first time, I often use cheaper paper, as I know these pieces will inevitably end up in the bin (or trash can, for my American friends).

It is important to have a variety of paper surfaces. Cold-pressed paper with a rough surface is perfect for gaining textural effects, whereas smoother hot-pressed paper is perfect for painting flowers with silky petals, like poppies. Do not use paper that is less than 300gsm (140lb) in weight because it simply isn't worth wasting painting time using materials that aren't suitable. It is like playing golf with a tennis racquet: not a wise move!

Paper is often available in recognized sizes such as quarter, half or full sheets. However, bear in mind that everyone else who buys standard-sized paper will be painting the same size paintings as you. I try to be unique with all areas of my art, so I sometimes tear my purchased paper size in half or quarters, lengthways or horizontally. This helps to create unusual compositions that suit my subjects, something we will look at later in this book

No piece of paper is too small. Some small flowers call for smaller pieces of paper which can look very dramatic when framed. Use your imagination to make your chosen subject look great on an attractively-shaped piece of paper. It is fascinating seeing what results you can come up with.

Do try to be different to everyone else. Try painting on square-shaped paper and make your composition work on it. Let your imagination run riot on what size and shape paper will suit each new subject you paint. It is a challenge that is fun and leads to brilliantly interesting paintings.

Scraps of paper are perfect for small studies, learning and for experiments.

Lupins
32 x 38cm (12½ x 15in)
Painted on a quarter sheet of cold-pressed paper.

Snowdrop
7 x 17cm (2¾ x 6¾in)
This flower is painted on a tiny scrap of paper.

Tip

You should never throw any pieces of paper away, unless you have painted on both sides or experimented as much as you can on them. If a painting goes wrong, use it to learn from your mistakes – try painting darker pigment on top of the original result or adding texture effects to the existing composition.

Brushes

The best advice I was given, years ago, was to invest in the best brushes I could afford. How right that is: painting should be a pleasure, so using the best equipment will lead you both to better results and also make your painting time so much more enjoyable. I have my own personal range of brushes which are fabulous, like working with silk. They are soft and wonderful to work with.

Cheap brushes do not hold water or release pigment so well and they can scratch the surface of good quality watercolour paper. A good brush should feel comfortable in your hand, and if you lightly draw a dry watercolour brush over the back of your hand it should feel soft, like a whisper. If it doesn't, you need to find a better brush.

My favourite brush set, suitable for all floral work.

I mostly use the following four brushes:

- A rigger, which is useful for creating fine lines – perfect for painting stems and adding details such as veins on leaves.

- A size 10 round which is terrific for creating petals and flower shapes.

- A size 12 round, which is better for working on larger subjects and paintings.

- I occasionally use a mop for painting large backgrounds but most of my floral work is carried out just with the three brushes mentioned above.

I must add a note here on brush care. I am horrified if I see brushes left in water pots, as this ruins them. Do not leave your brushes standing in water in between using them, as they will have a very short life if you do. Also be very careful with brush cleaners. Watercolour pigment washes out of good brushes easily, so a good swirl in clean water after use should be enough to keep brushes clean and in good condition, and will help them last far longer.

Colour

I could write a whole book just about the colours I use: I love colour and I possess a huge selection which are fabulous to use.

I opt for exciting vibrant shades that make me feel great when I use them, matching the colour to the type of flowers I am working on.

I prefer working with tubes of colour not pans. You may have your own favourite brand of watercolour products but I am smitten with Daniel Smith watercolours. I have tried so many products over the years but this range thrills me each time I use it. Gradually my whole collection of colours has changed to just one supplier and I am so happy with them. But we all have to use what makes us feel great; so as long as your watercolour products are of good quality you will be fine.

Tubes of colour in my studio that tempt me to paint daily.

Palette

I use a radial sorting tray, but any white surface or container can be used for holding your paints, as long as you keep your colours fresh and clean. Pigment can even be placed on clean paper to act as a palette, as long as the paper is good quality watercolour paper of a heavier weight (see 'Losing the palette' on page 28).

At times I squeeze a lot of colour into my palette to save me having to refill it. I was shocked to learn that a new artist on one of my courses washed all of the pigment out of their palette at the end of each of their painting sessions. There is no need to do this. Pigment will harden in your palette when left, but all you have to do is wet it next time you start painting and you are ready to create with it again. Don't waste pigment or throw money away by washing it all down the sink!

Other useful things

Easel

I have two easels: an upright standing easel and a tabletop version. I work at an angle, so having these two easels ready to work on makes my life as a professional artist far easier. Find out what painting angle works best for you.

When I travel I cannot take my easels with me. At times like these I work on almost anything I can find; hardboard or any surface that can be leant against creates a support for me to paint on.

Water and water containers

Anything will do, but please make sure you empty the water regularly during your painting sessions. Painting with dirty water leads to muddy results – we are aiming to paint flowers, not the ground they grow in!

Texture aids

Cling wrap, salt, string, lace... I use anything that can make a pattern in my watercolours. Card is a brilliant substitute for a brush if you need straight lines, such as when painting stems. In fact, I often use watercolour paper for this: it softens when wet and holds pigment beautifully which can then slide over paper easily to make patterns. Keeping an old toothbrush can be very useful for splattering, as can tissue for forming petal patterns on a wet surface. There is so much we can explore and have fun with in this book when we experiment – and we will be experimenting.

Vases and flower holders

When painting flowers at home (rather than outside in the garden) it is a good idea to have some lovely vases, glasses or perhaps unusual containers like teacups or teapots to place flowers in. These can then become part of an interesting composition.

Charity or thrift shops are ideal to find this kind of treasure, and can be re-donated when you become bored of painting them. Alternatively, you may have access to old family pieces that have long been forgotten. Keep an eye out for things that will contribute to your floral work. Observation when we are not painting often improves our work when we are.

"You can add to your collection of materials as time goes by. For now, however, paper, brushes, a few tubes of watercolour and some flowers are all that you need to get started."

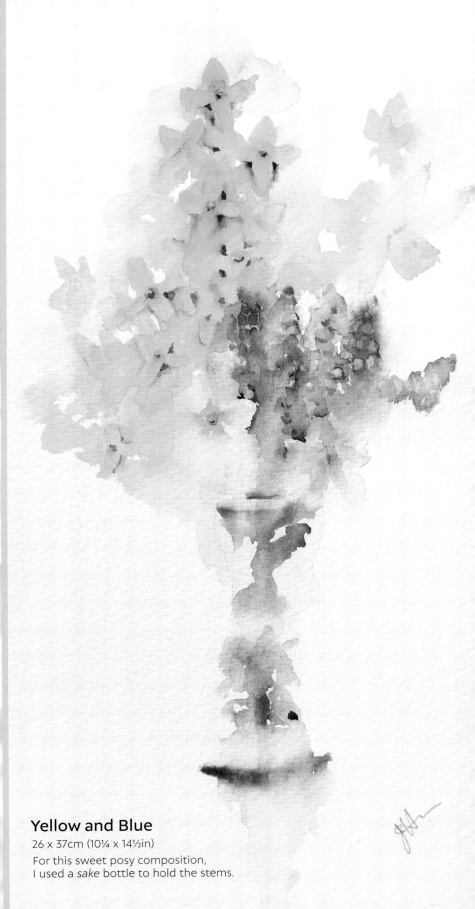

Yellow and Blue
26 x 37cm (10¼ x 14½in)
For this sweet posy composition, I used a *sake* bottle to hold the stems.

All about colour

"Colour tells the story of what you have painted as much as your brushwork."

Getting lots of ideas

There are so many ways to paint flowers, but having an endless supply of inspiration is as vital as having many techniques and brilliant ways to keep your enthusiasm high when creating. Consider the basic ideas in these pages to get you started, then we will move on to painting flowers a little more seriously.

Colour will tell the story of what you have painted just as much as your brushwork. Study the colour of each flower that you wish to paint and try to choose the right shade to match it. This will ensure that your work looks realistic, even if the result is loose and atmospheric. In fact, a brilliant colour choice tends to add that extra touch of realism to your atmospheric results, so colour and how we choose to use it is really important.

Colour selection

There are several ways to choose the right colour to match flowers you have chosen to paint. However, I find these two simple colour selection methods really helpful.

Matching colour to life

If you are painting real flowers, hold one next to the colours on your palette and see which matches. Placing a real daffodil next to the cadmium yellow shade on my palette matches perfectly, for example.

 This is also a fantastic technique for finding just the right shade of green for leaves and foliage.

 Please don't race to start a painting by taking a random guess at which shade will work. You could then spend hours on a beautiful composition only to realise your colour choice was wrong and your painting doesn't look as good as it could have – and all because you raced the colour choice decision. Take time to match colours to gain more accurate results.

Matching colour to photographs

If you are working from photographs, try placing tubes of colour on top of the image to see which shades match your chosen subject. With this method you often gain ideas of what colours work well; not only for the flower but for the background too.

 The strip of colour at the top of the watercolour tube indicates what shade the tube contains and is usually quite accurate unless the tube is faded or old. This method saves time in opening endless tubes of colour and is a very effective way to make your colour selection for the whole painting in one go.

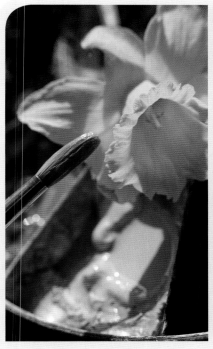

Match pigment from your palette to the real flower by placing the real flower next to a similar shade in your palette.

Finding the right shade of green for foliage.

Match colour to your flowers in photographs by placing the tubes against your image.

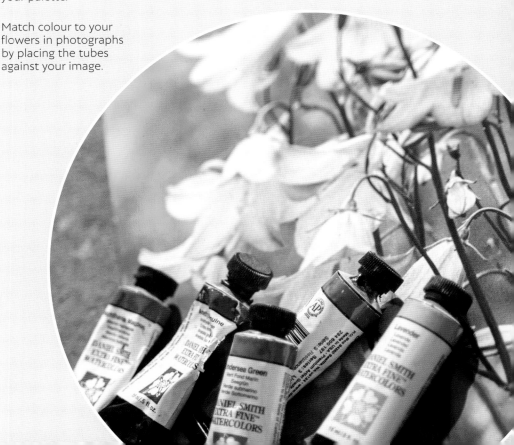

Losing the palette

Watercolours sing when colour is used correctly: freshly and straight from the tube. Too often we work with old colour that has been left on our palettes for far too long. Try this way of working for a change.

By painting on a piece of paper, not a palette, colours are kept fresh and clean, which is important for achieving vibrant watercolour results. This way of working also reduces the temptation to dip into any other colours already on your palette, keeping your artwork both simple and effective.

Working with neat pigment

Start by choosing a flower and select colours to paint it using one of the methods on page 27. You will need good quality watercolour paper for this exercise to work well.

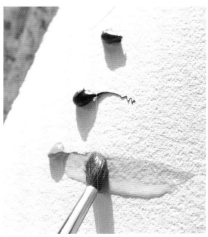

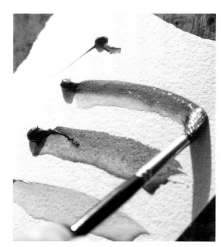

1 To see if your colour choice is correct, place a few dots of your selected colours on a piece of clean, fresh watercolour paper.

2 With a clean brush, add water alongside the dots of colour one at a time, and move the colour along the paper away from the original dot of pigment.

3 Once you have used all the dots to form lines of colour, allow them to dry and see which shades you like and which ones match your chosen flower.

"Adding water and moving pigment across the paper this way always gives clean fresh results. I use this technique when I try new colours to see how much water is needed to make them move more easily and see how they dry."

Tip

Do remember clean water gives you the best results when painting, so change your water often.

Water: how much is too much?

Get used to finding out how much water you are comfortable working with. I use a lot of water when I paint and I love how it aids colour flow, but for the new artist this aspect of working with watercolour can be daunting. So painting on scraps of paper often, just to get used to finding out how much water is enough, or too much, is time well spent.

Working with water

Working with watercolour can be easy when you have all the knowledge and tips of professional artists, but for me, the fun always has been in learning and discovery. These images show some simple tips.

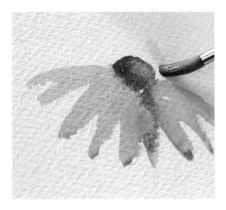

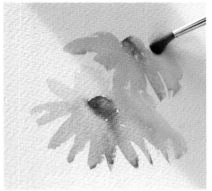

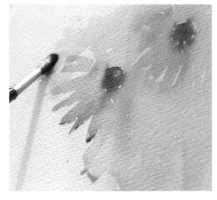

1 Try painting simple flowers using almost neat pigment. Here I have used a size 10 brush to apply bold cadmium yellow for the petals and quinacridone burnt scarlet for the flower centre.

2 While your flower painting is still wet, try adding a drop of clean water on the damp brown flower centre. This will create a pattern as the colour dries.

3 Try this too: while the flowers are still wet you can soften the outer edges. Take a clean damp brush and gently move the still-damp colour of the petals away into the surrounding dry paper area. Moving the slightly damp flower colour away gains a glorious softened effect, as seen above.

Tip

Once dry, watercolour always looks paler than the initial colour application. However, when used boldly, you can achieve stunning strong colour results with this wonderful medium – particularly cadmium shades.

Tip

You can also lift colour in this area by using a small piece of tissue to gently remove colour. The tissue absorbs the wet colour, creating a paler section. This creates a sunlit effect when dry as one area of the brown centre will be lighter than the other. This technique is beautiful when used in larger paintings.

Tip

Let the paint dry just a little before you attempt to move the colour – if you move completely wet pigment too soon, it can lose the original shape of your subject.

"I love all these little tips. They can make or break a painting and the more I practise them or share them, the more I want to get painting the real thing, in a serious painting."

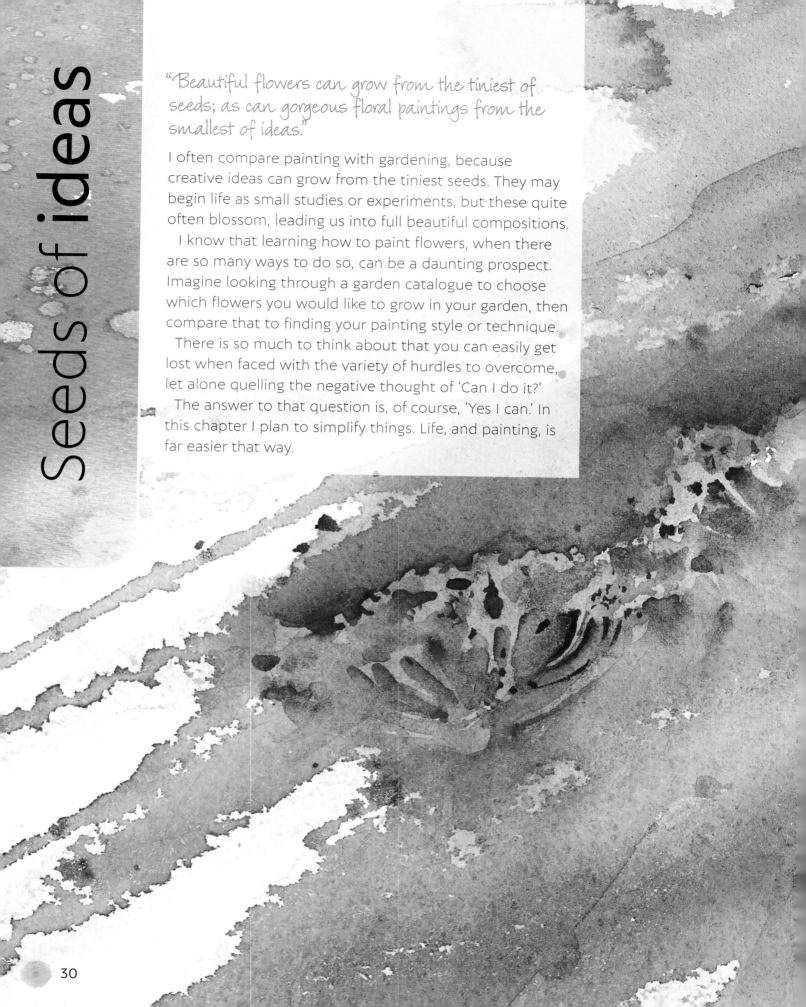

"Beautiful flowers can grow from the tiniest of seeds; as can gorgeous floral paintings from the smallest of ideas."

I often compare painting with gardening, because creative ideas can grow from the tiniest seeds. They may begin life as small studies or experiments, but these quite often blossom, leading us into full beautiful compositions.

I know that learning how to paint flowers, when there are so many ways to do so, can be a daunting prospect. Imagine looking through a garden catalogue to choose which flowers you would like to grow in your garden, then compare that to finding your painting style or technique.

There is so much to think about that you can easily get lost when faced with the variety of hurdles to overcome, let alone quelling the negative thought of 'Can I do it?'

The answer to that question is, of course, 'Yes I can.' In this chapter I plan to simplify things. Life, and painting, is far easier that way.

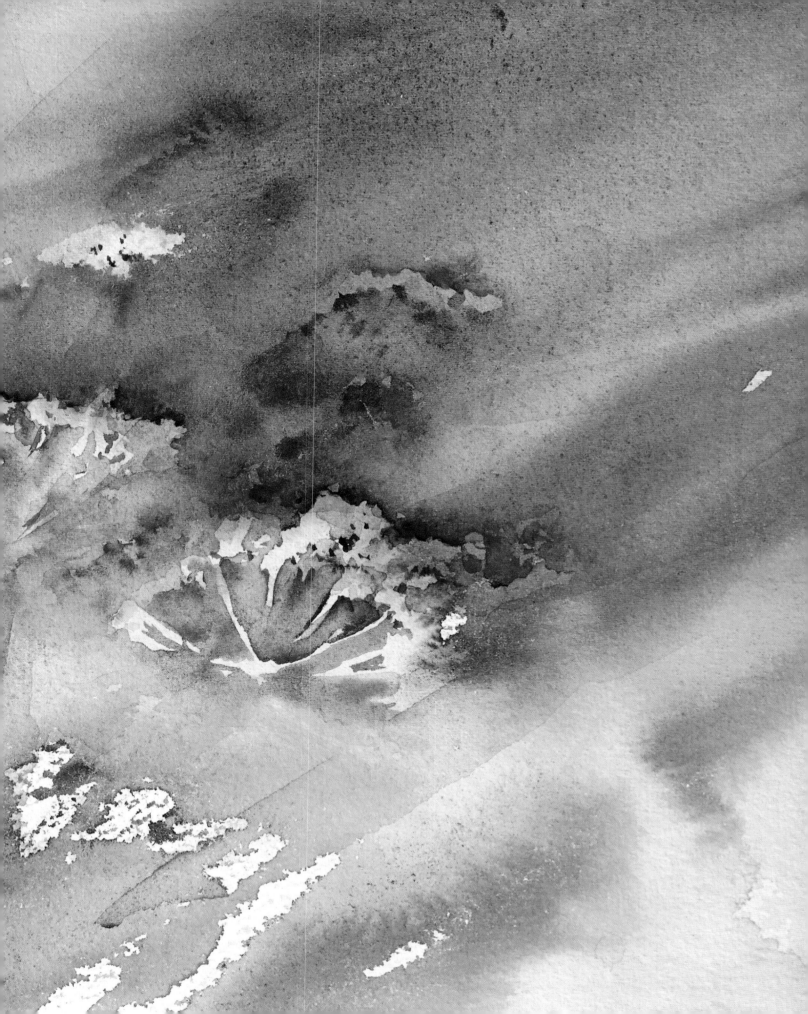

Seeds or weeds?

"Fabulous surprises in watercolour can sometimes break up the monotony of a well-planned painting."

As you work through this book you are going to come across ideas and demonstrations that you love, and find others that do not catch your imagination as strongly. When painting, you will discover that some techniques are extremely easy for you, while others prove difficult. Exploring all painting possibilities is how you find out what works for you, and continuing to experiment is important, as it will lead you to a style of painting which is the most enjoyable for you. I love the seeds of ideas that come to me now and then, such as new colours or new techniques that I just have to try.

Earlier, I likened painting to gardening. I am constantly learning about both. In the same way as I had to learn what is a weed and what isn't, I had to learn what is good watercolour technique and what isn't. I realised that I needed to read about plants to learn about what would grow in my garden well. Not all plants suit the soil in my cottage garden – and even if they did, I had to discover which looked beautiful alongside another. Some colours would clash terribly, some forms didn't work side by side. By putting the time in to learn, I now know from experience and practice what works for me in my garden. Nevertheless, I am still learning, as we all do when it comes to new skills.

No matter what I planted in my garden, weeds would always appear. Many self-seeding plants ended up growing in the least expected places. At times I thought these weeds or self-planted flowers ruined my regimented and meticulously-planned designs, but over time something interesting has happened. I now love the self-seeding plants. These act as fabulous surprises that break up the monotony of my well-planned flower border.

This is exactly what happens in a really good watercolour. It is possible to overthink or over-plan a painting at times. Accidental watermarks can be likened to unwanted weeds in a painting session – but if you embrace rather than avoid them, such watermarks can be your best friend. They can magically add atmosphere and spirit to what could have become a dull, boring piece of work.

Learn, like me in my garden, to live with the 'weeds' in your work and let them be integral to your compositions. These unplanned accidents can often never be repeated, which makes them all the more magical. Enjoy them. Embrace them and celebrate what watercolour does – and how beautifully!

What is beauty?

Not all weeds are ugly; and not all accidents in a painting are a disaster. Learn to see the beauty in your work, rather than constantly looking for the problems. Bear in mind that a weed to some is a magnificent flower. The same is true when it comes to art: what you don't like about your painting could be seen as a masterpiece to others. Learn the difference between good and bad 'weeds' in a painting!

Tulips and Forget-me-nots.

Forget-me-not, self-seeded in an unexpected place. Like an unplanned watermark in a painting, it has a beauty all its own.

Dandelion flower and clock, weeds or beauty?

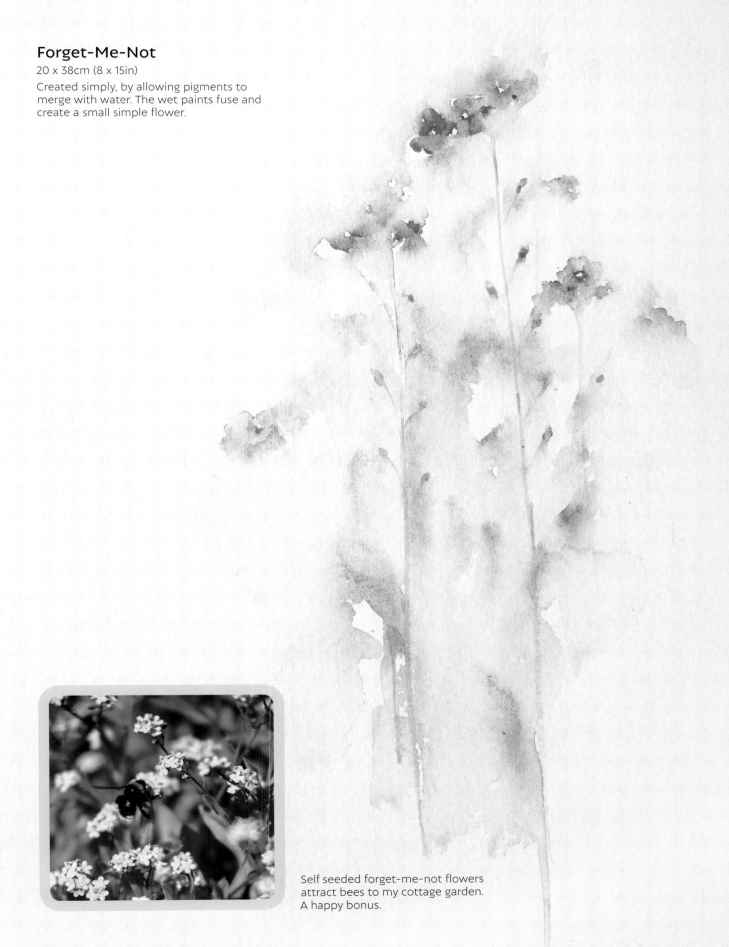

Forget-Me-Not

20 x 38cm (8 x 15in)

Created simply, by allowing pigments to merge with water. The wet paints fuse and create a small simple flower.

Self seeded forget-me-not flowers attract bees to my cottage garden. A happy bonus.

One of my early daisy paintings, where I created the basic outline first with a simple pencil sketch.

Seeds to grow from

The value of sketching

Firstly, lets look at painting style. You may have bought this book because you want to paint loose, atmospheric flowers. That is now my favourite style, but I reached this point in my career by painting realistically at first.

A few sketches with detail will help you grow as an artist and help you learn about form. To be a good floral artist you have to study your subject first: Look at shape, colour and form. Also, consider these points: is the flower delicate? Is it simple or complex in structure? Sketch your subjects from time to time to improve your drawing skill which will, in turn, aid your work when it comes to painting without a pencil sketch at all.

Many new artists fall in love with the notion of creating impressionistic art but to be able to do so, and well, knowing your subjects is important. Please don't give up sketching, particularly when you are approaching painting a new subject. See your sketches as seeds you are planting to create beautiful flower paintings from later on. Over time you can lose the pencil completely but it is a valuable part of growing as a really skilled artist.

The seed of life: creating movement

Adding life to your work creates interest to the viewers of your finished pieces. You need to ask yourself if the flower you are painting could literally move in a breeze, and if the answer is yes, you should add movement to your creation through clever brushwork or by painting the flowers so that they all face the same way, suggesting them leaning towards the light, or away from a breeze.

Creating a sense of life can add wonderful excitement to a painting. Directional placement of colour to achieve energy in a composition can be dramatic, simple, or both – and it will make a huge difference to your results.

A second early painting of mine. Another daisy, but one that carries a sense of movement, as though the flowers are dancing in the breeze.

Narcissi

19 x 25cm (7½ x 9¾in)

This painting is full of atmosphere, mystery and energy, but leaves quite a lot to the viewer's imagination. You can almost tell what the subject is at this point, but a little more definition will make this a finished painting. Of course, you may like it as it is – this is a stylistic choice.

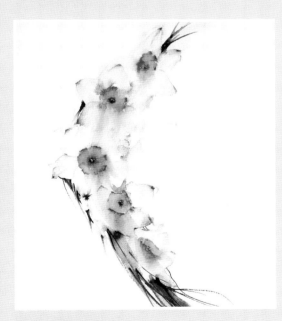

Elegance

28 x 38cm (11 x 15in)

Considerable thought has gone into the composition of this painting. There is enough detail to show exactly what kind of flowers these are, even though sections of the flowers are missing. There is enough detail to make the piece attractive but not too much so that it distracts from the simple beauty of the piece.

Choosing a loose or tight style

When buying plants some people will eagerly race for showy, large flowers, while others will opt for small, delicate plants. I am lucky – I love all flowers: large, small, delicate or hardy. Each one is my favourite! Your preferred painting style is a similarly personal decision for most artists.

When it comes to painting styles, I like most, but when creating personally, I enjoy a mix between a tight and loose style. There will always be a section in my paintings where the detail is apparent, telling the viewer of my work exactly what my subject is. However, this defined area will often be surrounded by a more abstract background that helps me to achieve the atmospheric results I yearn for. I find one area will show off the other, and the contrast of styles can be both exhilarating and exciting in a full composition.

Here are some valuable points to consider:

- If your work has too little detail, it can err on becoming an abstract; which is fine if you want to be an abstract artist.

- If your work is too detailed it can sometimes lack a sense of life and energy.

There needs to be a balance in an atmospheric painting. There needs to be enough detail to show what the subject is but not so much is kills the spontaneity of the finished art. This compromise, where both styles meet in harmony, will ensure your floral paintings look fabulous and full of atmosphere.

A personal style

I believe your style also has to suit you. Knowing what you like and what you want to achieve in your art is a huge asset. Seeds of ideas of where you think you might like to be in artistic style are well worth consideration.

I use the word beautiful so much when I am painting flowers because they are just that: beautiful. Our art should capture that feeling; so every single new idea is vital to our growth in style, bringing light and life into our work.

Compare the impressionistic *Narcissi* painting at the top of the page with *Elegance*, to the left. Think about how much, if any, detail you would add to complete the unfinished narcissi impression – or do you like it as it is? Questions like these will help you to think about what is enough or not enough in your work. I love the expression 'less is more'.

When planting seeds of ideas in a garden, they need space to survive. Give yourself the opportunity to grow as an artist by enjoying all new ideas that you come across; and always be on the look-out for more, whether they relate to finding new subjects, new techniques or new colours. Plant a healthy way of creating by being open-minded, enthusiastic and eager to paint new things from new ideas regularly. Be a good 'artistic gardener'.

First steps

"Sometimes it is the little things in life that bring the most happiness."

A garden is full of surprises and lessons to enrich your art. For example, if I planted the same things every year, wandering around the flower beds could eventually become boring, as I would be seeing the same flowers year in and year out. As much as I love my favourite plants, I am delighted to see something new now and then to add extra interest to my existing flower borders.

I am the same way with my painting style: I constantly yearn for something new – unlike the little bird I painted one spring, which was terrified to leave its nest. However, once it had learned to fly it was so happy. Blackbirds nest in our potting shed each year and the fledglings always bring me such pleasure when I see them ready to leave the nest, knowing that they survived.

It can be either frightening or exhilarating to take the first steps in trying something new. We can sometimes hold onto what we know rather than leap into a new adventure but right now that is exactly what we are going to do: pick up our brushes and aim to breathe life into a painting. We will start with something very small as a subject and with no preliminary pencil sketch, to show how easy painting without a pencil can be.

Bear in mind that the little fledgling has to face falling from a height; by losing the pencil, you are only risking ruining a piece of paper.

Opposite:

Grumpy
28 x 38cm (11 x 15in)
A baby blackbird, who definitely didn't want to leave the security of its nest!

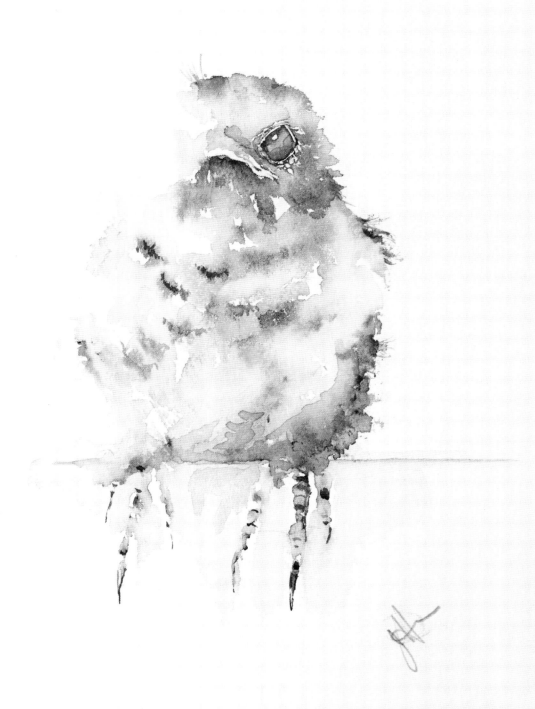

37

Sweet Scented Violets

I have chosen this simple little posy of violets as a step-by-step project both because it is such a popular subject of mine and because it is so lovely to paint. To hint at a glass vase, we are looking at leaving parts of a painting out – or rather, leaving them to the viewer's imagination.

Wild violet growing in my cottage garden.

Flower meaning: *Violet*

This tiny flower is said to represent modesty as it hides its flowers amongst its heart-shaped leaves. Sweetly scented, it makes a beautiful gift for someone you care about.

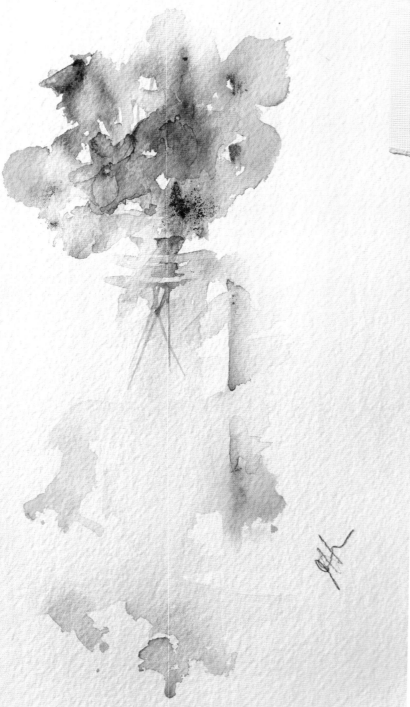

Sweet Scented Violets
23 x 33cm (9 x 13in)

Colour matching

Before we begin painting any floral subject, before we even pick up a brush, it is vital to get the watercolour shade match perfect. Some flowers' colours are so exact that if you paint them in a differing shade, true flower lovers will find it hard to accept that you have even seen the real flower, yet alone known what it is.

As described on page 27, you can hold a tube of watercolour against the real flower and compare it to see whether the colour will be suitable or not. This method of selecting colour often works, but it isn't infallible. For this violet posy, my initial colour choice was between two violet shades. I placed dots of both on a scrap of watercolour paper. As previously described, painting from this paper (rather than my palette) helps to keep my colours fresh and clean, which is important for achieving vibrant watercolour results. This way of working also prevents the temptation of dipping into many other colours already on my palette. As mentioned on page 28, running a line of water from the dots of pigment on the paper allows me to see what they will look like when dry.

Time taken to choose my colours before painting allows me to see which shade will match the real flower perfectly. This vital decision will mean accuracy in colour matching and help me gain a more believable outcome. Even when creating in a loose style, the storytelling of what kind of flower you are painting needs to be as true to life as possible. I opted for cascade green for the leaves and cobalt violet for the flowers. These two shades will form the foundation of an idea for a simple yet effective painting.

We need very little in the way of materials to create. I believe we sometimes make painting harder work than it should be by having too many colours to choose from. For subjects such as this, I prefer to keep my art results effective and beautiful by use of very limited colour combinations. You may find you have different shades that you prefer to paint violets with, and that is terrific because then your results will vary from mine. Now, with my colours chosen, I can begin painting.

Testing out colour options.

> # Tip
> *Colour can suggest the delicacy of a plant, or the particular season, so do take your time in making the correct colour selection before you start painting.*

Warming up

Before painting any new subject, I often practise creating petal shapes and flower formations on a scrap of paper first. If you are new to painting flowers I highly recommend this warm-up exercise. This way of working helps to ensure that you eliminate any possible problems later, when painting the real thing on fresh new paper. I have the basic seed of an idea for a painting but I want to make sure the idea grows into a beautiful composition by taking care of the seed well.

For my first warm-up exercise with this project, I painted little petal shapes individually to form one violet flower (1). For my second warm-up exercise, I dropped water onto the paper in the shape of the violet, then dropped pigment into it to form a flower naturally: the colour flowed where the water had been placed (2). Both exercise flowers dried beautifully. My third exercise was to paint the flower but allow my selected green shade to merge and run into it (3). I loved this effect most of all. Finally I painted a flower but created a lighter purple area next to it. This was done by using the same shade but with more water added to it (4). This gave an illusion of a shadow, or possibly another flower behind the first one. These little seeds of ideas led me to the full painting.

Next I painted a rough study of what I wanted to achieve using all the little exercise ideas in one area on my scrap of paper. After these little warm up exercises I am ready to paint the real thing, as you will be.

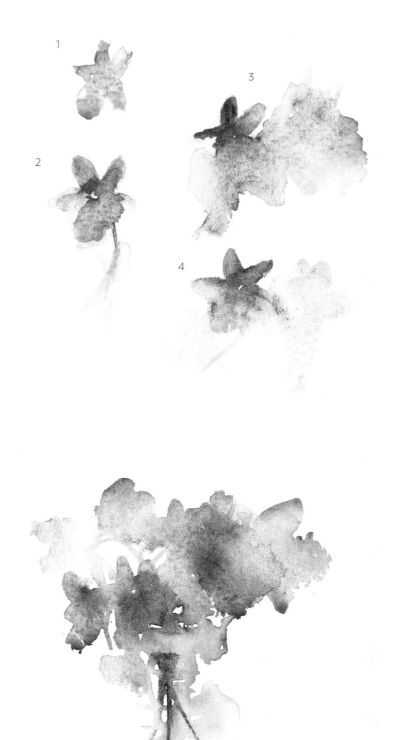

The rough study.

Step-by-step Violet

Painting a violet

This step-by-step leads you from a small starting point of one flower to a simple composition. Repetition of flower shapes when learning helps you improve your skill, adding to a painting teaches you how to build up a composition, and good colour selection can tell the story of what the flower is quite effectively

Materials

Watercolour paper, 300gsm (140lb) weight

Card for painting a straight line.

Size 10 and rigger brush

Watercolour paints: green appetite genuine, cobalt violet deep, cadmium yellow, cobalt turquoise

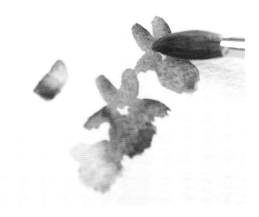

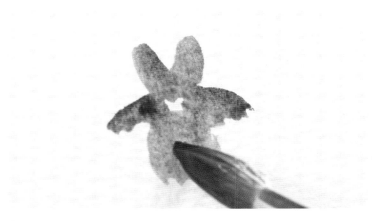

1 Working from a starting point of one petal at first, followed by others around it, I created this flower using a matching colour to my subject. I chose cobalt violet deep which is a shade that, with the addition of water, can vary from lighter to darker colour effects. I studied the real flower shape before painting to ensure my interpretation of its shape was accurate for this plant.

2 Next I repeated the process by adding other flowers alongside it to build up my composition. I also painted bud shapes for added interest in my composition. At the edge of my violet petals I also dropped in a touch of cobalt turquoise, to give a boost of unexpected colour which will lead to my finished result as being more unique.

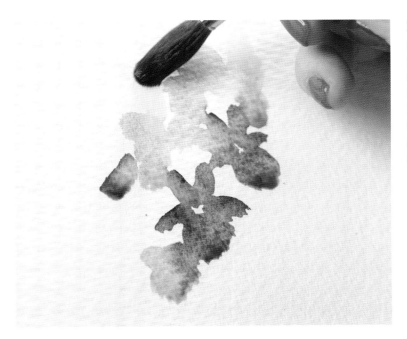

3 I allow this initial colour application to dry slightly before softening some edges of my painted flowers. By blurring away colour from outline sections using a clean damp brush I can form more flowers in the background behind the initial two main blooms. This technique is wonderful for creating atmospheric results and paintings that have a feeling of life in them.

4 Once my flowers were in place I began to add foliage, by adding a green shade and allowing it to merge randomly with the still-damp flower colour. This connects the two parts of my floral painting.

5 When my initial work was completely dry I began adding detail to the flower centres by strengthening any pale sections I felt needed extra colour added or further definition by detail.

6 Adding small stems and keeping their brushwork appropriate for the size of the flowers helps to further bring the small flowers to life. These I created with diluted green as used in the foliage earlier. I kept them looking quite delicate to match the real plant.

Tip

It is worth noting that I often add a tiny amount of cadmium yellow to give warmth to my green sections in a floral painting. Adding yellow helps a floral painting look far more pleasing, as if sunshine has hit the leaves here.

8 When this initial colour for the edge of the vase was dry, I then defined the vase shape with bolder colour, to match the green shade in the foliage.

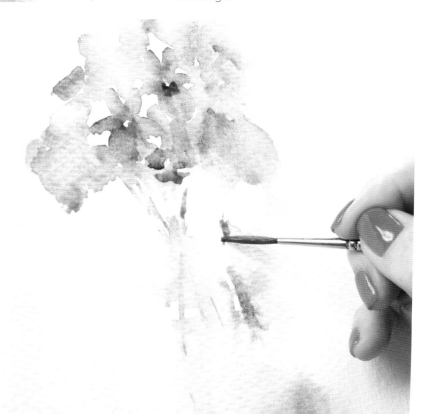

7 In order to add the impression of a vase I used a clean piece of watercolour paper and laid it on my paper so that I could create a straight line where needed to replicate the interesting outer edge of a vase I had placed my violets in.

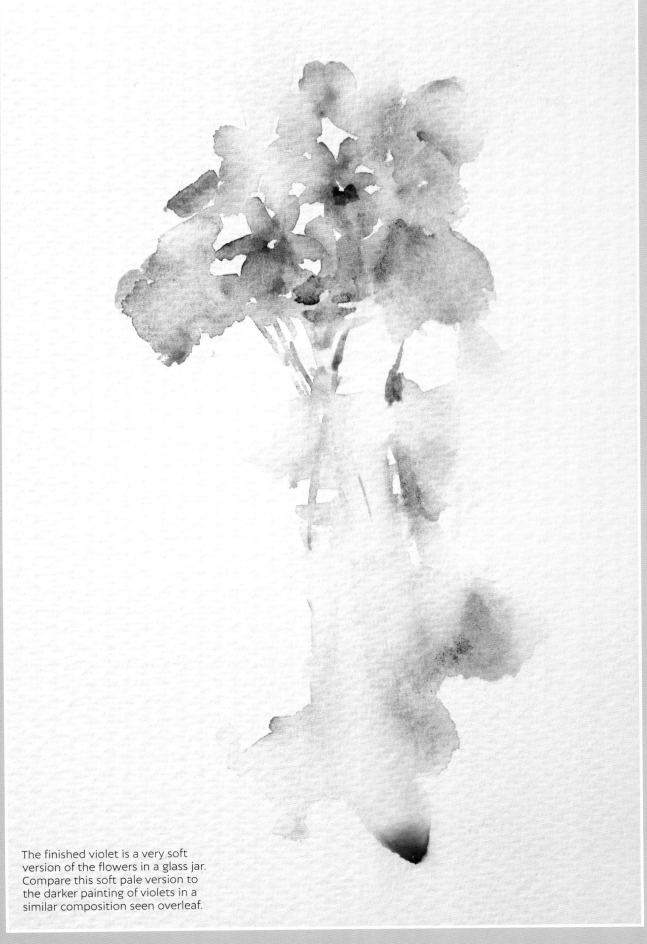

The finished violet is a very soft
version of the flowers in a glass jar.
Compare this soft pale version to
the darker painting of violets in a
similar composition seen overleaf.

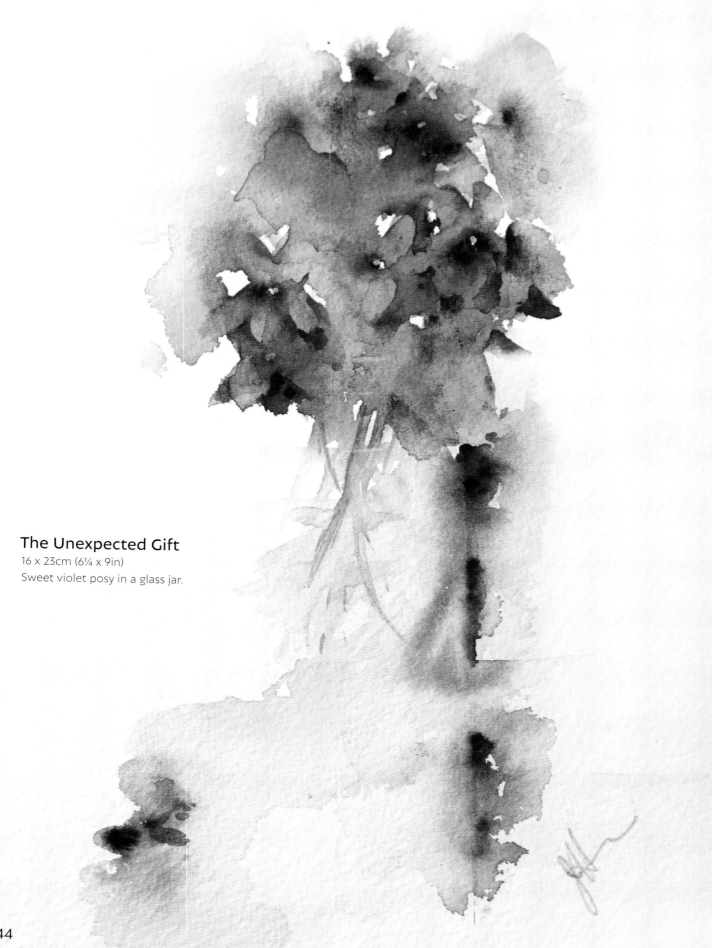

The Unexpected Gift
16 x 23cm (6¼ x 9in)
Sweet violet posy in a glass jar.

The Unexpected Gift

The story behind the painting opposite is that I was once given a gift of violets by my friend, Christine. She had placed the tiny flowers in the sweetest of glass jars that was so small it held the little posy perfectly. I couldn't resist painting my unexpected gift and my painting turned out beautifully. Later, I gave the very old glass jar back to Christine after the flowers in it had died. But my friend knew how much I loved it. The following Christmas I opened a box from my friend and in it was a little glass jar of my own for future paintings. All the money in the world couldn't have brought me more joy.

Sometimes it is the little things in life that bring the most happiness. Little acts of kindness. Little gestures that show you care. Little flowers may not be as big as others, but their beauty is still very much the same. Small things make a difference in life. This little posy kept on giving as the original painting was given as a gift by Christine to a friend of hers who had cancer. I later painted a similar piece for Christine to keep. Perhaps you too could give a gift of a posy to someone you know. A lasting unexpected gift of a posy painted with love.

Whispers and shouts in colour

If you compare the various violet paintings in this section, you can see how use of colour plays a huge part of the story in any painting. Using heavily diluted pigment creates an illusion of delicate flowers and petals, whereas using bolder, strong pigment has a completely different effect.

In the step-by-step demonstration on pages 41–43, I used diluted pigment to achieve an almost ethereal outcome, while the colours used for *The Unexpected Gift* on the opposite page were far stronger. You will discover which style you prefer as you paint the challenges throughout this book. Try both soft and bold colour with each new flower that you paint.

Painting challenge

- Keep your first painting soft and gentle in colour, as in the example on page 43 (and shown to the left). Try painting the project again, using much darker colour next time.

- Try using the same techniques to paint other small flowers in a glass jar. Paint studies first to learn from as seeds of ideas. Some will work, some will not. Create a lovely composition using ideas generated from your successful warm-up exercises.

- Try replacing the glass jar with one of another shape as I have in the demonstrations: a vase, perhaps, or a pot – even a teacup. Be creative!

Simply blue

"It is the ability to see the positive in painting mistakes that pushes us forward into creating something totally beautiful."

As we saw earlier, one of the main problems when painting is choosing which colours to use. In fact, one of the main problems we face when creating at all is that we have too much choice: too many styles, too many techniques and too many colours to choose from. 'Simplify' is a favourite word of mine when teaching. It is a great word to remember when facing a complex decision in your art, such as choosing colour.

When painting flowers, getting the shade exactly right can make a huge difference, but is a challenge. For example, bluebells have a stunning colour that can be difficult to match. Lavender similarly needs careful thought when it comes to choosing the right shade.

Let's simplify and look at our brushwork alone. In the exercises here I have worked with just one colour, phthalo blue. It is a gorgeous colour to work with, and makes my painting time really enjoyable.

Tip

Painting with any shade that makes us feel particularly good is a positive – my palette is full of my favourite shades, chosen for just this reason. You could build up your own personal collection of favourite colours as you work through the chapters of this book; colours that add to your day, making you feel good or helping you relax.

Simplicity – basic ideas for creating floral patterns

For these exercises you will need scraps of paper, clean water, one colour of your choice, kitchen paper, and cling wrap. The aim is to see the variety of effects that you can achieve with just one colour, and see how they could act as the basis for future flower work. This is also a great way to learn brush control and observe how colour reacts with water to make terrific patterns.

Watercolour is a magical medium. The effects you can create simply by combining a pigment with water are fabulous. These patterns are what we need to learn about and understand if we are to become good watercolourists. As with any skill, the more we paint the better artists we become. Just as a gardener learns the difference between a weed and a flower, as artists we are learning what works and what doesn't starting from tiny simple steps – just like taking seeds of ideas and watching them grow.

Tip

I never use a hairdryer to speed up the drying time of my watercolours. I have found natural patterns can be lost when doing so, which is why I prefer to allow my art to always dry naturally.

Rose patterns: moving paint

Place a circle of colour on paper and while the pigment is still wet, make circular marks in it using a clean, damp brush. Start in the centre by making small circular or semi-circular marks, radiating to larger ones towards the outer edge of the coloured circle. Allow this shape to dry and then see if you have created what could be the base for a rose (1).

Don't try too hard – just use soft brushwork, with a clean damp brush and allow the rose pattern to dry naturally. You are, in effect simply moving colour out of the way; encouraging the pigment to dry in a rose formation. I am often surprised at how beautiful my results are when I take just a few seconds on these experiments. Often they are far better than results when I have deliberately tried too hard or taken a long time on them. With practice they get better and better.

Primrose pattern: lifting out

I placed a second circle of colour on the same scrap of paper alongside the rose pattern. This time I used tissue to gently 'lift' a flower shape out from the still-wet pigment. It doesn't matter what the flower shape is for the exercise, as we are at the moment only learning watercolour techniques. I chose a primrose. (2)

Interestingly, this shape could be filled in with yellow once it has dried, to form a more believable primrose. Alternatively, you could use a technique called 'glazing', in which you paint a thin layer of colour over the whole area – in this example, over the new white space and the existing blue background. The white space will then become yellow, while the blue space will become slightly green as the yellow glaze covers it. There is so much in the way of technique to experiment with when painting flowers, and so much to enjoy.

Carnation pattern: using cling wrap

My third circle of colour is the technique I use for painting flowers with many petals, such as carnations and peony. Unless we use an effective and simple technique to create the complex patterns, they can take ages to paint. I have found this method to be the best. Paint a circle of colour and while it is still wet place crumpled cling wrap on top of it. Leave it in place until the paint is completely dry. Once you remove it, a beautiful texture will have appeared (3).

This method works best with plastic wrap that has been used before (I call it 'pre-loved') because it already has wrinkles in, making it easier to crumple than new plastic wrap, which you need to manipulate well with your fingers to gain a great pattern. I keep a box of pre-loved wrap especially for this purpose.

Experiment

Try creating your own patterns, using all kinds of materials – not just those listed above. Make these patterns using just one colour: this will help you to learn tonal values. Knowing where to add depth is a skill professional artists possess from painting repeatedly over time. New artists can get to this stage far more quickly if they experiment often and with just one colour. By the time you then paint a large composition, you are armed with the knowledge of which colour to place where and how.

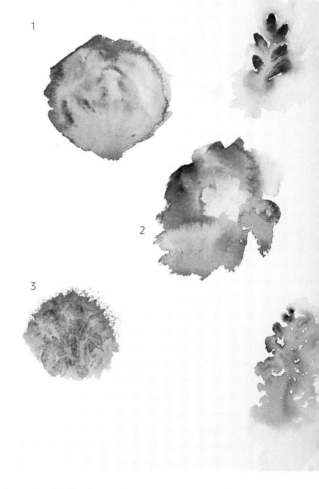

I used a single piece of paper to warm up for the exercise and to learn.

Making paintings from seeds of ideas

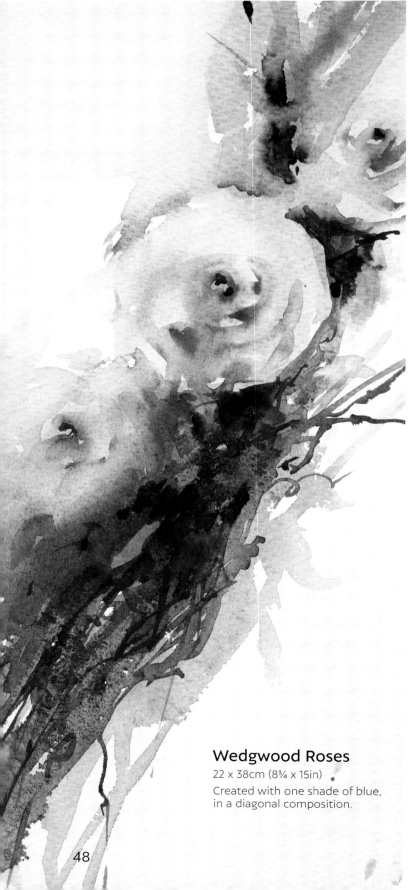

Using one colour

Once you feel you have a grasp of creating patterns from the exercises on the previous page, move on to painting a full composition in just one colour. *Wedgwood Roses*, which can be seen to the left, is an example of this.

I painted three circular shapes and created roses from them in exactly the same way as shown in the exercise on the previous page. I then enhanced the illusion of direction by using brushwork that echoed the three flowers' diagonal format. A few fine brush marks to hint at stems completed the scene. This painting is simple, elegant and beautiful. It reminds me of Delft blue porcelain, of which I am very fond.

Adding a second colour

When you are happy working with just one shade leap into the next exercise which is adding just one other colour. In *Tears of a Rose*, below, I used phthalo blue and cobalt turquoise and allowed clean water to flow through the pigment to create interesting patterns. The rose shape is there with an almost abstract effect. This painting carries a sense of atmosphere which is missing from the more detailed way of working in *Wedgwood Roses*.

Tears of a Rose
28 x 38cm (11 x 15in)

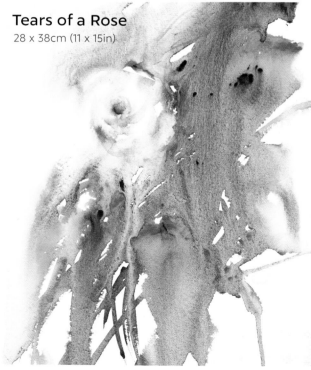

Wedgwood Roses
22 x 38cm (8¾ x 15in)
Created with one shade of blue, in a diagonal composition.

Learning from exercises

What we learn from these exercises, and what we need to think about when we paint, is that some ideas work, and others don't. Some accidental results are gorgeous, while others are simply a mess. At times things go wrong, but we learn from what goes wrong far more than from what goes right. It is the ability to see the positive in mistakes that pushes us forward into creating something totally beautiful. As artists, we need to 'weed out' what goes wrong until our work is stunning and enjoyable.

What is a weed, anyway? It can be a plant that no one wants in their perfect garden. But a weed, or mistake, in a painting can be seen as either beautiful or make us appreciate what to us really is fabulous.

I can honestly say it took a lot of weeds – that is, paintings I didn't like – to get to where I am today in terms of my art. However, I adored the journey it took to get me to this stage in my career. I can now paint more complicated compositions like *Goat's Willow*, shown to the right. This is a painting I built up on top of a wash from my book *Paint Yourself Calm*. The initial wash (painted using my waterfall technique of letting very fluid colour flow down the paper) acted as a great base for this piece, but without my time experimenting I wouldn't have been able to create it.

We need both a healthy mixture of seeds as ideas and the skill to distinguish between those which will grow and add to a painting, and those which are in fact weeds that will choke a good painting.

How good an artistic gardener will you be when it comes to selecting techniques that suit you, and make you feel brilliant, when painting? Take time to find out!

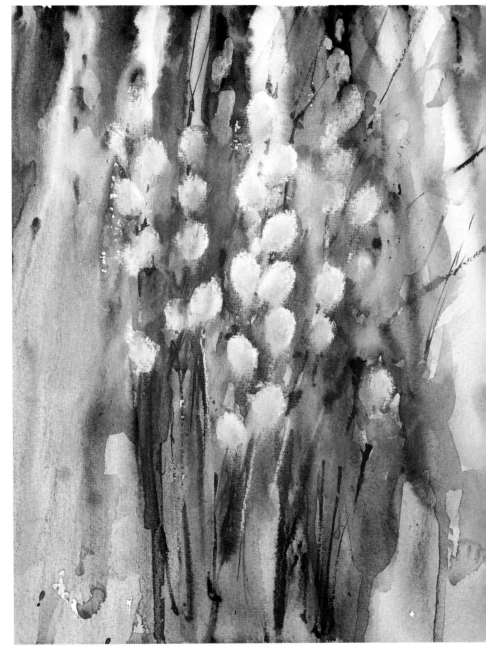

Goat's Willow
28 x 38cm (11 x 15in)
Otherwise known as pussy willow, these soft fluffy buds appear on the twigs during springtime in the UK.

The point of no return

One common problem I consistently see when teaching my watercolour workshops is an artist's painting becoming far too tight: the painting has so much detail added that the subject cannot breathe. The artist's disappointment is heartbreaking. They will have started out wonderfully in their journey to achieve a loose, atmospheric result but at a certain stage in the creative process they crossed a line. They didn't stop painting soon enough and they kept fiddling, adding far too much unnecessary detail. We all do it, or have done it. By overworking a painting it is possible to lose the fresh, spontaneous energy in a composition. This is what I call the 'point of no return'. There is no going back during the creative process once too much detail has been added to a painting.

How do we overcome this problem? My approach will hopefully help you to consider the thought process in achieving a loose painting and help you gain your longed-for atmospheric results.

In the previous chapter, *Simply Blue*, we covered ways to create patterns by working with just one colour. By applying pigment to paper and making shapes or patterns within that initial colour application, hints of flowers began to appear. There are many ways to form flowers using this technique. A similar way to create flowers in watercolour is to work by adding detail on top of a one colour first wash, which leads me to my next demonstration of forsythia, a stunning yellow flowering shrub that blossoms in springtime in the UK.

You can use any flower to follow this simple step-by-step as it is an easy method for creating floral subjects made up of complex tiny flowers (like lilac, for example).

Flower meaning: *Forsythia*

This beautiful spring flower was named after William Forsyth (1737–1804), a Scottish botanist. It is said to represent anticipation, which really does work well as a meaning for a flower that heralds the spring and all the colourful flowers that come with this time of year.

Step-by-step Forsythia

Colour selection

This is the most important step of any good floral painting. You need to match the colour to the flower as perfectly as you can. Please don't race to paint until you are absolutely sure you have found the right shade. I found cadmium yellow to be the best in this demonstration. I also tested browns for the branches and loved the effect that quinacridone burnt scarlet gave me. So with just these two shades, I was ready to apply colour to paper.

Simplifying complex flowers

When painting any subject with multiple tiny flowers, try applying an overall wash of the flower colour first. I applied a yellow wash for this forsythia painting. Leaving sections of paper white gives a feeling of lightness and air for the subject to breathe.

Materials

Watercolour paper, 300gsm (140lb) weight
Size 10 and rigger brush
Watercolour paints:
 cadmium yellow,
 quinacridone burnt scarlet

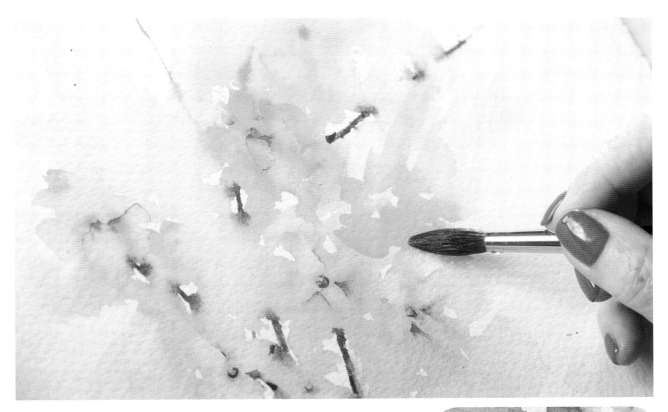

1 Use the size 10 round brush to paint a cadmium yellow wash, leaving white gaps and varying the yellow shade: leaving pigment strong in some areas will contrast with the paler sections and hint at flowers being seen as if in strong sunlight and in the distance. Soften the outline edges of colour for the same reason. Use stronger paint to add the petals of individual flowers, keeping the shape accurate using cadmium yellow. Once the flowers are in place, gradually add hints of stems or twigs with quinacridone burnt scarlet to connect the yellow shapes and white spaces, allowing colours to merge randomly. This creates subtle harmony between the flowers and stems, more appealing than having definite hard brown lines abruptly stopping in a composition.

> ### Tip
>
> *I am very careful not to add too much detail as it could make my work look overly fussy, suffocating the atmospheric appearance. Keeping my painting simple and clean by using fresh application of glowing colour is more pleasing.*

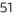

Finding the subject

If you are using a first wash, leaving it to dry completely before adding any details is an ideal way of working. It is vitally important to remember that you are aiming for an atmospheric painting, not a botanical study. You want to 'tell the story' so that your flowers are recognisable but not add too much detail so that your work becomes tight and botanical. I believe there is a line we cross when painting in a loose style. This is the point when we cannot go back to the atmospheric stage we once loved.

To complete my painting, I used my rigger brush to add darker colour to strengthen the tiny circular centres of the forsythia flowers. I also added corner marks in between petals as seen in the step by step photographs that follow. By painting around the outer shape, the flower comes to life beautifully in the once-yellow wash. When clusters of small flowers grow on branches or stems applying a first wash of the flower colour and then picking out individual blooms is such an easier painting method.

When dry, you can add one or two more dark details to bring your flower painting further to life. Remember to limit your brushwork when finishing off a painting. Add just a few additional brush strokes at a time to avoid reaching the dreaded 'point of no return'.

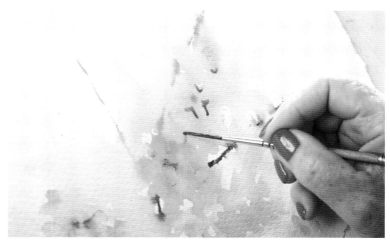

2 Build up the painting with the rigger brush by finding detail of each small flower on top of the dry first wash.

3 Once the detail has been added, use strong colour to form the small individual flowers. Soften these new hard edges with a clean damp brush, as in the previous violet demonstration.

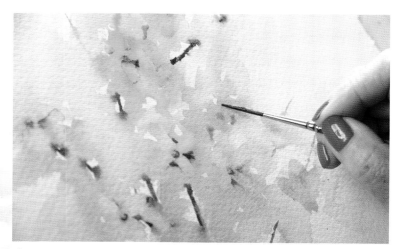

4 Adding centres to flowers working across a composition builds up the painting and makes your creation time for a more complex subject more enjoyable.

Finishing off

This is the part of the painting process when you need to seriously slow down and only add detail to your painting if it really needs it. If my creation looks like the flower I am painting at this stage I stop. I don't even consider if the painting is completed or not. I know the story of what it is has been told. I often leave a painting at this stage and start a new one. I sometimes add more detail to my next painting of the same subject and then compare the two results. I usually prefer one to the other and without question it is often the one that has less detail. Over the years this way of working has made me appreciate the more atmospheric paintings I love so much. And this way of creating has also helped me stop over-working.

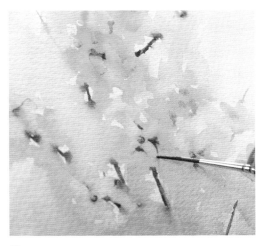

5 Use the rigger and quinacridone burnt scarlet to paint behind the small yellow shapes. Painting their background in an attractive contrasting shade will help suggest the form of the flowers.

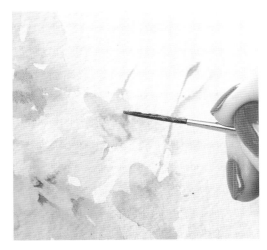

6 Add twigs or stems in the background with the rigger. It is also useful for painting the centres of each small flower.

The finished forsythia.

Finding your style

A great exercise for working in a loose style is to have three small paintings on the go at one time. Paint three initial washes, then add detail to each at the same time. Stop early on the first, and aim to overwork the third study. The first painting should look underworked, the third overworked and the middle painting should be a happy combination of the two.

Once dry, look at each of the three paintings and consider which you personally like the best. This is a great indication of your style choice. Perhaps you will find work that is underworked isn't for you, or that the too-detailed work leaves you cold. Whatever you decide, it is great practice to improve your painting skills as an artist as this exercise can lead you to finding a really terrific style of your own that suits you.

These practise pieces can teach you so much about the value of not overworking. I experimented with several small studies of forsythia to discover their form and shape as seen on these pages.

Tip

Another way of learning is to paint the same subject but aim to make each painting different.

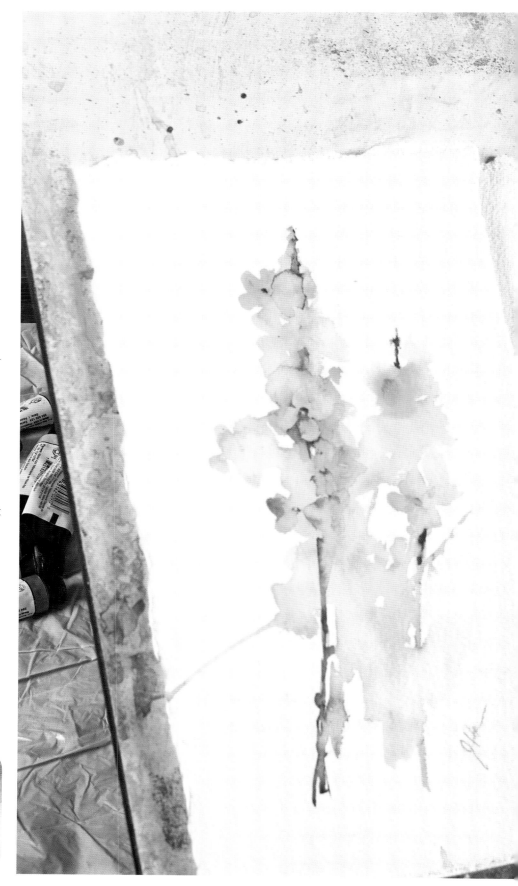

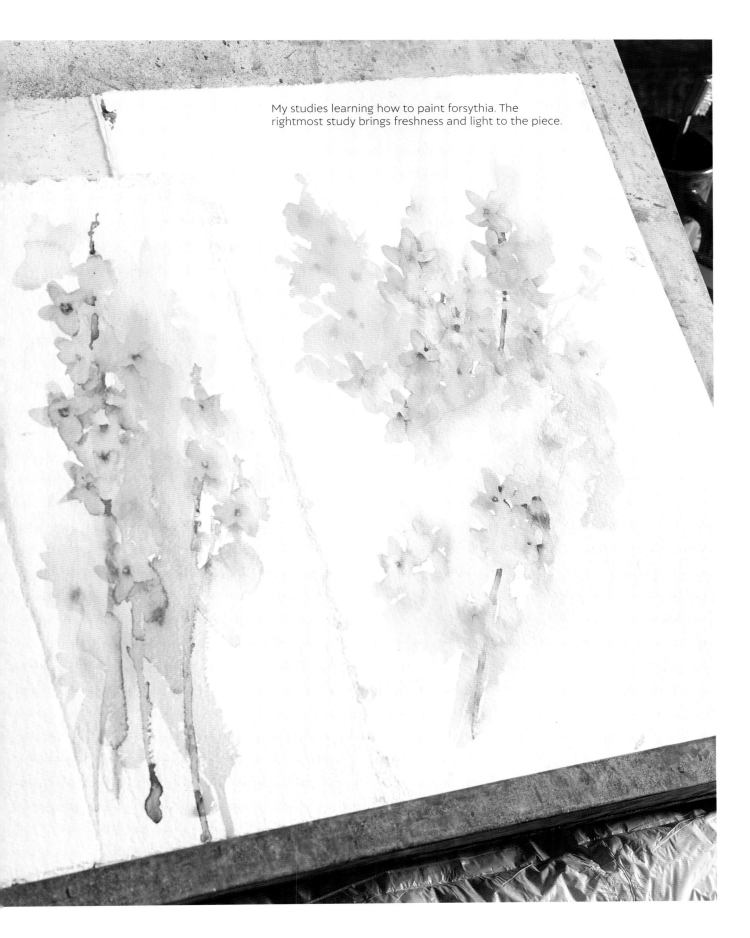

My studies learning how to paint forsythia. The rightmost study brings freshness and light to the piece.

Adding interest to a painting of flowers

If you paint the same subject repeatedly you could become very bored. If you only paint flowers all the time, you could end up feeling the same way. Whenever I create a painting of a beautiful flower I often wonder what else could I add to the composition to make it more interesting.

Additions such as a bird or insect help to add to the story of a painting. The painting of forsythia opposite, which includes a small bird, is a perfect example of this. I painted a small study of a blue tit (see below) before adding it to my now well-loved way of painting the forsythia flowers, detailed on the previous pages. The result is extremely pleasing to me.

You need to practise painting both subjects and flowers, and learn about compositions and how they work to create a piece such as this. But it really does show you how a simple flower such as forsythia can become a really exciting subject to paint – as can any flower with a little care, thought, planning and correct colour selection.

There is so much to enjoy and think about when painting flowers in watercolour – and we have only just started!

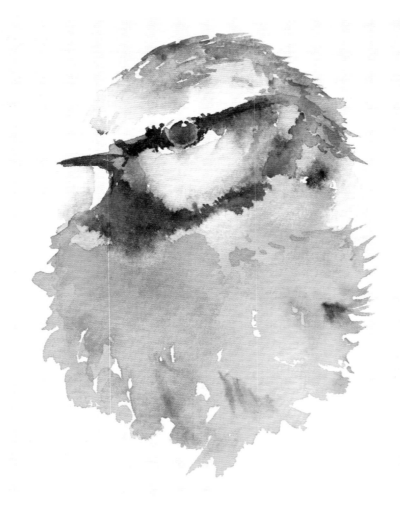

Blue tit study
18 x 20cm (7 x 8in)

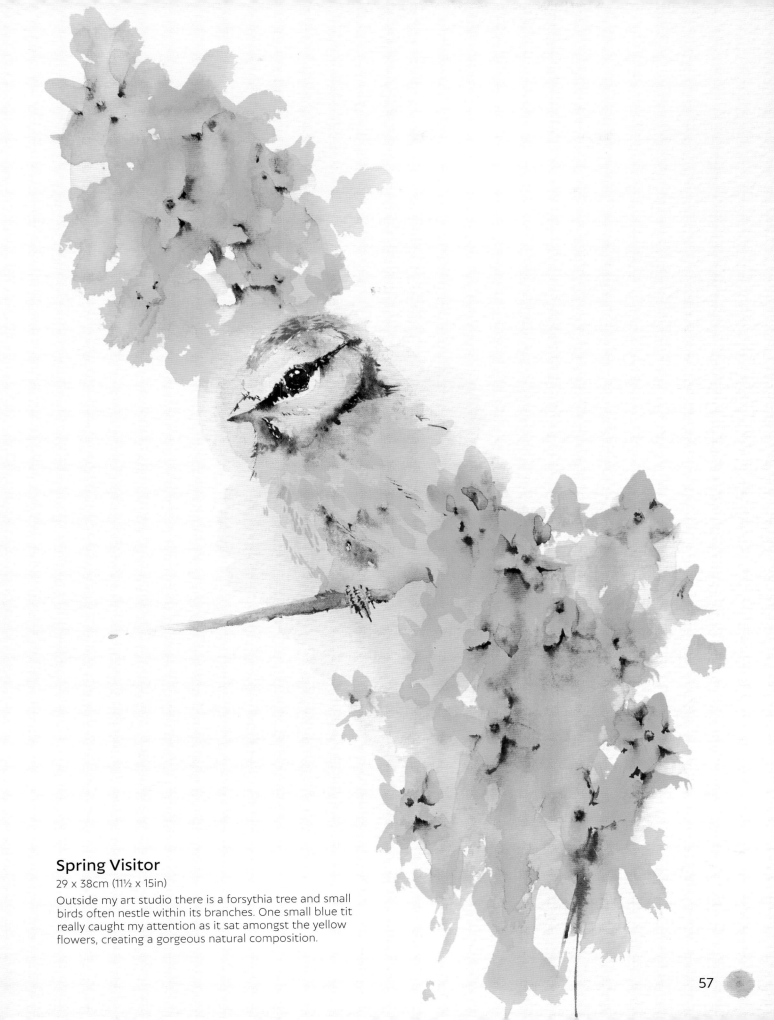

Spring Visitor

29 x 38cm (11½ x 15in)

Outside my art studio there is a forsythia tree and small birds often nestle within its branches. One small blue tit really caught my attention as it sat amongst the yellow flowers, creating a gorgeous natural composition.

To Bee or Not to Bee

"Insects, wildlife and birds have become integral to my paintings, bringing with them a sense of life and action to my compositions."

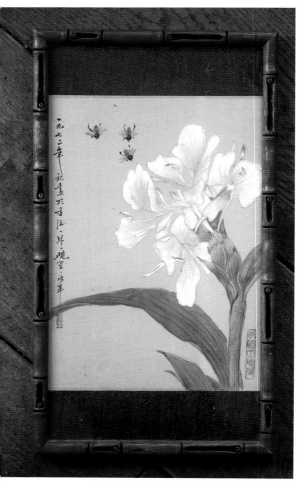

My Chinese mentor's painting of a flower with bees. From my time studying Chinese brushwork in Asia.

The techniques explored when learning how to paint flowers in watercolour will also aid you when painting other subjects, such as wildlife, insects or birds, that can be surrounded by the flowers of your choice. The addition of a living subject, a bee for example, can add life and change a once simple painting into something far more interesting, turning it into something fascinating, with a story to tell as a composition.

Consider how the addition of a simple insect can bring a sense of action to what might have been regarded as a still life painting without it. While I am gardening I become mesmerised by the insects, wildlife and birds which consistently become integral to my paintings. I have sat for hours watching bees collect pollen from flowers and, without fail, become enthralled by how busy they are and how active. They never seem to give up – a lesson we, as artists, should take up.

Please study my painting opposite, *Daffodil with Bee*. This small painting of a daffodil changed the minute I added a small bee alongside it. Try placing your hand over the bee in my painting, and ask yourself if you prefer the flower with or without the insect. With the addition of the bee, there is a story of whether the bee is going to land, collect pollen or fly away. The bee being there adds a sense of action rather than this painting being of a simple solitary flower.

Subtle connection

There is more than meets the eye in the simple composition of a flower and a bee on the opposite page. At first glance, you may think this is a nice painting; easy to do and with little thought behind it. But think again: look at the position of the bee. It is above the flower. Now look at the flower. It is facing the insect, looking up towards it, in fact. These carefully thought-out placement decisions create a subtle connection between the two subjects, making the composition work and more interesting. The story now has a connection and this leads to it being believable. It works because there is a connection between the flower and the bee.

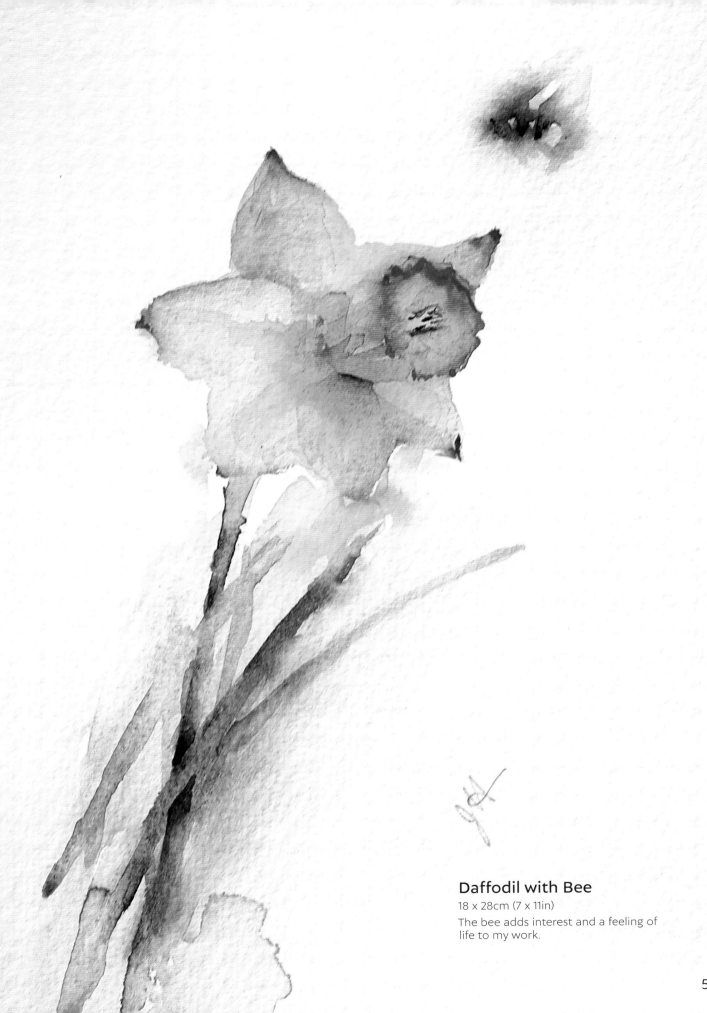

Daffodil with Bee
18 x 28cm (7 x 11in)
The bee adds interest and a feeling of life to my work.

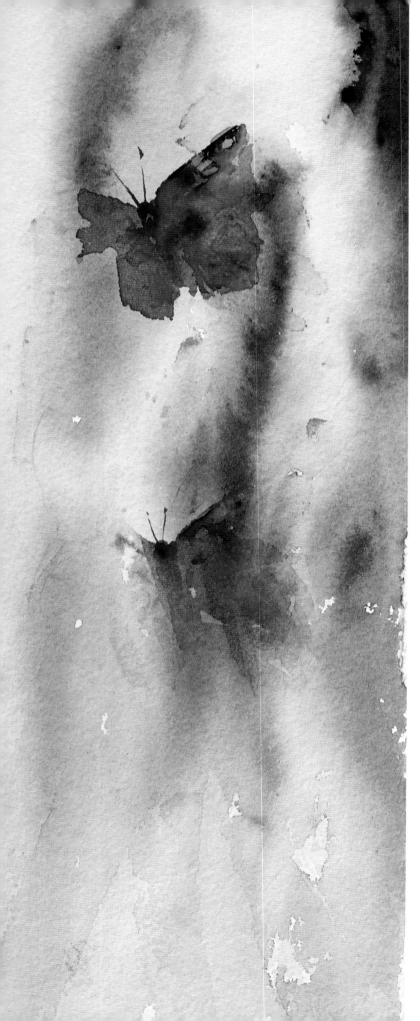

Butterflies and bugs

Butterflies and bugs are gorgeous subjects to paint; just think about all the incredible insects that you could add to your floral paintings. Do experiment painting them on their own before adding them to your floral compositions, however. There is no point in risking ruining a fabulous painting if these are new subjects to you. Just as with a new flower, practise painting such additions as insects beforehand.

Use insects to add to the beauty in your work not detract from it. Use them to add energy, life and that magical sense of movement that sometimes can be missing from a floral piece. Study butterflies, bees and all manner of gorgeous insects to make your floral work look stunning. Perhaps you will end up with many small paintings of insects that you actually love too.

Painting illusions

Try taking a scrap of paper and paint a light colour on it to act as a background. In *Butterfly Blue*, left, I chose a vertical strip of white paper, placed blue and purple shades on it and then allowed water to run through the still-wet pigment. This water application breaks up the colour application, forming alternating vertical lines of colour and white space. Another example of the 'waterfall wash' technique is shown on page 49.

When the colour was dry I added two butterflies. The upper butterfly I painted in full detail in strong colours. The lower butterfly I only half-painted, to create an illusion of it only just coming into sight. By painting a half-finished subject next to a fully painted subject, you can give this wonderful effect of the latter being in either strong sunlight or just out of view. This is a great tip, and worth remembering.

Butterfly Blue
13 x 38cm (5 x 15in)
The waterfall wash technique summarised above is shown in more detail in my book *Paint Yourself Calm*.

Bitten by the bug

Of course, once you get bitten by the bug of painting insects you can easily become addicted to them as well as to painting flowers, as my painting *Butterfly Explosion* shows. Here I became so carried away with painting butterflies just about to take flight that the painting was soon all about butterflies and no flowers!

This painting is a memory of my time living in Asia. While walking through a remote area of a country park, my foot touched a pile of what I thought were brown leaves on the ground. The 'pile of leaves' moved, and in front of my eyes a magical swarm of butterflies appeared. They briefly surrounded me as they went higher and higher into the sky above me; a cloud of orange, copper and gold hues. I was thrilled – and saddened that I had no camera with me. This painting is the closest thing to my memory of them.

Paintings can do so much in bringing memories alive. While I work through this book I see flowers that are linked to so many occasions in my life that I had seemed to have forgotten. I hope that it is the same for you; with the flowers bringing back your own wonderful memories in a way that only they can.

Butterfly Explosion
29 x 38cm (11½ x 15in)
A memory from a walk in Asia.

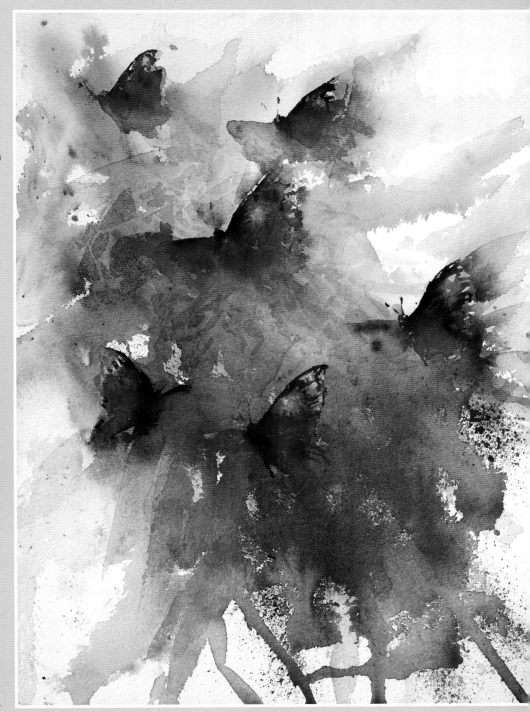

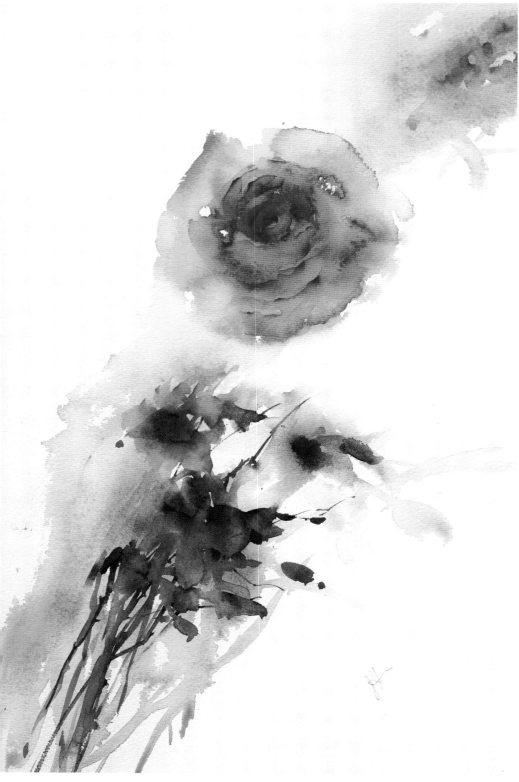

The sting

Now I would like you to look at the paintings on these pages. They are both beautiful rose paintings. Consider how they change when bees are added alongside one flower but not the other. I actually love both paintings but one carries more interest. Which do you prefer?

A great tip to share at this point is that if you have created a gorgeous painting but you are unsure as to whether to add to it or not, always leave it until the next day so you can take your time making your decision with fresh eyes.

Never race to add. If a painting looks fantastic as it is, do not touch it. However, if it isn't working, or you think it looks boring, then take the risk of addition. Always practise painting whatever you are going to add before you touch any almost-complete painting. That way the risks of ruining it are far less.

Beauty in Love
38 x 56cm (15 x 22in)

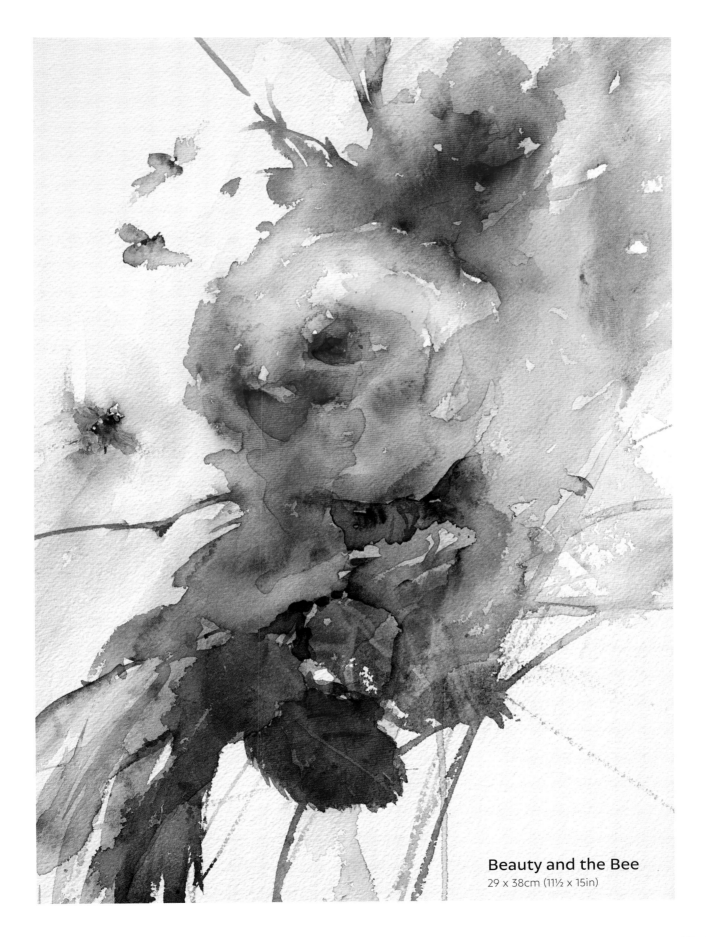

Beauty and the Bee
29 x 38cm (11½ x 15in)

All things white and beautiful

Of all the colours of flowers in a garden, white flowers are said to be the most popular. They bring a feeling of peace to a perennial border as well as adding a sense of light. They come in numerous shapes and varieties, from the simplest of forms to more complex plants carrying many tiny blooms. To the artist learning how to use white paper space, how to create fabulous backgrounds, and how to define outline shapes by negative painting, white flowers are invaluable. This section looks at all these intriguing aspects of creating white floral subjects in art.

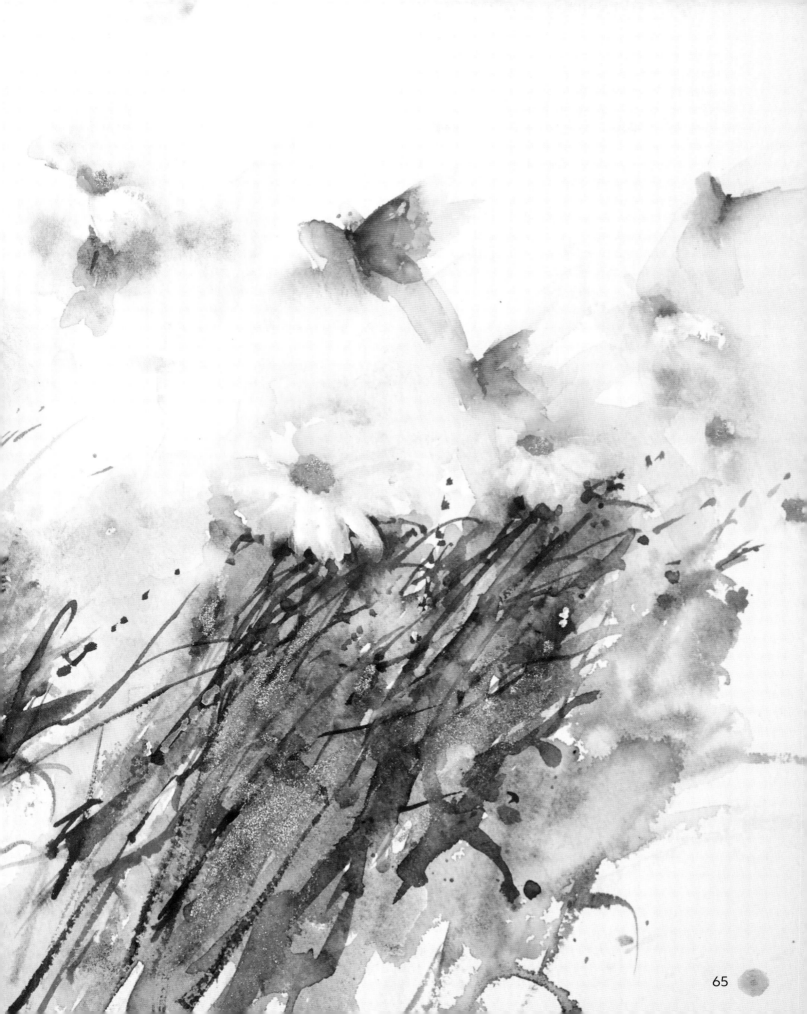

Painting white flowers

"It is only by experimenting, trying new things and repeating what we know that we can really improve as artists and move on in our art journey."

Flowers come in all shapes and sizes. Large, small, tall, round, with both simple or more complex structures. For the passionate artist there is much to love and observe, which adds to the pleasure when creating floral paintings. But what happens when the flower you wish to paint is white? I know this can be a stumbling block for many new artists, as on my watercolour courses I am often asked how I paint white subjects. This section of my book is dedicated to creating stunning watercolours of a variety of white flowers. By learning how to paint them we will also improve our skills when it comes to adding colour in the demonstrations that follow.

When wandering around my garden, I find myself mesmerised by white flowers and I love painting them. As a gardener, I know adding white plants to a perennial border adds a sense of light, just as it does in a painting when an artist leaves white paper.

A blank piece of watercolour paper is often white or cream. We cover it with colour to create our chosen subjects. When painting a white subject, however, I find it far easier to forget the subject altogether and place my focus on painting the background instead. I will show you how in the following demonstrations.

First, however, I like to think of shape and formation; just as I do when gardening. To be a good floral artist we really do need to study these two factors, as I touched on earlier on page 34, where we talked about sketching. In garden design, a variety of shapes are often planted specifically to create a pleasing overall result. The same is true when we paint. We place a variety of lines, blocks of colour and patterns to form a beautiful composition. To the new artist, the knowledge of how to do so can be quite daunting. I am going to simplify the idea of painting white flowers as simple shapes with differing outlines. This method of working leads nicely towards creating more complex paintings as you progress in style and technique.

Lily of the Valley

28 x 38cm (11 x 15in)

Small white bell shapes hang from one stem and the plant looks wonderful in a cottage garden landscape.

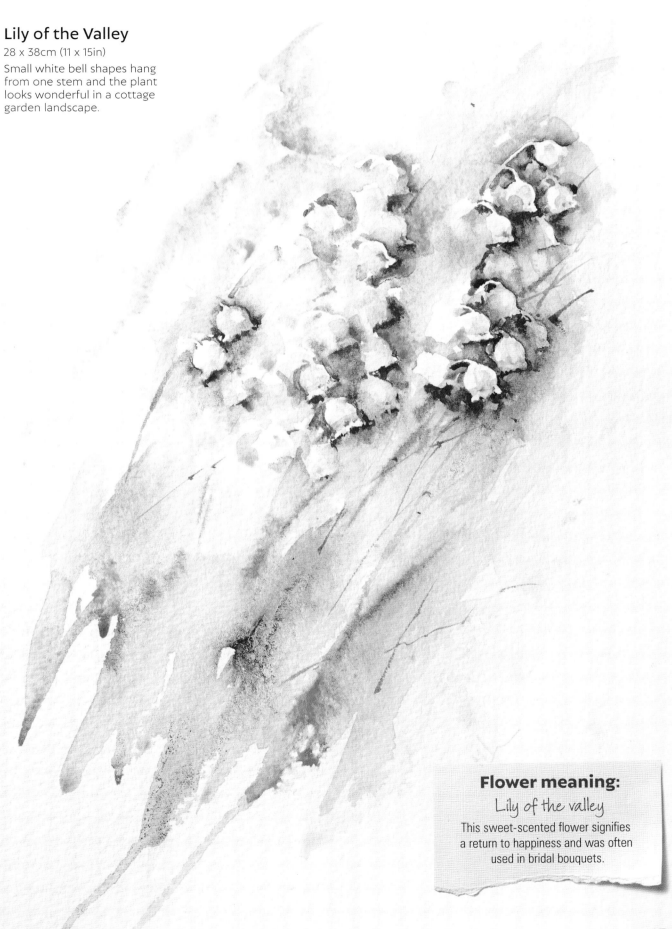

Flower meaning:

Lily of the valley

This sweet-scented flower signifies a return to happiness and was often used in bridal bouquets.

Round flower shapes

To paint any flower it is vital to first study its shape. This important information tells the story of your finished work. When painting white flowers I first create the outline and take my time to look closely at my chosen white floral subject. In the following demonstrations we are aiming to bring the outline of a white flower to life. There are many ways to do so using tips and art tricks to achieve stunning results. I am so happy to share mine here in this book.

Round-shaped flowers are often the easiest to paint. You can choose any round flower for this exercise as your subject, paint around it by simply leaving a white space on paper selecting stunning colours to form an attractive background. For this demonstration I have selected a bindweed flower, sometimes known as 'morning glory'.

These trumpet-like flowers are often thought of as weeds in UK due to their rapid growth. How funny that one garden plant is not wanted and the yet others are adored. Just like paintings, perhaps. But then, what is a weed? As we saw earlier, to some people all plants are a form of beauty and I tend to agree.

Tip

I find artists who always work on small pieces of paper can tend to create tight or overworked pieces. Working on larger paper gives you more room to use expressive brushwork with ease. It also enables you to have large areas for colourful background effects. You gain a sense of freedom when you are able to paint on larger space. So be brave, paint big!

Flower meaning: Bindweed

The bindweed flower grows by clinging and twining itself to everything around it. It represents attachment and is connected to family. These flowers used to be given as garlands to parents or grandparents as tokens of appreciation on special occasions. To some they are seen as a weed but they can add brightness to a dull garden corner on a grey day.

Bindweed study

By painting around a circular outline on white paper, and by making a background area flow with colour around it, I am telling a very simple story. This is a fairly easy white subject to paint so my approach in creating needs to be simple also.

In this painting, when my background colour was dry I added a few details to the flower, using my reference photograph, like the one opposite, for the information on what was needed to make my painting look complete and believable.

Painting small studies is a brilliant way to observe what works for you and what doesn't, especially if you use different colours or techniques each time you paint them. Of course, you can also use them to repeat ideas that are successful.

Step-by-step Bindweed

Simplicity

I have used a simple white flower for this step-by-step. It has no complicated edges. It is basically a white circle in shape which I am bringing to life mainly by use of background colour. You can use any white flower to follow this step-by-step but do try to choose one that is very easy to replicate in a painting.

Materials

- Watercolour paper, 300gsm (140lb) weight
- Size 10 round brush and rigger
- Watercolour paints: cascade green, cadmium yellow, quinacridone gold, opera rose

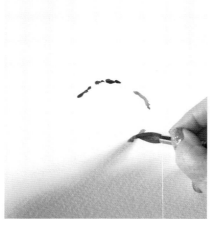

1 Using my size 10 brush and cascade green, I created an outline shape first as a starting point for my flower. Please notice, I deliberately leave gaps in this circle outline rather than create a fully defined shape.

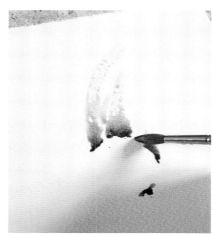

2 While the outline pigment is still damp I begin to move it away using a clean damp brush. By doing so I move the initial colour application into the background area.

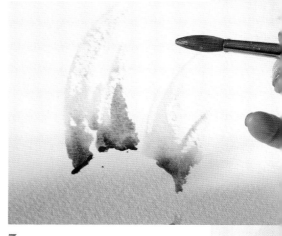

3 To ensure that the green background doesn't look too solid or boring I add a touch of cadmium yellow to the green. This adds a little bit of sunshine.

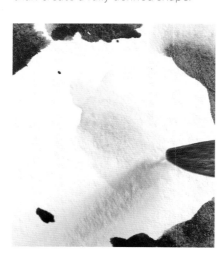

4 Next I add a touch of quinacridone gold for the centre of my flower. While this colour addition is still wet, I use a clean damp brush to gently add and soften the central colour; moving it slightly towards the lower edge of the flower for shadow effects.

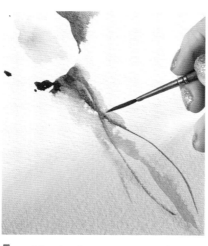

5 While the flower centre is drying, I then add a few hints of stems to the background. For this I use my rigger brush and I make sure these lines are placed in an interesting formation.

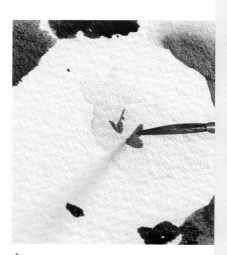

6 When the flower centre is completely dry I use my rigger to add fine detail to this part of my study. These brushmarks are aimed at bringing the central stamen to life.

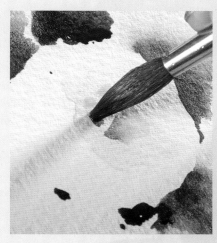

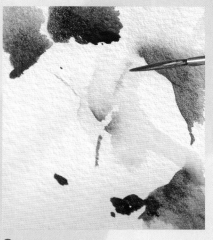

7 As before, I used a clean damp brush to soften the original darker colour away.

8 Using the colour opera rose and my rigger brush I add a few small lines to separate the individual petals.

9 Finally, I soften any lines that appear too hard. This will help to keep my painting looking atmospheric. This little study leads me to ideas that can be used on larger paintings where I will perhaps have more than one flower. If you keep practising these small studies your art will improve and you will connect more easily with new subjects.

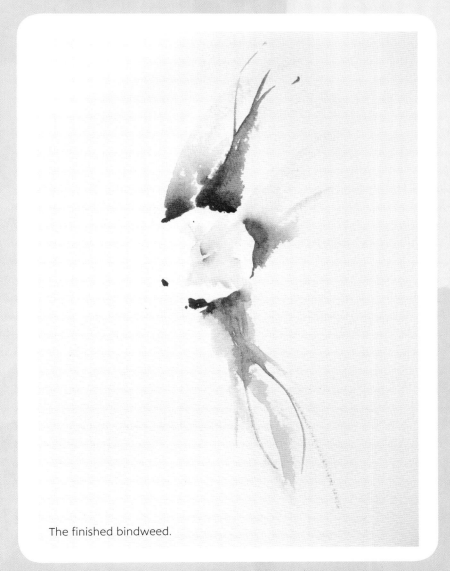

The finished bindweed.

Tip

Remember: a study like this is a method of creating a small painting for the purpose of learning. Studies can be painted on scraps of paper as warm-up exercises, experimental work or can be used to aid your discovery when approaching new subject matter.

Growing with confidence

In the small study I was experimenting mainly to discover which colours I enjoyed using for the background effect of these beautiful flowers. Happy with my study, I immediately created a full painting on a larger piece of paper, repeating the creative process. The technique is the same but I changed the composition.

If you work in this way regularly, you will gain confidence as you leap from experimental pieces to full paintings, taking with you the knowledge and experience gained from practising. Painting small studies not only helps us to grow as artists but can lead us into some really exciting ideas for larger work.

For example, I repeated the idea of my small bindweed study on two larger paintings, shown here. In the study on the left, the background was been painted first, leaving white flower shapes, with the colour flowing in one beautiful direction to give a feeling of life to my work. The paint colours I used were cascade green, cadmium yellow and phthalo turquoise.

I allowed colour from my background to flood gently into the white space that had initially been left for the flowers. Once you have a pleasing background and the background painting is dry, you can add detail to complete your work. This way of working makes the background connect with the subject beautifully. It is softer in effect with a feeling of life and energy in my result.

For my second attempt at painting bindweed (see opposite) on larger paper I experimented by adding another colour, violet. I can now look at all three paintings – my study, second version and completed painting – and choose which I like best. If I were to paint another composition I would take what I love best from all three pieces, collating the information to create a beautiful new masterpiece.

Bindweed work in progress
30 x 57cm (11¾ x 22½in)
Simple flowing colour around white shapes acts as the base for pleasing compositions.

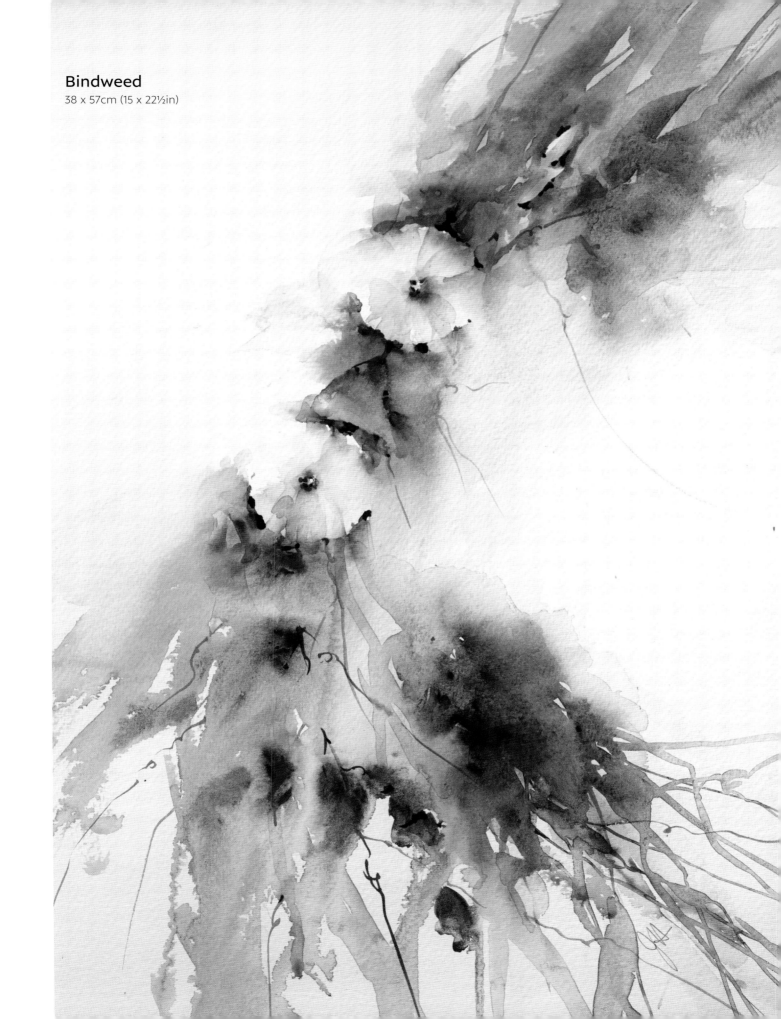

Bindweed
38 x 57cm (15 x 22½in)

Roses

Painting a background first works well as a technique for painting many flowers but it is especially successful as a method for painting white flowers.

On these pages you can see how I have adapted the techniques seen previously to create beautiful paintings of white roses; simply by painting the background first around white circular shapes. Detail was then added to bring the central white sections of these flowers to life.

Flower meaning: *White rose*

Symbols of love and unity, in the Victorian period white roses were often used in a 'tussie-mussie', a small posy of flowers given to a loved one in early courtship, where they represented purity.

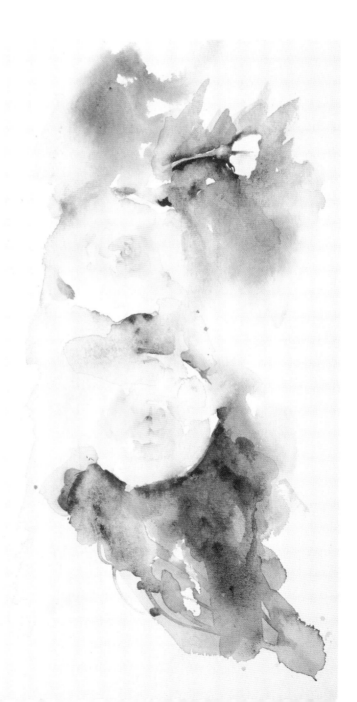

White rose small study
28 x 38cm (11 x 15in)
Painted using a white rose from my cottage garden to learn from.

Keeping spontaneity

Beware. When you paint a study, the initial enthusiasm for a new challenge leads to freshness and spontaneity; this can sometimes be lost due to over-thinking or over-planning a painting too much in advance. Try to find a happy balance between the two ways of working

The value of experimenting

It is only by experimenting, trying new things and repeating what we know that we can really improve as artists and move on in our art journey. Like learning that some flowers grow better in my garden than others, so too do some painting ideas develop better than others. Painting does take time: to learn, to practise, and simply to paint.

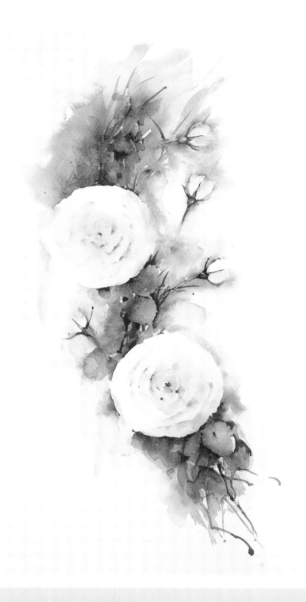

Peace and Love
38 x 57cm (15 x 22½in)
A white rose painting on a larger piece of paper. This uses exactly the same colours as in my study opposite, but creates a completely new composition.

Painting challenge

The trick for improving your art when working from photographs is to ignore any black or dark shapes. Choose a beautiful colour instead when painting these sections to add life to your work.

Study this photograph of a white rose and consider the interesting outline shape. Ignore the dark background in the photograph and choose something beautiful to paint as your background colours. Try opting for green to act as foliage or blue for a summer sky.

Paint the background first and allow it to dry, then paint the centre of the flower and begin to add the lines you see between the petals. Do not fall into the trap of painting everything you see. Leave some sections to the imagination of the viewer of your finished works. Remember that, when painting in a loose style, less is more.

Simplifying complicated shapes

"White space on paper is oxygen, allowing a painting to breathe. It brings with it a sense of air and life."

Once the technique of painting fascinating backgrounds for white subjects has been mastered, a whole new world of art is at our fingertips; as nothing – no subject, no matter how complex – should be seen as anything other than a new challenge. If you look at a floral subject that is made up of small clusters of shapes, simplify painting them by selecting beautiful background colours and paint a large outline at first for each group of small flowers and then place colour around some of the individual small flowers in each cluster.

Begin with a small study and then move on to a larger painting, bearing in mind that the more space you have on paper for colour to flow, the more spontaneous your result will be. That will carry with it a sense of freedom.

My painting, *Summer Whites*, next to phlox flowers.

Flower meaning: *Phlox*

Phlox means 'We think alike' and, as artists, I think we often do. I love the idea that this flower has magical properties: it has traditionally been thought of that way. It is said to create harmony in families if planted in the garden. Within each cluster of small flowers, each individual flower represents a family member; all happily grouped together or even as friends united. A lovely thought.

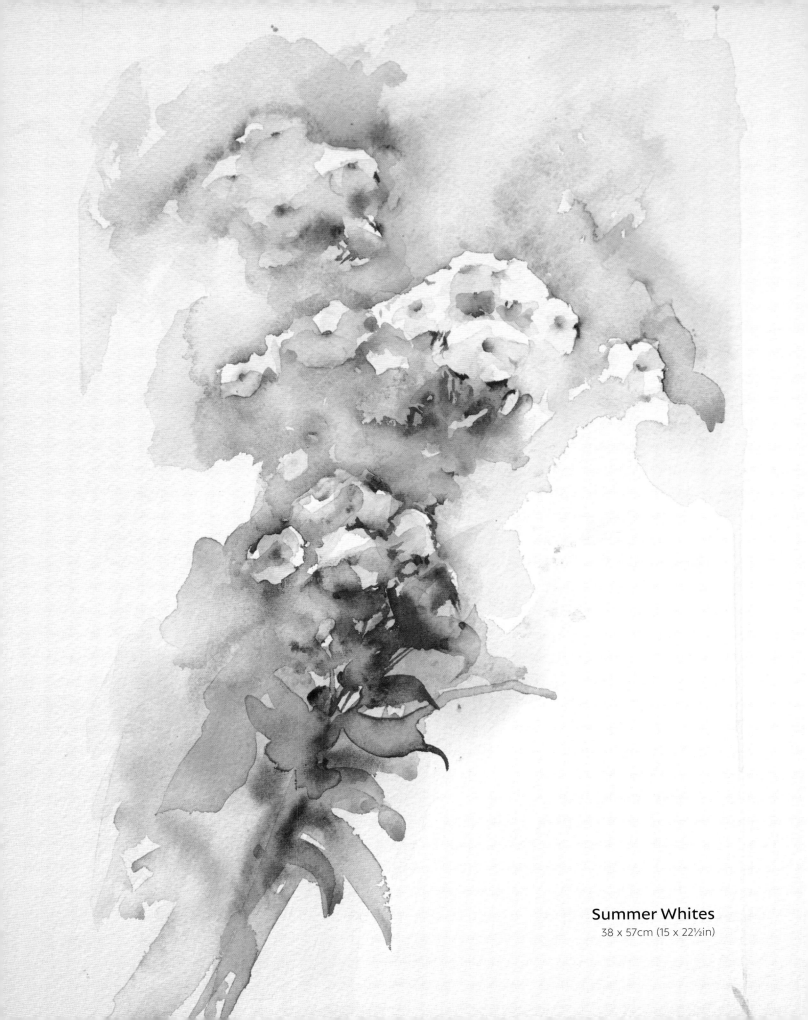

Summer Whites
38 x 57cm (15 x 22½in)

Life in a painting

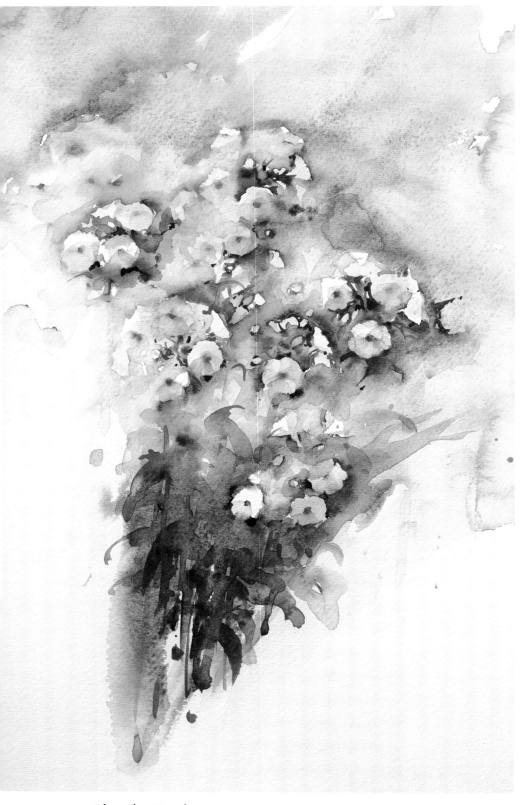

"Simplify is my magic word for the most successful of my white floral paintings."

White space on paper to me is oxygen allowing a painting to breathe; bringing with it a sense of air and life. If you study my painting *Summer Whites* on the previous page, you will see that very little detail has been added to the small clusters of flowers. The background colours of cascade green, cadmium yellow and cobalt turquoise interact effectively to create a beautiful image on the white paper.

In both of my paintings, *Summer Whites* and *Simple Magic*, I took my time creating the outline of the small individual white flowers and, as in my previous white flower demonstrations, allowed the background to dry completely before adding the smallest of details to finish the piece.

White paper is fresh. It gives an illusion of light. It seems clean and pure. To add too many colours or detail too early in the background painting process can sometimes detract from beauty and elegance of white flowers as floral subjects, whatever they might be.

'Simplify' is my magic word in the most successful of my white floral paintings, and as phlox has been seen as a magical flower in the past, a painting of them should be just as magical too.

Simple Magic
38 x 57cm (15 x 22½in)

Painting challenge

To recap on what we have covered so far, here are some tips to guide you in painting this challenge.

- Study your subject and look carefully at its outline and shape. Search for interesting patterns in the flower's forms that will tell the viewer of your finished painting exactly what the white flower you have painted is.

- Select only a few complementary colours for the background. Limit yourself to just one to three shades. Try keeping the upper part of your background lighter and the base darker so that the upper flowers can be seen as if in sunlight.

- Don't add too much detail. Over-fussy work tends to kill the atmospheric illusion.

- Leave white paper to give 'oxygen' to your painting.

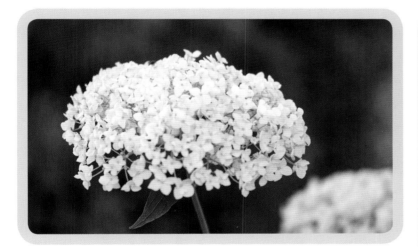

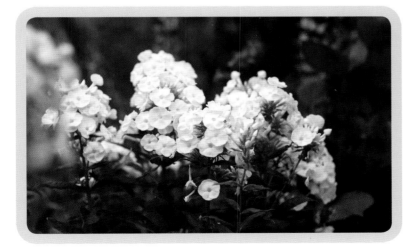

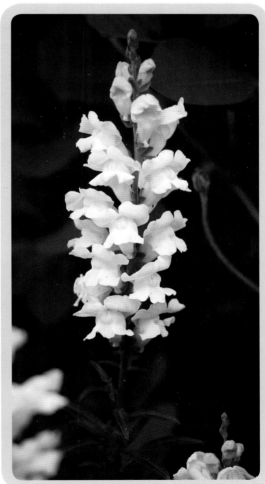

Standing tall

There is no doubt that white flowers make breathtakingly beautiful subjects to paint in watercolour. You can paint around their shapes to add a colourful background while leaving white space on paper for the flowers, as in the bindweed and rose demonstrations on the previous pages.

In fact, you can paint around any shape at all to bring a white subject to life with fascinating results. For this next demonstration I am looking at the taller, straight, candlestick-type shapes such as lupins. These upright flowers have a central stem which is covered with many small flower shapes, and the lessons below will help you paint any similarly-shaped flower.

Observe, select and create

Start by observing your tall white flower. Look at its outer edges carefully and see what formations are there that could add interest when painting around them. Here I am going to give you some tips on creating a background so that it adds to the beauty of your finished piece.

Next, select colours that will make the white paper space glow, as though sunshine is hitting your painted flowers. Cadmium yellow as a shade is perfect for this effect. Of course, used alone as a background, yellow could be seen as boring, so aim to make even the yellow colour application glow by placing it on top of another colour. In the example of the opposite page, I have used a random turquoise wash. The yellow has merged with the turquoise blue creating a vibrantly alive green shade, achieved from the natural mix of these two beautiful colours.

If you study my painting of lupin flowers on the opposite page you will see I have not left rigid outlines on either side of the flower. I have allowed some colour to merge from the background into the flower itself connecting both sections. This gives a wonderful sense of unity, harmony and connection throughout. You can also make out the subtle suggestion of a single segment of a second flower in this painting. This is a useful trick in adding a feeling of distance to a composition.

Flower meaning: Lupin

This should be the artist's favourite plant as the lupin flower is considered to be the emblem of imagination. To me they represent reaching for the sky, aiming for goals making dreams come true. These pretty flowers, an all-time cottage garden favourite, were once given as gifts as a way of bringing cheer.

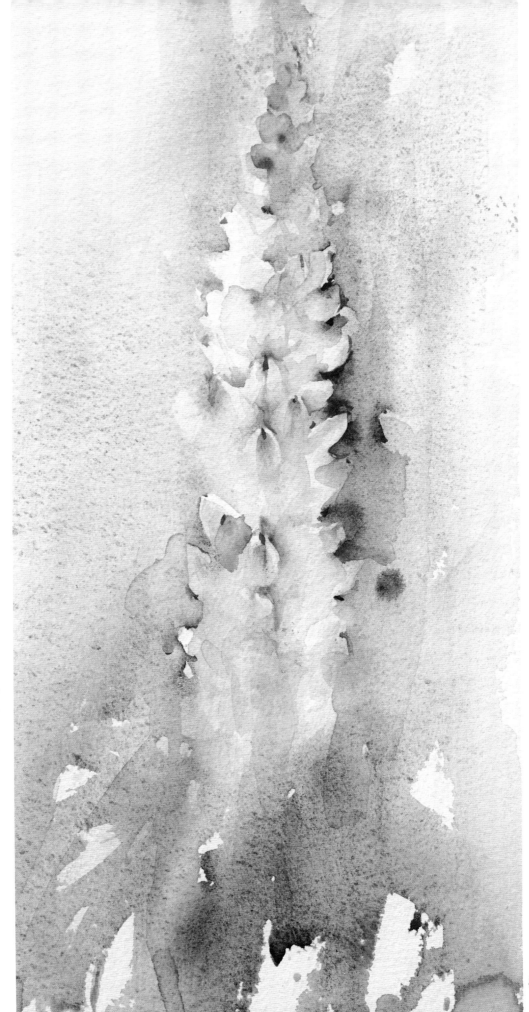

**Lupin in
Watercolour**
20 x 38cm (8 x 15in)

Lupins: first washes

Creating excitement in a first wash

What we have created so far as backgrounds for white subjects has been quite simple: just allowing colour to run around white space left on paper. These background washes can be even more exciting if you take time to experiment, as I do regularly.

Adding texture with rubbing alcohol

Compare the painting of lupins on the previous page with the more exciting and attractive colour effects on these pages. Here I have used not only a variety of colours to form my background, but I have also used a texture technique where I carefully apply drops of rubbing alcohol on still-wet pigment. You need to experiment with this technique as some pigments will give you better effects than others when alcohol is used on top of them, but the pretty patterns formed are so effective that the time taken to learn is worth it.

Rubbing alcohol and the old brush used to apply it.

First wash Yellow, green and turquoise make stunning effects when allowed to run downwards on paper freely. As shown earlier, this will leave white spaces of paper that form the basis of flower shapes which will be painted in later when the first wash is dry.

Applying rubbing alcohol Using a brush to apply some touches of rubbing alcohol to the surface while the paint remains wet will result in a more exciting background wash than simply letting it dry. You can see the effect the alcohol has on the wet paint, pushing it away in places.

This large wash combines the simple wash technique and texture provided by adding rubbing alcohol while the paint was still wet. Keeping the upper part of a floral wash lighter adds to the illusion of depth in the foliage at the base of this plant.

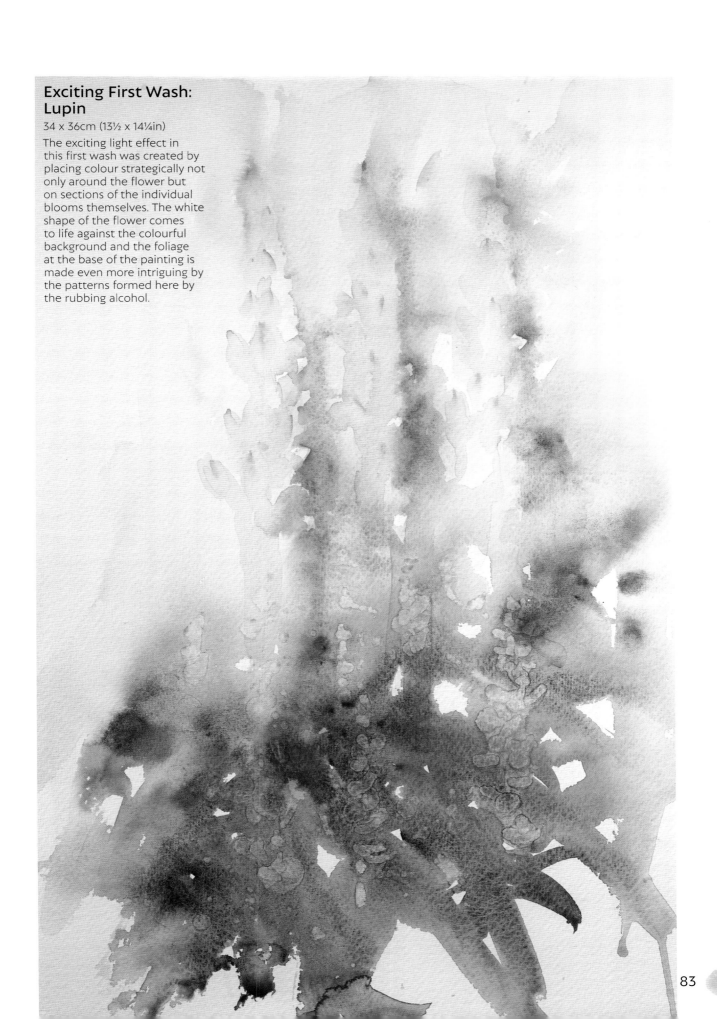

Exciting First Wash: Lupin

34 x 36cm (13½ x 14¼in)

The exciting light effect in this first wash was created by placing colour strategically not only around the flower but on sections of the individual blooms themselves. The white shape of the flower comes to life against the colourful background and the foliage at the base of the painting is made even more intriguing by the patterns formed here by the rubbing alcohol.

Adding detail

Detail can be added to the inner flowers, as seen in this large painting, *Standing Tall*, which was created in my cottage garden. The first wash has to be completely dry before you attempt this stage in the painting process. At this point I always take my time. I study my work so that I know exactly what is to be added where. By taking breaks and looking at your work often throughout the creative process you will find it harder to overwork, so don't rush to finish your masterpieces. Enjoy the process as each piece comes to life!

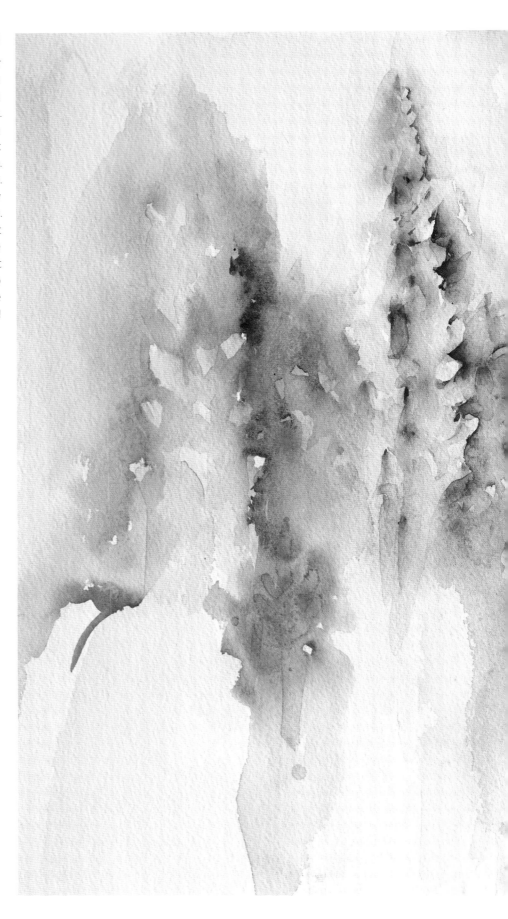

Standing Tall
57 x 38cm (22½ x 15in)
Lupins in watercolour.

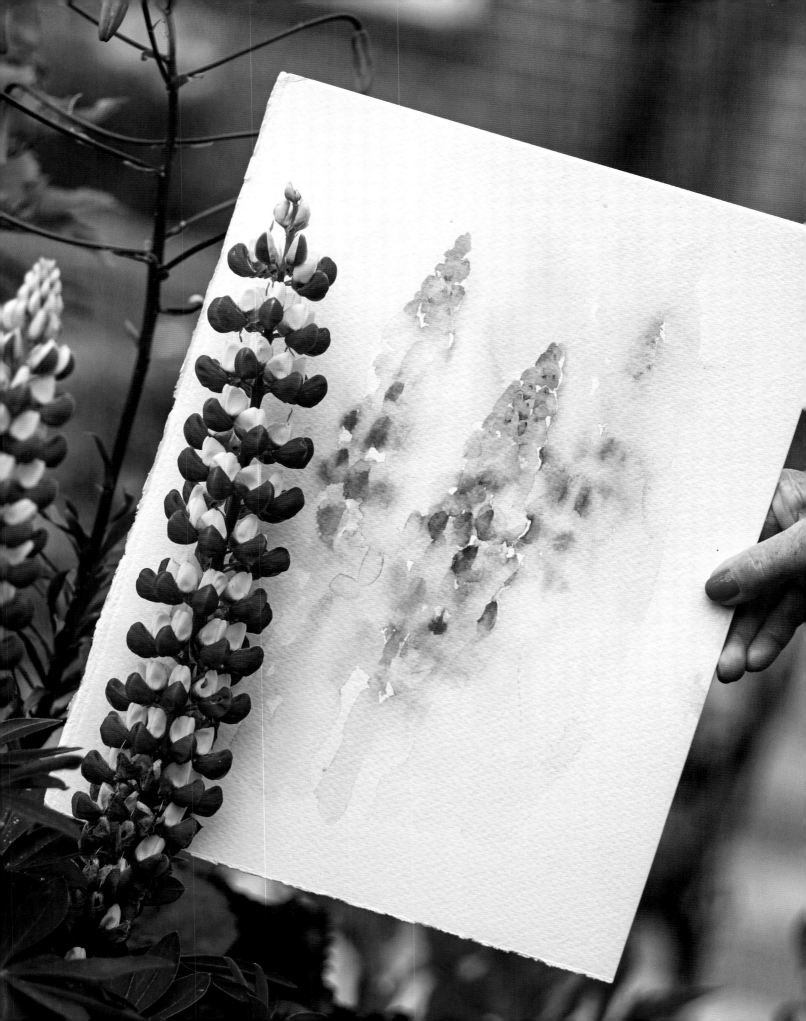

Adding colour

You can also start to add colour to spaces left for white flowers, as seen on pages 70–71. In fact this is an ideal way to create white shapes on paper for any number of flowers which you can then add detail or colour to once the background painting is completely dry.

Painting challenge

How would you paint the image below? You can paint it as a white flower or add colour. Follow the tips from my paintings of lupins to create your own painting!

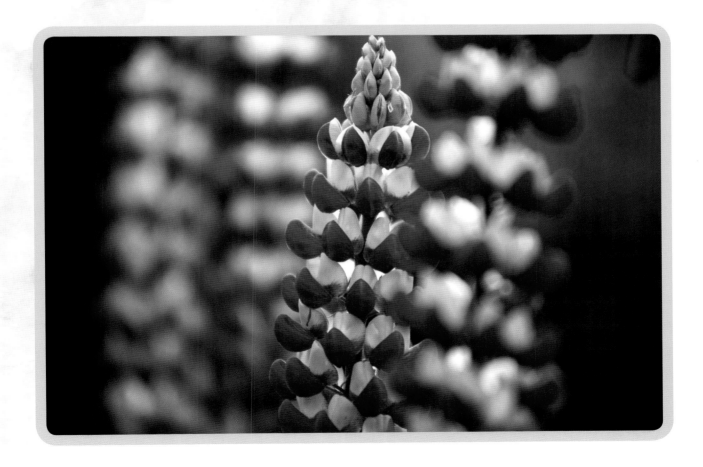

Taking flight with white

As discussed in the previous pages, painting white flowers can be so refreshing as a change for the artist who is in love with constantly working with vibrant colours.

The challenge of deliberately leaving white paper and making it sing by surrounding the white space with carefully selected colours is an absolutely fabulous journey in art. How to make that white space breathe and feel as though it is alive is vitally important.

When it comes to colourful floral subjects, we can take what we have learned from painting white flowers into making our more colourful compositions shine in an enlightened way. The joy in painting white subjects by leaving white paper is a rewarding experience as it allows a composition to breathe, and breathe beautifully. This reminds us that white space can be a very good thing.

If you observe the hummingbird in flight in *Essence of Life*, the placement of colour brings the small bird to life. The missing sections of the bird add to the sense of movement and energy in the piece, bringing with it an ethereal sense of atmosphere.

The white space left on paper is as important as the painted areas. This is a valuable point to remember. So when you are faced with subjects that are white, or even those that have colour, first consider where you could leave white paper to allow your work to breathe.

Essence of Life
28 x 38cm (11 x 38in)
A study of a hummingbird on the wing.

Painting magnolia

How would you approach painting this subject, a magnolia in bloom? Which sections would you leave white? How would you paint the background and what colour? Think about these questions before you even pick up your brushes. Eliminate complex ideas and simplify your approach.

Although part of the flower is pink, bear in mind that the same principles used when painting white subjects applies here too. The central area of pink in the white magnolia outline shape can be placed on paper for the flowers, before you commence painting the background wash.

Flower meaning: *Magnolia*

Named after a French botanist, Pierre Magnol (1638–1715) who helped scientists determine that plants came in families and not just species.

Magnolias represent femininity in many cultures. In ancient China, magnolias were thought to be the perfect symbols of womanly beauty and gentleness.

Step-by-step Magnolia

Painting from life

I sat in my cottage garden painting these beautiful magnolia flowers in sunshine. Sunlight played upon the petals so prettily. I believe painting outside and from life is the best way to see natural light and gain the best ideas of which colours to use. Natural colour combinations by shadows cast are so much better for an artist as inspiration than by constantly painting from photographs alone.

I encourage watermarks in this step-by-step; they give that magical spontaneous watercolour feel which no other medium possesses. Soft and hard edges are exciting in this composition. Note that I used a cobalt turquoise to outline the white petals, in order to hint at a sunny sky.

Materials

Watercolour paper, 300gsm (140lb) weight

Size 10 round brush, rigger

Watercolour paints: opera pink, cobalt turquoise, quinacridone gold, cascade green

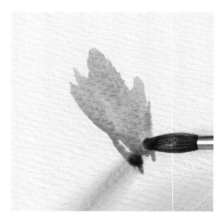

1 I place a pink starting area for the main petal of my magnolia flower using opera pink and the size 10 round. I keep this a softened section without any hard defined lines.

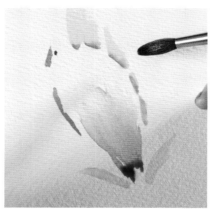

2 Next I add the outline shape by painting a background, here I used a blue shade (cobalt turquoise) but you could create a green or even pink background if you wish.

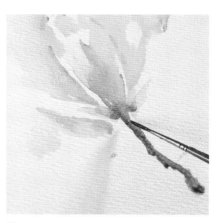

3 Adding the stem at the base of the flower with quinacridone gold and cascade green anchors my bloom in place on the flowering tree.

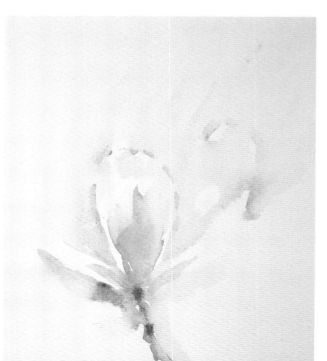

4 At this stage I can add other flowers in the background.

Tip

Painting from life gives you the perfect opportunity to really see natural colour which can sometimes be lost when working from resource photographs, no matter how wonderful they may be.

Painting from life makes it easier to bring life into the results of your painting efforts.

Light and inspiration

The light and air of mystery in the painting on the right, *Gentle Beauty*, was gained by painting outside in my garden in natural light. This made it easier for me to see where to add beautiful colour and omit sections in my composition that I felt were less important.

Once my pink magnolia flowers were in place, I used cascade green at the base of a few of my flowers to hint at the stems and foliage. Simple pink placement of colour acts as the flowers in the background, making my main flower stand out as the star. I use this technique often when painting, allowing one area within a composition to outshine all others.

Pleased with this piece, I was still in the mood to enjoy painting magnolia, so I moved on to creating a larger composition, which can be seen below. I quite often find that I fall in love with a subject and want to paint it over and over again. That is the pleasure of being an artist in love with her subjects and the medium they are worked in.

Tip

Do paint outside as often as possible even if it is to simply get colour ideas to paint from at a later stage.

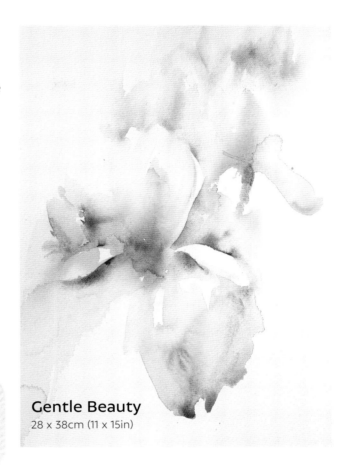

Gentle Beauty
28 x 38cm (11 x 15in)

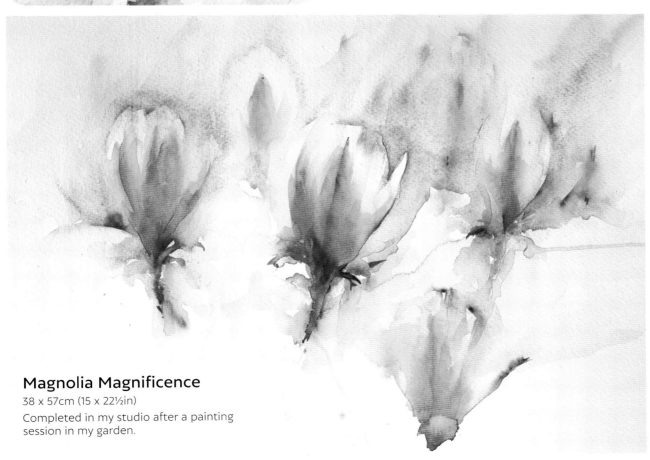

Magnolia Magnificence
38 x 57cm (15 x 22½in)
Completed in my studio after a painting session in my garden.

Energy and light

Painting white subjects, whether they are partly white or totally devoid of colour, brings incredible pleasure to the artist yearning to make a painting burst with light. Try painting white butterflies on flowers to bring an extra feeling of energy to your floral work.

Remember that you can use the method of painting a background first for any flower to bring it to life, simply by painting the outline of the flower and then adding colour and detail to the white space once the background around it is dry.

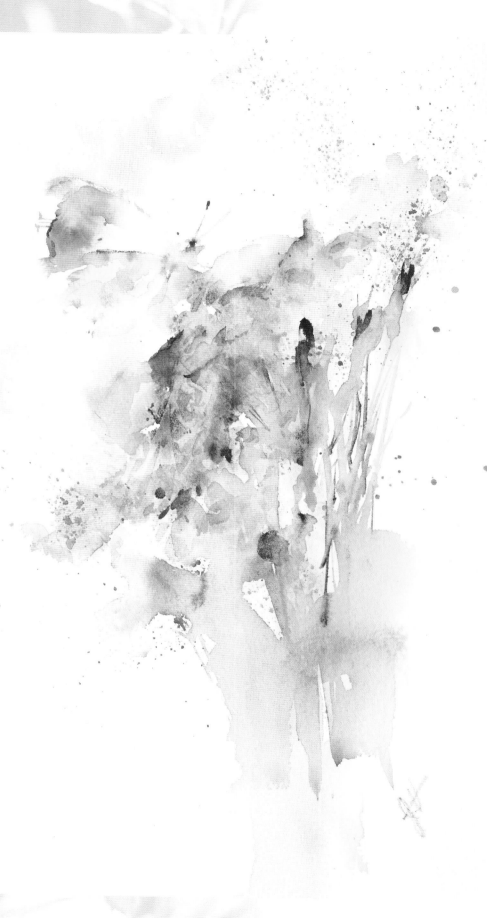

On Honesty
38 x 57cm (15 x 22½in)
Simple butterfly painting.

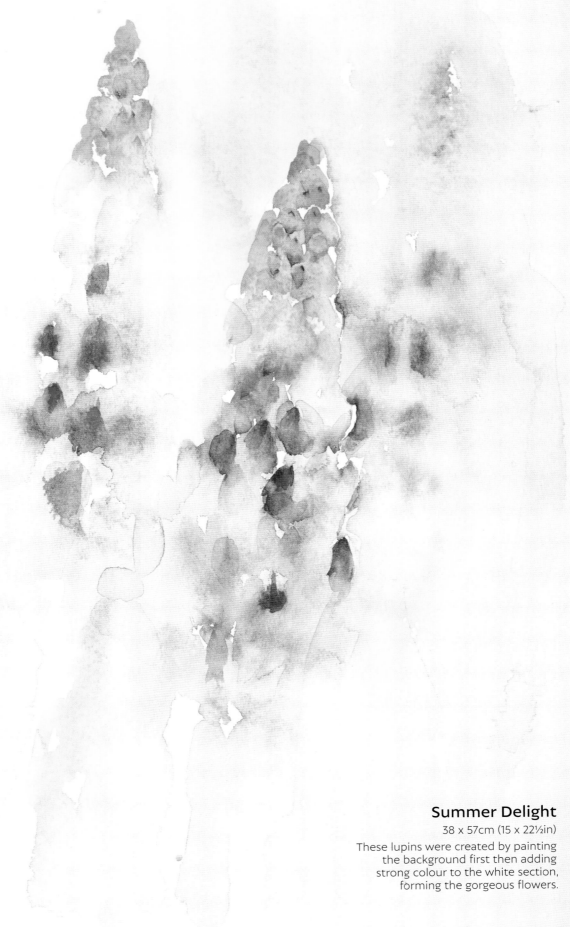

Summer Delight
38 x 57cm (15 x 22½in)
These lupins were created by painting
the background first then adding
strong colour to the white section,
forming the gorgeous flowers.

Seasons of life

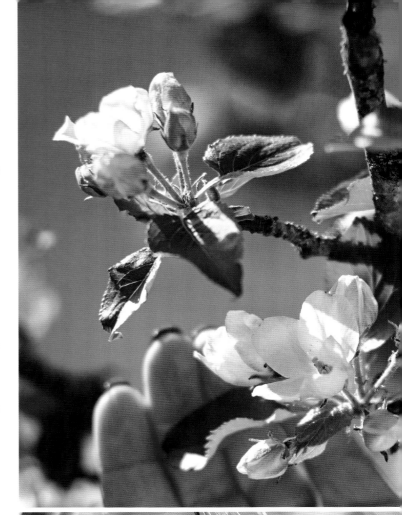

"I compare both painting and gardening with the four seasons and try to combine a mixture of each in my compositions."

I am inspired by nature. I love the vibrant new life and energy that comes with spring. The delightful kaleidoscope of colour of a beautifully blossoming summer brings with it an annual form of 'artist's fever' as I race to paint each new flower as it opens. Autumn's undeniable richness is full of golden hues and deep reds, and it is followed by what I think of as peaceful resting period of winter, when plants are dormant.

There is much we can learn from and be inspired by as each season passes, ringing changes in our art. As each approaches, my excitement grows with what I look forward to, wish to achieve and yearn for.

This cycle, from the earliest budding signs of life to the final farewell of falling leaves, is a privilege that should never be taken for granted. Let me lead you through my 'circle of life' with a seasonal approach to floral painting.

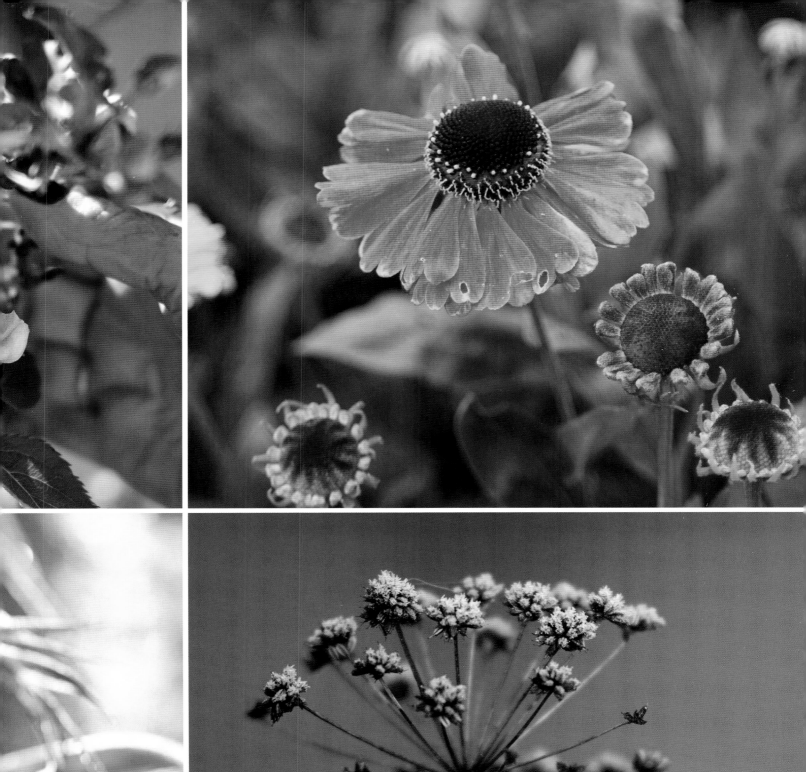

95

SPRING

"Spring is not a season for art to look dull and uninteresting."

This is the time of year that naturally seems to herald a fresh start. It is what I refer to as the 'white paper' time of the year, with so much to look forward to in the coming days and months. A time to feel energised and new, in the year ahead. While plants are appearing in the garden after a long dull winter, their colours give an illusion of being far brighter than usual. This can be stunningly depicted in floral work that portrays what has to be the most refreshing of all seasons. What better time is there than spring to look at your art and improve it by learning from Mother Nature?

This is a time for experimenting with new ideas or trying new colours, for looking at where you are in your personal art journey, and for making decisions for the year ahead that will help you grow as an artist in both skill and in your enthusiasm for painting. Spring is a time for ideas to be born, a time to set new challenges, a time to look at where we are and where we are going in our art. It is a time when exciting shades, full of life, can represent the energy of the season, telling the story of flowers bursting into life. A time when it is so good to feel as though we are alive and raring to go – and that is exactly why I adore painting spring flowers!

Spring clean your equipment and approach to painting

When painting spring flowers it is even more important to keep colours fresh, clean and full of life. I know many artists who, like me, have purchased and collected many tubes of watercolour over the years. Favourite colours get used regularly, while those colours that we aren't so keen on get left forgotten and unwanted.

If you are one of these artists, how about a spring clean of your watercolour shade collection? Take everything that is suitable for the spring season and work with it, experimenting with them to create unusual washes. If you have been working with the same colours for a long time, now is the time to treat yourself to something new to enrich your spring palette. There are gorgeous spring greens, spring golds and a vast variety of yellow shades that can readily add excitement to your work. Explore, be adventurous and have fun choosing new spring shades to bring your work to life with renewed energy and that fabulous zest for life that is spring.

It is not only colour that makes a difference. Keep your brushwork full of energy too by considering directional touches of colour that add a feeling of movement to your paintings. Think about how you place colour and why.

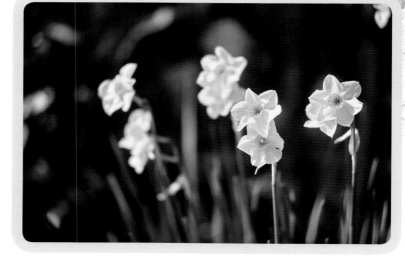

Spring flowers seem to celebrate the coming of the season.

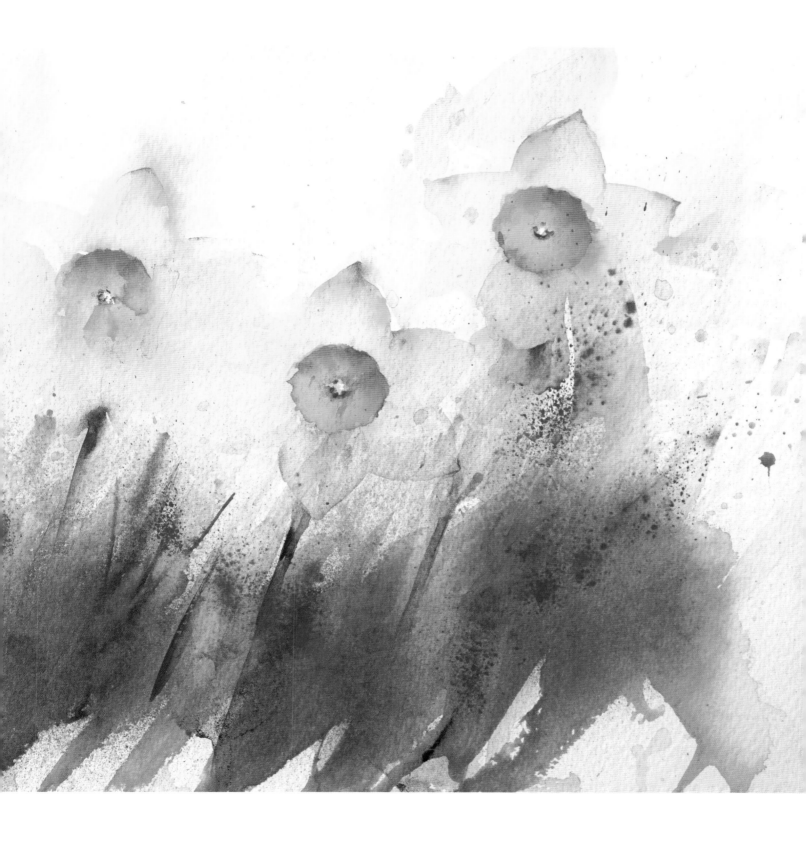

97

Primroses

"I think the most important word in this chapter is look."

A walk to see flowers growing in their natural settings can lead to ideas for many beautiful pieces of art. Interesting compositions can be gained by admiring and learning from nature, whether you are painting a single flower or a whole cluster. Take time to observe how flowers grow naturally.

The value of observation

I believe that Mother Nature has much to offer in the way of art lessons. You can learn about composition, colour, shape and form simply by taking time to look and observe. Looking at the same thing at different times of day and in differing weather conditions will teach you so much about light and how it affects the beauty of a flower in bloom. Look for shadows too, as these become an integral part of painting nature scenes.

I think the most important word in this chapter is 'look' because we race to paint so often that we don't take time to absorb all the information about what we are painting first. Look at the photograph of primroses below, and learn from it. Is there a colour flow? Is there a focal point? Where is the light? What colours would you use for the green foliage and yellow petals? Look for the darks and where you would apply them when painting to make your lighter sections scream with energy. Looking raises so many questions, but it is a lot of fun exploring to find the answers, and as artists we will all come to varying decisions, which will make our art unique.

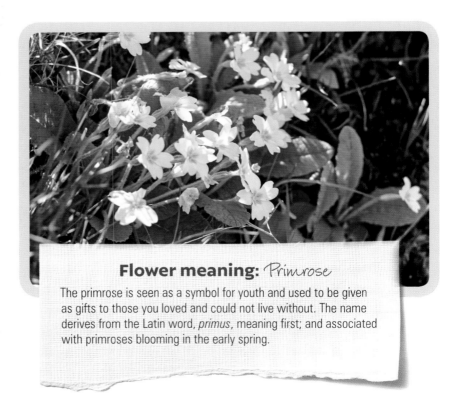

Flower meaning: *Primrose*

The primrose is seen as a symbol for youth and used to be given as gifts to those you loved and could not live without. The name derives from the Latin word, *primus,* meaning first; and associated with primroses blooming in the early spring.

Seeing these primroses growing naturally in the countryside, I painted them from life.

Step-by-step Single primrose

There are many ways to approach painting these beautiful flowers. The demonstration below shows how to create each flower individually using a single petal as a simple starting point. This is a very good way to learn before moving on to larger compositions.

Painting from a starting point

The first way is to paint the individual flower shape of a primrose using appropriate colours to portray the spring flower. Here I have used heavily diluted cadmium yellow.

Materials

Watercolour paper, 300gsm (140lb) weight

Size 10 round brush, rigger

Watercolour paints: cadmium yellow, cadmium orange, quinacridone gold, cascade green

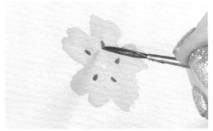

1 Using my size 10 brush I begin by painting a single petal using heavily diluted cadmium yellow. I create this outline shape by observing the real flower. Once my first petal is in place I add the remaining petals, observing the real flower to ensure their shape is correct. I vary the colour of each petal by softening sections with water, a clean damp brush and gentle brushwork.

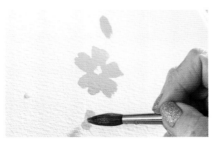

2 I add buds at either side of this first flower to create a pleasing composition. I like to paint flowers in different stages of their lives in each of my floral paintings. Creating small flower studies is a perfect time to learn about their shape.

3 Using my rigger, I add fine brush marks to the centre, to create definition and add to the accuracy of the flower painting. Study the real flower carefully for information on where these marks should be placed.

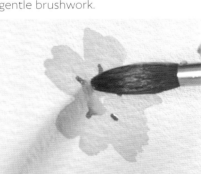

4 While these brushmarks are still wet, I take a clean damp brush and soften the inner section of colour placement. My aim is to encourage this central colour to flow inwards. You will be diluting colour as you do so. This leads to a darker outer edge to the central flower pattern, with a paler central area where the stamen would be.

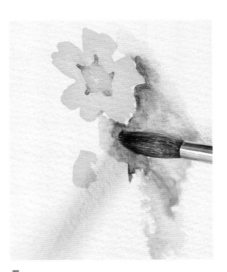

5 Once I am happy with the individual flower I begin to paint leaves. This is done by placing my selected green shade next to the flower. At this stage the outer edge of the petal can be defined or corrected.

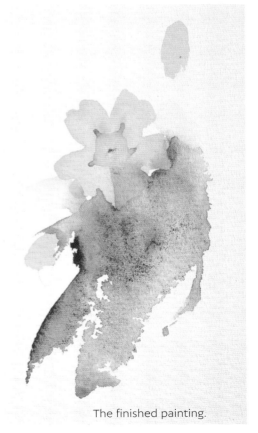

The finished painting.

Step-by-step Primroses

Painting flowers from a colourful first wash

In the previous demonstration we were learning how to paint individual flowers. It really is important to learn about every flower shape before moving on to this more fascinating technique.

Here I am placing an initial wash of colour for my flowers, allowing it to dry and then finding the flowers within it. This is a beautiful way of working which leads to wonderfully unique results.

Materials

- Watercolour paper, 300gsm (140lb) weight
- Size 10 round brush, rigger
- Watercolour paints: cadmium yellow, cascade green, cadmium orange, quinacridone gold
- Cling wrap

1 I paint an initial first wash using the colours that will form the basis for my primroses: heavily-diluted cadmium yellow for the flowers and cascade green for the foliage. I place the green shade where the foliage will meet the flowers.

2 I gradually surround this yellow section with my green shade. Diluting sections of the foliage area gives me a variety of greenery effects; with some sections left paler than others.

3 Using my rigger brush I now begin to add the basis of flower centres using cadmium orange, applying this colour while the yellow pigment is still damp so that the shades gently merge. It is advisable to allow the yellow pigment to dry slightly before adding the orange pigment. This controls how the colours will interact.

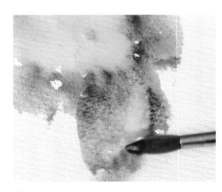
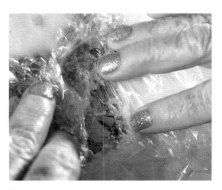

4 Using a clean damp brush I begin to lift out shapes for the individual primrose petals.

5 I carefully place cling wrap on the still wet foliage to create patterns for veins on the leaves.

6 When this colour is completely dry I remove my cling wrap before continuing to paint.

"As the cascade green shade dries, beautiful turquoise colour appears randomly. This is a fabulous quality of this particular shade."

7 Using my rigger brush I can now strengthen the centres of the flowers. The initial pale orange area works perfectly as a backdrop for more detail to be added here.

8 Next I define the outer edges of the petals, using stronger cascade green and the rigger. I deliberately avoid adding each petal edge. Just a few defined flowers in a composition look beautiful against those with less detail.

9 Almost immediately I use a damp brush to soften the hard lines of these newly-placed lines on the outer edges of the petals. This keeps my work soft, atmospheric and ethereal.

The finished primroses. The foundation for many new compositions of these gorgeous spring flowers.

10 Working on the patterns formed by the cling wrap application, I add detail for the primrose leaves with the rigger and cascade green.

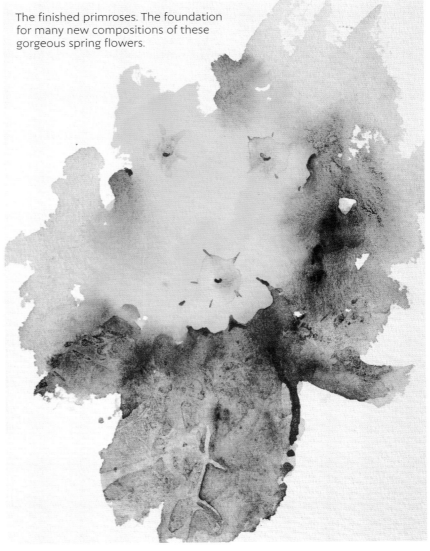

11 I take my time adding defined detail for the flower centres with cadmium orange and quinacridone gold. Tiny dots of cascade green form the detail in the centre of some of my primroses.

Painting clusters of flowers

When painting clusters of flowers such as primroses I take the easiest and simplest route. The technique seen on the previous pages is wonderful for painting flowers where you see a large block of colour rather than individual blossoms. Here are a few extra tips to make your floral paintings look really beautiful.

Tip

Your first wash of colour can include a variety of shades or just one. For example, you could use a blue shade in the upper section of your painting to represent the sky. This colour can merge with the colour of the flowers which in turn could merge with the green foliage below.

I have placed an overall wash of colour, using heavily diluted cadmium yellow, cobalt turquoise and cascade green for my first wash. The diluted yellow pigment dries to a very pale shade which is perfect for spring primroses, while the cobalt turquoise gives the beautiful effect of a fresh spring day.

Whatever the background colour I initially use in any painting will often be repeated as the same colour to define a negative edge. In this image you can see I have used the same cobalt turquoise shade to create the outline of the flowers against the cobalt turquoise sky. I will then bleed this new colour application into the background. Do vary the size of your flowers and buds in an outline. Observe how they grow naturally for inspiration on where to place them.

Here you can see that I'm painting a negative edge for my flowers, using different colours throughout the composition: blue against the blue sky, and quinacridone gold to flow into the green foliage area. This creates interest, avoids outline repetition and makes your paintings look more beautiful.

You can build up a foliage area by adding stronger green colour on top of your initial wash. Bear in mind that cool green shades don't always give the feeling of light and the warmth of a spring day, which is why I often choose to add gold or yellow colour to the foliage sections – spring is not a season for art to look dull and uninteresting!

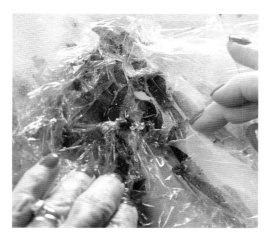

Cling wrap can be used twice in the same area. Sometimes you remove the cling wrap and find a disappointing result, or perhaps it's simply too pale for the composition. Using wrap twice, as in layering patterns, also works very well where complex patterns are desired. When your application is completely dry and the wrap removed, add a further layer of colour and a second application of cling wrap. Allow this to dry again completely before removing. The initial pattern will form a foundation for the second cling wrap application. This creates even more complex patterns, giving you truly wonderful results.

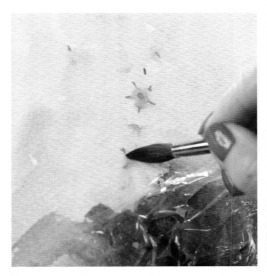

If you have cling wrap on the lower section of your paper in the foliage area, you can still work on the centres of the flowers while this green section is drying. Do take your time when adding detail as this really can be the most beautiful part of floral art.

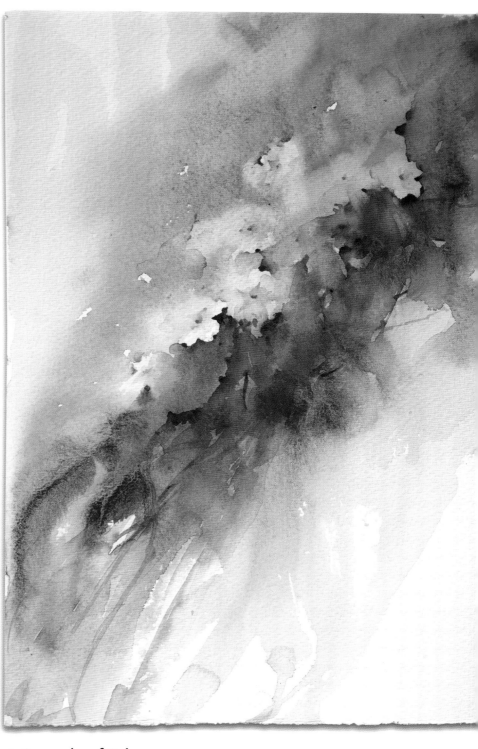

A Cascade of Primroses
28 x 38cm (11 x 15in)
Combining all the tips and techniques on these pages can lead to stunning and unique paintings of primroses.

Painting
challenge

Following the previous tips on painting primroses how would you paint this cluster of spring flowers?

- You could paint a piece of paper all yellow at first and leave it to dry. Next, you could work on the upper negative edges of the primroses in a darker yellow with a few green touches and then add a lower negative edge of darker green for the lower leaves. When you have painted the outline edges above and below the flowers, you could begin to add detail to the centres of your primroses created by the negative edge work.

- How would you paint the dying flowers? I would leave a few out but drop some gold colour in places to represent perhaps one or two.

When we paint we use artistic license to improve our vision which in turn we then show to others as a finished painting. I often beautify when I create, but sometimes art is better if we don't as it can be more interesting; which is why I selected this photograph as a challenge for you to work on.

You could try painting other spring flowers this way too. How about using daffodils for your next experiment? Have fun!

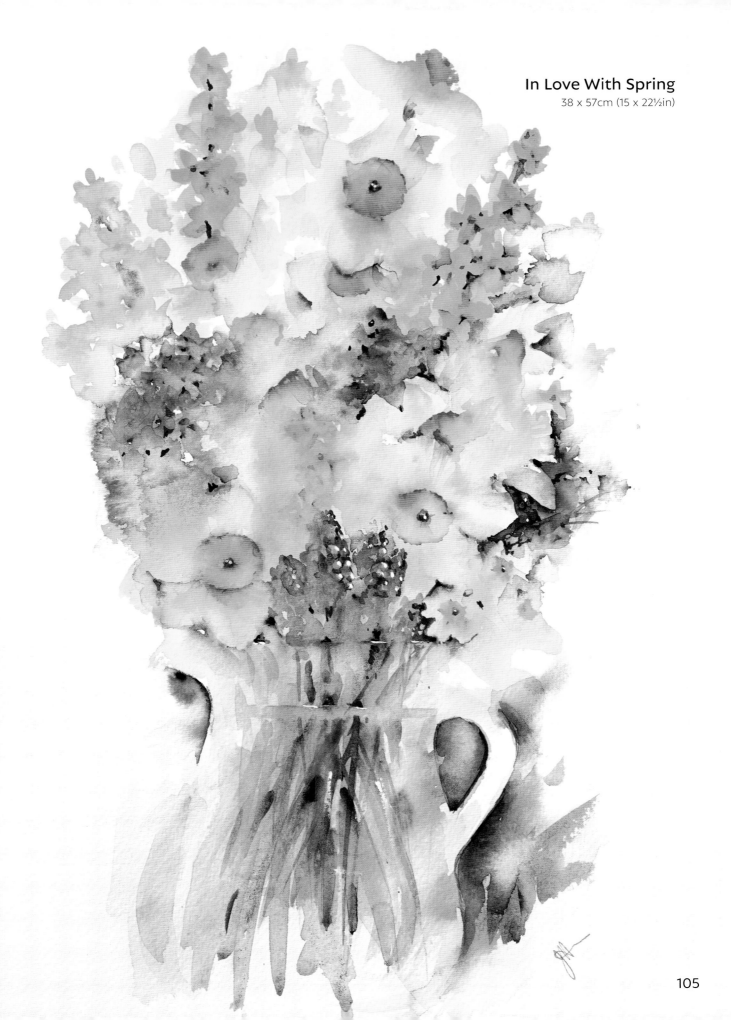

Daffodils

*"I wandered lonely as a cloud
That floats on high o'er vales and hills,
When all at once I saw a crowd,
A host, of golden daffodils;"*

Daffodils, William Wordsworth

I am from Wales, where the daffodil is the national flower. Because of this I grew up loving these gloriously-trumpeted blooms, the appearance of which heralds spring. To me their yellow colour was a sure sign that summer and sunshine wasn't too far away.

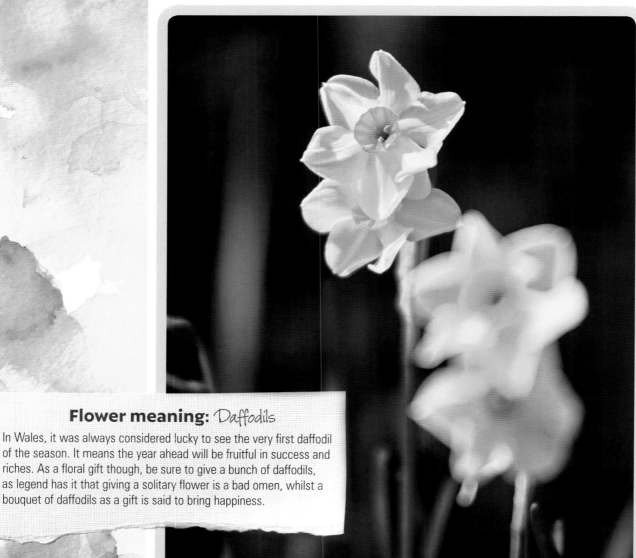

Flower meaning: *Daffodils*

In Wales, it was always considered lucky to see the very first daffodil of the season. It means the year ahead will be fruitful in success and riches. As a floral gift though, be sure to give a bunch of daffodils, as legend has it that giving a solitary flower is a bad omen, whilst a bouquet of daffodils as a gift is said to bring happiness.

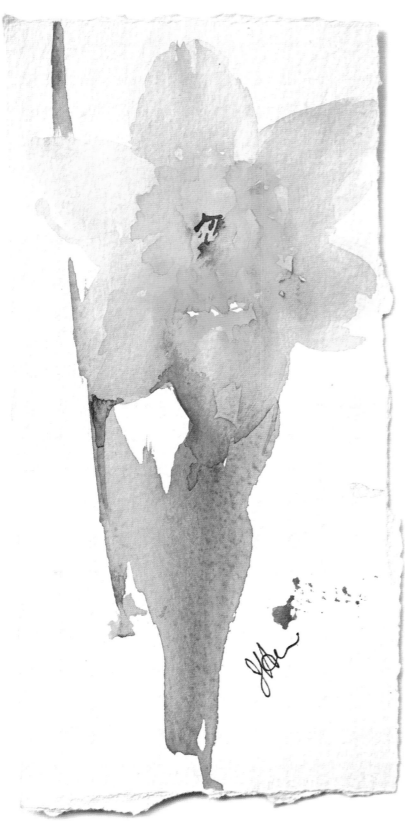

The important study

I see daffodils and immediately think of cadmium yellow, a pigment which is perfect to depict these very strongly-coloured flowers. I find painting a single study is the best way to learn about flower shapes, so I recommend taking time to paint a small study before moving onto a larger painting. As mentioned earlier, this will help you to learn about shape and form first.

If you look at my daffodil study, you will note the flower literally flows into the stem section. I deliberately allowed a selected colour to unite the two parts of this particular bloom.

It is worth noting that when we sketch a subject we often define individual parts of each flower by separating petals, stems and leaves with well-placed pencil lines. But when we work without a preliminary sketch, colour has more freedom to unite these interesting sections, which in turn gives a painting a beautiful soft illusion of life. Imagine, if you can, a hard green line underneath the lower middle daffodil petal in my watercolour study. If present, it could make the flower pop out more, but it could also kill the feeling of energy in the piece.

Similarly, observe the very simple green vertical line to the side of the flower behind the petals. This tiny green line adds an illusion of distance. As artists we often create illusions in our work. We can hint at what is – or is not – actually there with the tiniest brushstroke. We become magicians in a way.

Once mastered, these little tips can make all the difference to a finished painting. We often instinctively know a painting needs something more, but at that stage in creating we can often mistakenly add far too much which can over complicate our end result.

A touch is sometimes all that is needed to make a huge impact on something so ordinary. In this study, a single flower.

"In a way artists become magicians, creating illusions in watercolour."

Building up a composition

Once you know how to paint just one bloom, painting a larger or more exciting composition becomes far easier.

Daffodil wash

I often paint a first wash in the colour of my selected flowers on paper before adding any detail. For my first wash of daffodils shown here I used cadmium yellow and cadmium orange. Placing a colour wash on a large piece of paper allows me space to encourage colour flow of daffodil shapes, particularly at the edges of my first wash. Varying the intensity of the yellow shade but by using water alone in places with my brush I can gain translucent effects. When a first wash is dry I can add more detail, finding the centres of my flowers using cadmium orange for a lovely vibrant contrast.

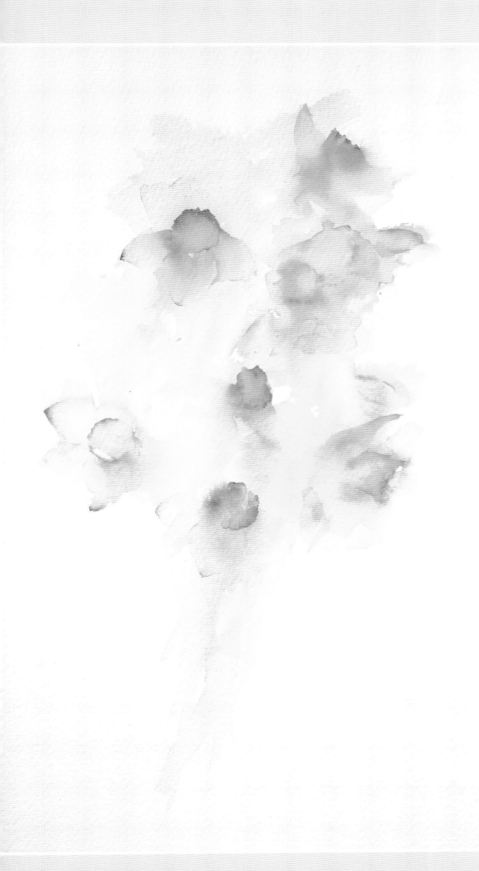

Working from a starting point

Rather than paint a first wash of colour and work on top adding detail, I often paint flower centres first, as seen in this second painting of daffodils, where I placed them in a random bouquet effect on paper. To me, painting flowers is like creating a floral arrangement, but on paper rather than in a vase. When I am working on a larger composition I simply place new flowers where I feel they will look good. This is something that gets easier in time; in that the more you paint, the more you instinctively know what goes where to create a pleasing painting. In exactly the same way that you would learn when studying floral arrangements.

I often paint from my imagination but you could also place your flowers in a vase in front of you and paint them exactly as you see them. Better still, sitting outside in a garden to paint them growing naturally will give you fabulous results that are unique to you, bringing nature to life in watercolour.

Daffodil centres were painted first then petals have been created by moving heavily diluted colour from the centres with a clean damp brush. White space has been left for white petal shapes.

Sculpting shapes with water

When painting with watercolour, our focus as artists is often drawn to where we place the pigment on the paper. For more atmospheric results I often create with my emphasis on how I use water. I 'sculpt' the petals, creating their shapes through my use of a clean damp brush within a first wash. It is an exciting and intriguing technique. My initial application of pigment has to be accurate in terms of the colour match and shape of the flowers I am depicting in my art. Once this colour has been placed, I can then use a clean damp brush to remove or lift pigment in a way that the white of my paper shines through in places, leading to a beautiful translucent outcome.

In the images below I show how I strengthen the outline of colour or sculpt a shape with water. My aim of working this way is to achieve a lovely three-dimensional effect, as seen in the daffodil paintings on the previous pages. You can see it particularly clearly in the central parts of the fluted daffodil trumpet.

You can gently move pigment with a clean damp brush at any stage in a painting's development, leading to stunning results. It dilutes colour in defined areas which, depending on the amount of water that you use, can lead to unexpected watermarks or controlled patterns. To sculpt patterns in a first wash it is vital to wait until your first application of pigment is slightly dry. If you work on a wash that is still very wet, huge blooms will appear rather than the shapes you had hoped for.

I prefer to use this method of watercolour sculpting to lift colour rather than using tissue, which can lead to hard, unnatural edges. These I strive to avoid.

1 In this image my initial wash for a daffodil is completely dry. The centre is pale because colour has been lifted previously, using a circular brushstroke with a clean damp brush on my initial wash. I use my rigger brush and cadmium yellow to add detail for the fluted edge of the daffodil trumpet.

2 The newly-defined details added with additional colour (see step 1) can be softened throughout the painting process, but only while the freshly-applied pigment is still damp.

3 Here I am adding subtle fine detail to separate and define petals once they are dry; which helps to bring each flower to life.

Adding an orange centre against a pale yellow background adds beautiful impact.

Using a fine rigger, tiny details for the inner flower centre can be added once the first stages are completely dry.

Keep the centre detail work light so as not to detract from the softness of the gorgeous flower around it.

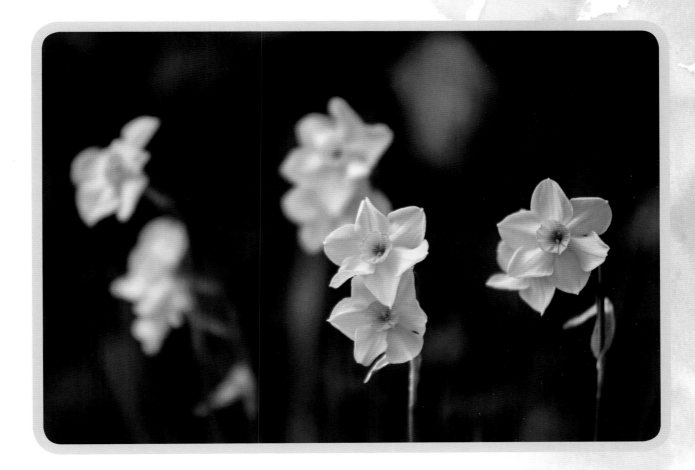

Painting challenge

Study this photograph of daffodils from my garden and consider how you would paint them. There are so many options.

- You could paint one single flower beautifully on a white background or perhaps with colour behind it,

- You could paint a yellow wash of daffodil shapes as I did, and when this is dry add detail to the centres.

- Alternatively, you could paint the orange centres and work away from them as your starting point to build up a painting.

The endless possibilities for painting the same thing make creating so refreshingly soul-charging. The season of spring recharges your batteries so well.

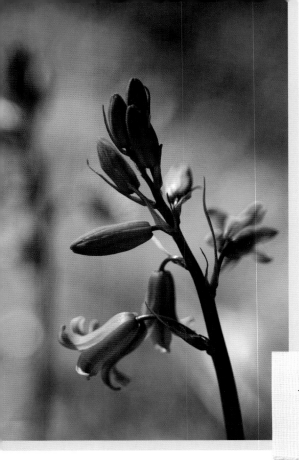

Bluebells

"Spring cleaning with new techniques and ideas for painting."

I love going for long walks in spring as it clears my head and enables me to think about what I am painting. I get excited at seeing the first spring flowers appear and tend to take many photographs to work from when the weather isn't so wonderful.

I also find I tire of painting in the same way so I play with many products around my home to see if I can gain fascinating results from them. One such experiment was using washing-up liquid. You can mix pigment and water with the suds, creating bubbles on paper which leave pretty effects.

Flower meaning: *Bluebells*

The most popular meaning for bluebells is gratitude. As a child I was told that bluebells could also be referred as 'fairy thimbles' and if you rang them fairies would appear.

Playing with ideas

For my bluebell painting seen here, I simply moved, or slid, the pigment with the soapy fluid to create the bells of the spring flower I love so much. It gave quite an atmospheric effect.

To experiment like this, place a little washing-up liquid in a dish (not on your palette) and then add pigment. Merge these two products with water and then use a sliding action when applying the mix with your brush to paper. Different amounts of liquid and pigment will give you varying affects, but I find using the liquid minimally gives far better results.

Bluebell effects created by playing with washing-up liquid and pigment.

The value of accurate colour matching

When painting certain flowers, it is absolutely vital to gain an accurate match when selecting a colour. The bluebell is a perfect example of this. The name itself suggests the flower is blue, but when observing the plant it is clear the petals take on more of a violet hue. This can make colour matching seem to be quite a task. If you don't achieve a successful colour match, viewers of your finished piece might not believe you have seen the real flower. This can be said for all flower paintings, not just bluebells, to the viewer who knows the plants very well.

Bluebell study

As explained in the previous chapter, I like to paint a study first before attempting to paint a full composition of any flower. Matching the colour for bluebells was a hard task because they are slightly more violet in colour than being a true blue. I used cobalt blue violet with a touch of cobalt turquoise to bring these bell-shaped flowers to life. This was more effective than using just a purple or blue shade alone for my colour selection.

Once I had painted a single bluebell in my study, I added a few more beside it. While the colour was still damp I used a clean damp brush to soften a few outer edges of each bell, blurring this still-wet colour into the clean white paper around my subject, which gave the impression of more flowers behind the first ones. Aiming for atmospheric paintings means we do need to lose detail in places. This technique is perfect for doing just that. Soften edges appropriately in your floral paintings and you will instantly add an illusion of light and life.

Once my colour selection is correct, I can move on to painting larger, more interesting scenes. In my painting *Bluebells in a Woodland Scene*, seen on the next page, only the flowers in the foreground are important and they act as the focal point. There is a hint of the same flower colour in the distance to suggest there are more flowers there, but these are less defined and out of view.

Again, going outside to see the real thing helped me to achieve this final painting. I needed to know how the flowers grow in the wild, in their natural setting, to paint a full composition. I aimed to bring the atmosphere of a misty spring morning into my results.

Bluebell study
28 x 38cm (11 x 15in)
Paint one flower to learn about its shape prior to painting a larger composition.

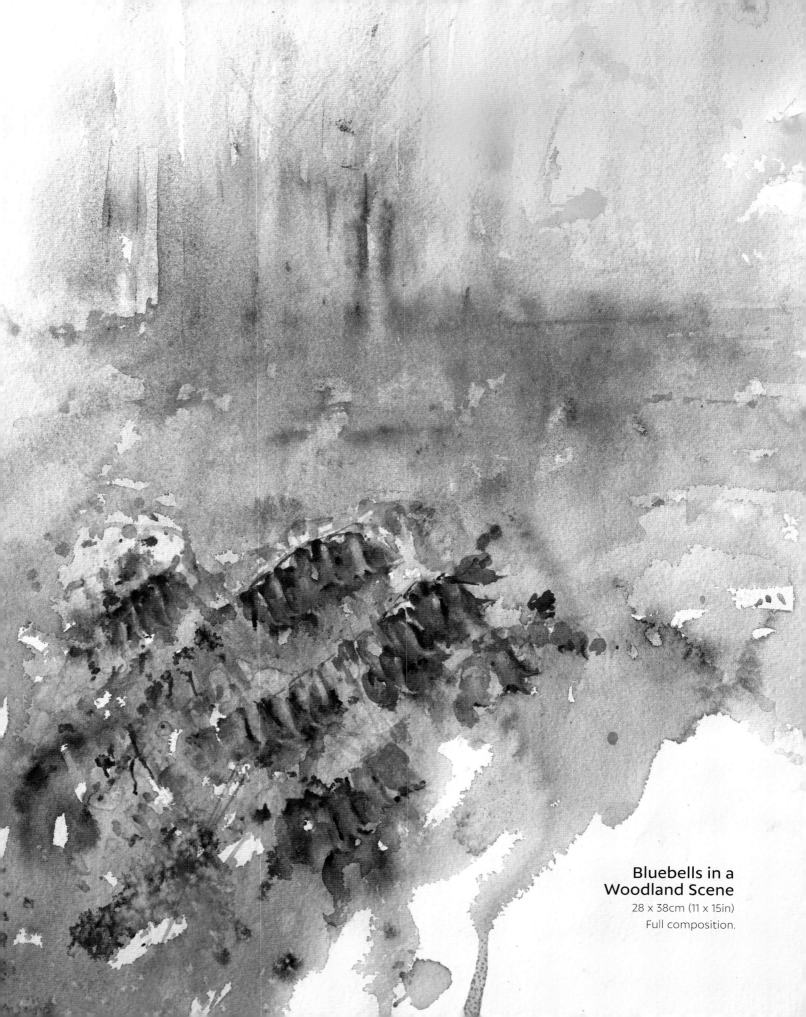

Bluebells in a
Woodland Scene
28 x 38cm (11 x 15in)
Full composition.

Painting challenge

What colours would you use to paint this bluebell? Matching colour for some flowers as a challenge isn't always easy, so this is an interesting task.

Following my study, how would you paint the single flower? Would you add others around it and soften the edges to create a feeling of light and life in your work? Or would you choose to just paint one flower, standing alone as it is in this photograph?

There are many ways you can paint this image of a bluebell, but you are the artist, and the choice is yours.

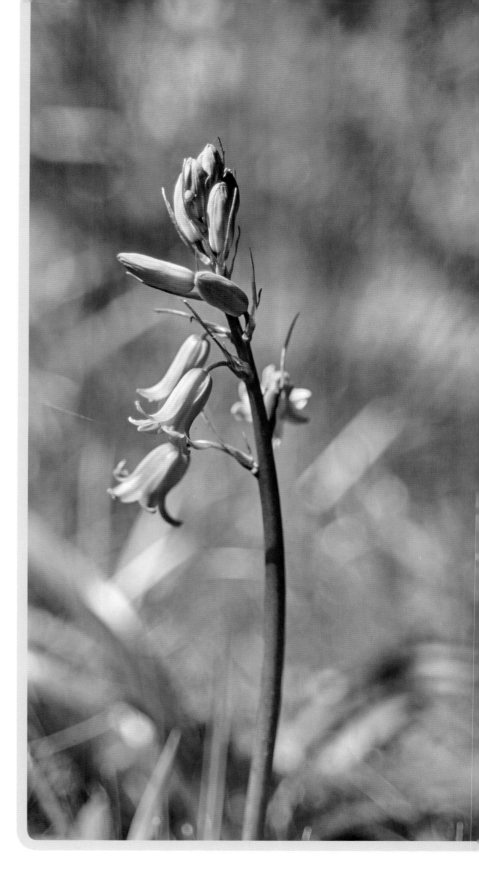

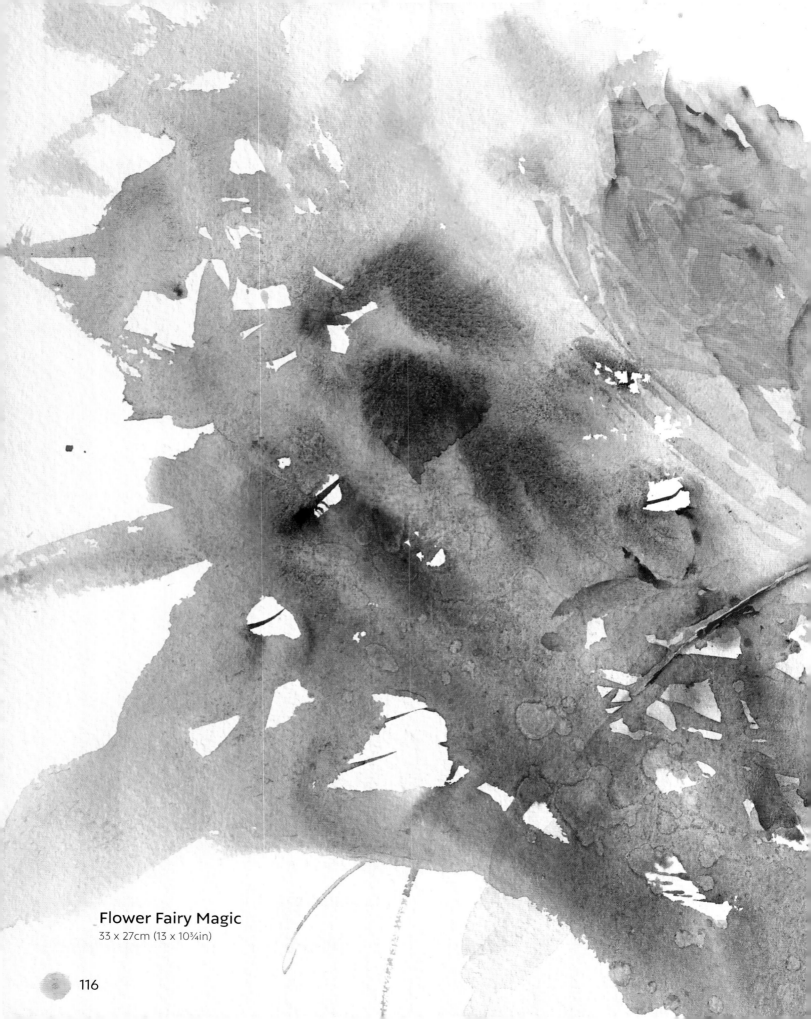

Flower Fairy Magic
33 x 27cm (13 x 10¾in)

SUMMER

"Nothings says summer like roses growing in an English garden, with their wonderful perfume filling the air."

A time to blossom, grow and mature, summer invites us to learn from the growth that is springtime in our art, and take it to a whole new level. Techniques and ideas can come totally into play in gorgeous new work, full of stunning colour, that constantly tempts us to reach for our brushes to capture all that we see.

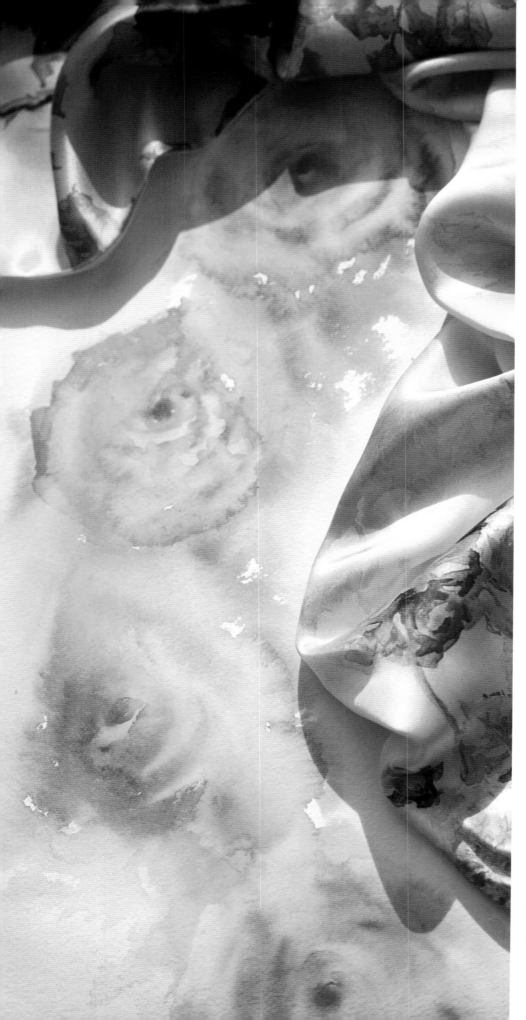

Roses

"The beauty of any flower is to be enjoyed, but none more so than the rose."

Roses are such a beautiful flower that they are often used in home decor or on fashion items. They come in a variety of glowing colours but it is the silkiness of the petals that fascinates me as an artist. I remember my Chinese mentor teaching me to try to tell the story of how something feels when I paint. It is especially important to gain that feeling of soft silky petals when you paint roses, so that the viewer of your finished work understands how soft and delicate the petals are. This is possible through using diluted pigment and by allowing the white of the paper to be seen clearly through applied colour.

Summer silk: a rose-inspired silk scarf alongside one of my rose paintings created in watercolour.

Step-by-step Rose

Colour puddle

In this demonstration I'm aiming to show how magical watermarks can be. Wet pigment will not move into dry sections around it on paper unless encouraged to do so. If a block of colour is placed as a shape in the centre of a clean white piece of paper it will be contained, only able to move within that wet space. Working with your paper at an angle enables pigment carried by water to move towards the base of the damp shape. Here it will form a puddle where the dry and wet paper meet. As the puddle dries it can only move backwards into the still wet central section. Interestingly this colour will keep moving until your paper is completely dry. This is what creates fascinating watermarks that when used effectively can add superb interest to a flower painting.

Materials

Watercolour paper, 300gsm (140lb) weight
Size 10 round brush, rigger
Watercolour paints: opera pink, cadmium yellow

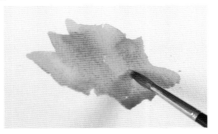
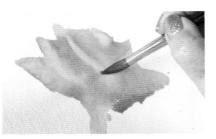

1 Using my size 10 brush and opera pink for my colour choice, I began by painting a block of colour representing the profile view of a rose. I use the real flower to guide where my outline edges will be.

2 Next I strengthen colour in places, adding a minimal touch of cadmium yellow to give a hint of warmth to my flower. I work at an angle so the newly-added pigment and water flows to the base of the flower. Here it sits in a puddle; as the pigment dries it will be pushed backwards into the central area of the flower. When dry this will create a watermark.

3 While the first wash is still slightly damp I use a clean damp brush to create patterns in the first wash. This movement of colour can form beautiful petal formations and act as if light is hitting the flower. Gentle sweeping brushstrokes with water alone not only lift the colour but also move the previously-placed pigment to other areas, creating depth.

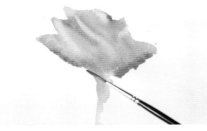
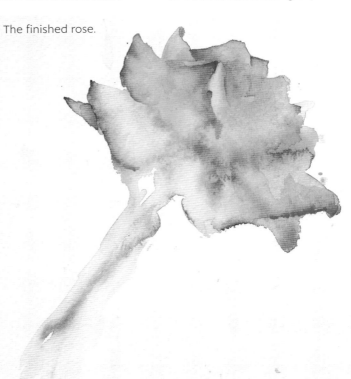

4 When this first wash is completely dry, I add detail where I feel it is necessary, using my rigger brush to define petals that appeal to me, choosing those shapes to work from that look beautiful in the real flower. My aim is to be impressionistic rather than over-detailed. Importantly, I stop painting as soon as I can see a flower appearing. This avoids crossing the line where a painting can tend to look overworked and leads to a fascinating result that is unique.

The finished rose.

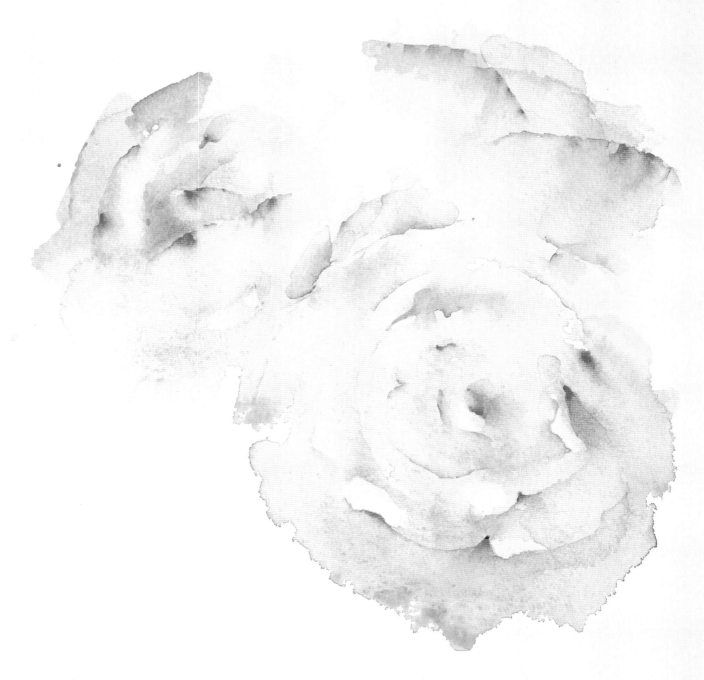

Foliage or not?

Learning from a single study helps towards creating larger more complex compositions. Once I am happy that I know the shape of a flower I can move on with confidence to paint more than one rose, as in this example.

I find that new artists often worry about painting foliage, when in fact paintings of flowers often look fantastic without the addition of green or leaves. Never feel you have to add green in a floral painting. Being unique and painting something in your own way can lead to much more interesting results.

Climbing roses in my garden look so beautiful, but it is the flowers themselves that appeal to me, and they gave me an idea for a simple composition: a cascade of tumbling roses, all in one colour, which is a really effective way to capture the essence of this beautiful flower.

Summer Posy
27 x 33cm (10½ x 13in)

Tumbling Roses

38 x 57cm (15 x 22½in)

This painting was inspired by the climbing roses in my cottage garden. I dismissed the foliage in the scene completely to gain this pretty result. We don't always have to paint what we see. Our artist's interpretation can often be simpler and say so much more with less detail and information added.

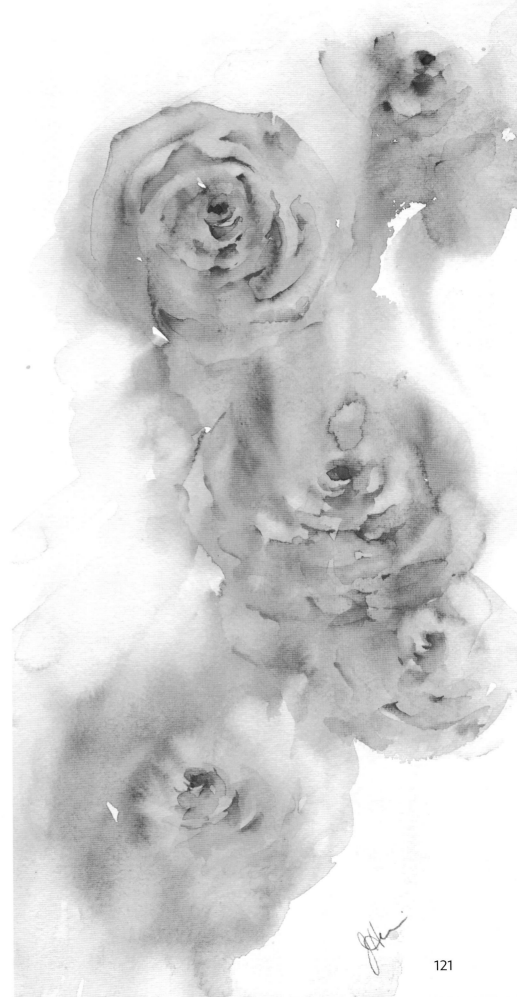

Sweet pea

"No other flower creates such magical illusions of perfume the minute its name is mentioned."

Growing up with my grandfather was where I originally learned so much about flowers and gardening. Every year he grew rows of sweet pea flowers that had the most heavenly scent. These he grew from seed; something which I do annually now too.

There is nothing quite like watching a plant grow from the tiniest of seeds. In the same way that learning to use watercolours feels; you start with a small painting and, gaining confidence over time, move to a bigger one.

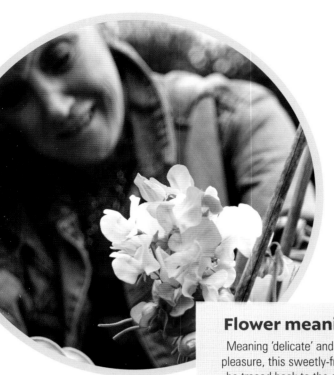

Picking sweet pea flowers in my cottage garden.

Flower meaning: *Sweet pea*
Meaning 'delicate' and symbolising blissful pleasure, this sweetly-fragranced flower can be traced back to the seventeenth century.

Step-by-step Sweet pea

Just like a rose, the sweet pea flower is delicate and the petals seem almost transparent, so using diluted pigment will allow the paper to show through and give an illusion of soft, silky petals. I use opera pink as my main colour in this step by step, using a size 10 brush for the main painting and my fine rigger for adding detail.

Materials

Watercolour paper, 300gsm (140lb) weight

Size 10 round brush, rigger

Watercolour paints: opera pink, cascade green and cobalt blue, plus a little quinacridone gold for warmth

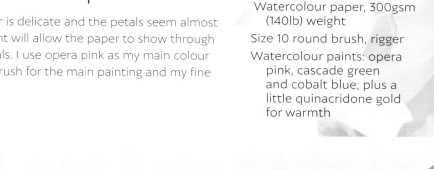

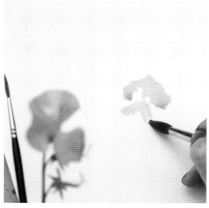

1 Holding a sweet pea flower in my free hand to observe throughout my painting, I begin to paint the shape of the flower. I start with strong pigment at the outer edge, which I then gently encourage towards the centre area with directional brushwork.

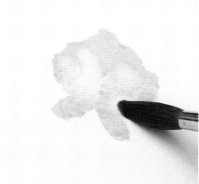

2 Moving pigment with a clean damp brush gives you a variety of shades as water dilutes the colour on the paper. Opera pink and a size 10 brush were used here.

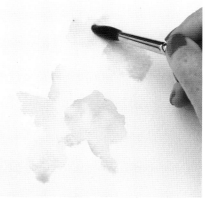

3 I add a few more flowers around my first sweet pea, gradually building up my composition in a way that is pleasing to me. I am now working from my imagination and only looking at the flower in my hand for ideas on how to add further flower shapes by looking at the same bloom from different angles.

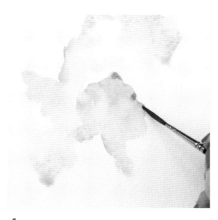

4 Using the rigger, I go back to add stronger colour to the outline edge of the first flower once the colour is dry. This will form the beautiful detail here. I continue to work on all the flowers in this way.

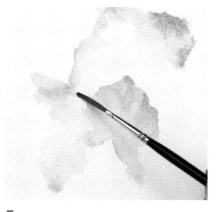

5 Adding colour to each flower's upper outline at first gives me definition, but I can then pull this outer colour intermittently towards the centre of each flower, with a clean damp brush, creating a fluted effect that is so typical of the pea family of flowers.

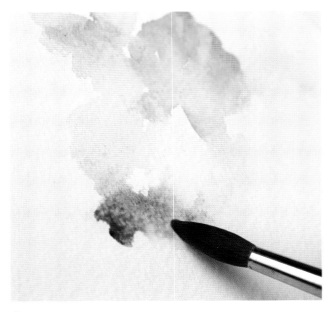

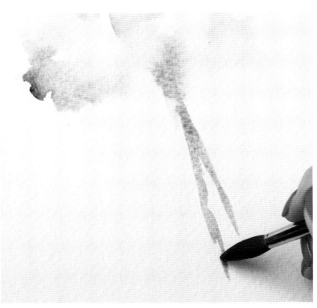

6 Next I use a blue shade to act as the edge of white flowers in my posy, and this also to add interest. Leaving just blank white spaces for white flowers doesn't always work for a floral painting. If you observe any white flower, you should be able to see shadow areas of violet or pale blue. When choosing a blue shade for this purpose, please keep your colour choices suitable for the season.

7 Once I am happy with the rough outline of my posy, I begin to add stems. Similarly to the violet demonstration on pages 41–43, I am aiming at painting the posy as if it is in a glass vase. Here I have used soft diluted cascade green, because the colour of the sweet pea stems seems to have a cool green to them rather than a warm tone.

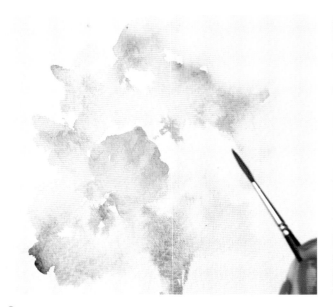

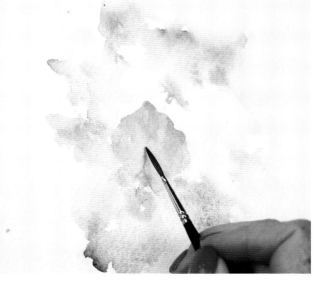

8 I begin to fill in space, adding colour where I feel it contributes to the composition. I stay with the same colours throughout my painting.

9 Finally I add details to the centres of some of the flowers using my rigger brush – just a simple line for the sweet pea centre. Not all flowers will be painted in full detail, which will give an air of mystery and create atmosphere. This way of working means I can keep my work loose and atmospheric.

> ## Tip
>
> *Try to avoid using too many shades in a piece. Three or four is fine for a subject such as this.*

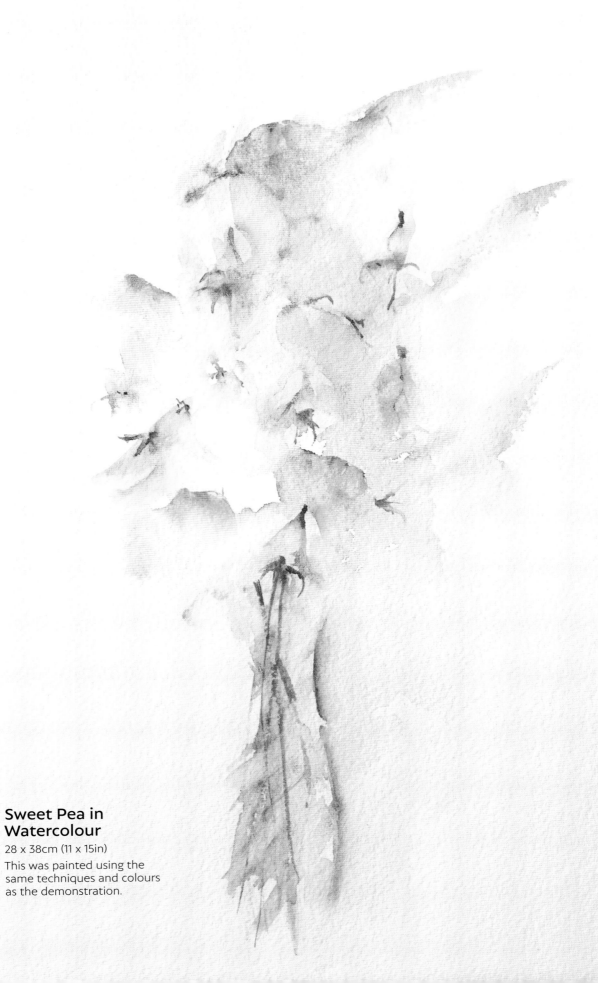

Sweet Pea in Watercolour

28 x 38cm (11 x 15in)

This was painted using the same techniques and colours as the demonstration.

Sweet and simple

We only need one or two flowers to create a beautiful floral painting. In the two paintings of sweet peas on these pages, simple sprays of flowers form easy to create compositions. Selective placement of the flowers ensures that the white paper of the background shows off the colour in each bloom.

The three sweet pea flowers in the vertical composition on this page form a painting pleasing in its simplicity, while the more translucent sweet pea picture on the opposite page is enhanced by the use of twining greenery. This soft foliage leads the viewer of the finished piece into the white background space in a very subtle way.

Bear in mind that just the touch of a brush with a small amount of colour, or the simple placement of a tiny stem, can complete a painting. Sometimes that is all that is needed: just one touch of colour. The energy in each of these paintings is quite different. But their story is the same. They both beautifully depict the sweetness that is the sweet pea flower.

Sweet Peas
15 x 38cm (6 x 15in)

Sweetness

28 x 38cm (11 x 15in)

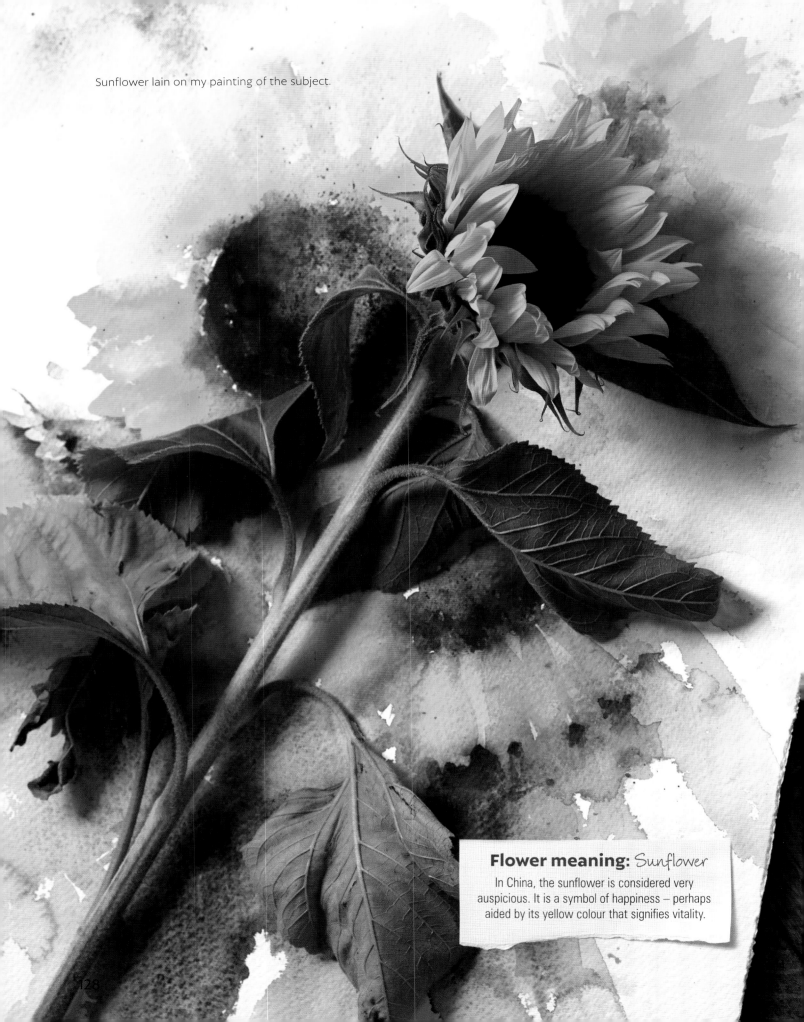

Sunflower lain on my painting of the subject.

Flower meaning: *Sunflower*

In China, the sunflower is considered very auspicious. It is a symbol of happiness – perhaps aided by its yellow colour that signifies vitality.

Sunflowers

"Who cannot feel instant cheer when faced with this strong and colourful flower?"

For a time I lived in France and delighted in passing fields of these stunningly beautiful flowers that will always mean summer to me. I am fascinated by how they turn their heads to face the sun – just as I do, I must admit!

Step-by-step Sunflower

Bold decisions

When painting many flowers our attention often falls on the petals but when it comes to painting sunflowers, it is the gorgeous bold centre that grabs my attention, and this is where I start painting. Unlike roses or sweet peas, we can leap straight into using bold pigment to depict the strength and energy of this bloom. Now is the time to be brave when applying colour and play with colour application, building up sections by layering of pigment and using textural techniques.

Materials

Watercolour paper, 300gsm (140lb) weight

Size 10 round brush, rigger

Watercolour paints: quinacridone burnt scarlet, quinacridone gold, cadmium yellow, quinacridone burnt scarlet

Toothbrush

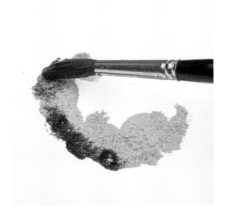

1 I start painting sunflowers by creating their centres; here, by using the size 10 brush to add strong brown and gold shades. I have used quinacridone burnt scarlet and quinacridone gold in this demonstration.

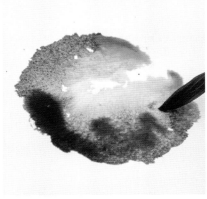

2 With my focus on half of the lower central shape I begin to add delicious puddles of strong colour.

3 I allow these colours to merge to create patterns.

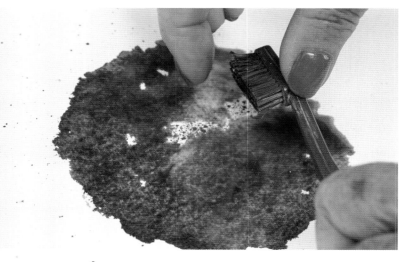
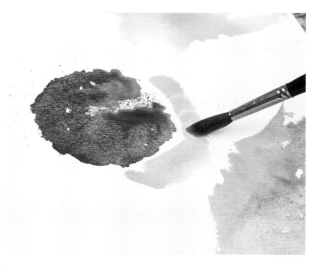

4 While the paint is still wet and in the process of drying, I use my toothbrush to splatter fresh colour onto the still slightly damp section. This will give me terrific textural effects when the tiny dots of colour merge softly with the existing central colour. I allow the centre to dry slightly before moving to the next stage.

5 Next I use cadmium yellow to form a ring around the outside of my drying sunflower centre. Using directional brushstrokes, I can then make petals in yellow which will radiate away from the centre, moving towards the outer edges of my paper.

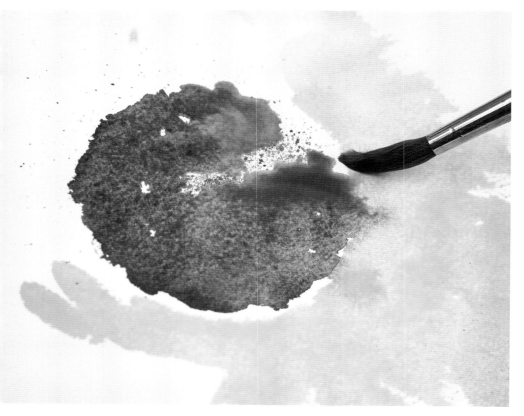

Colour fusion

6 I gently touch the brown centre with my brush randomly to encourage the slightly damp brown colour of the centre to merge with the newly added yellow colour around it. This will give me a fabulous loose effect rather than a tidy botanical result.

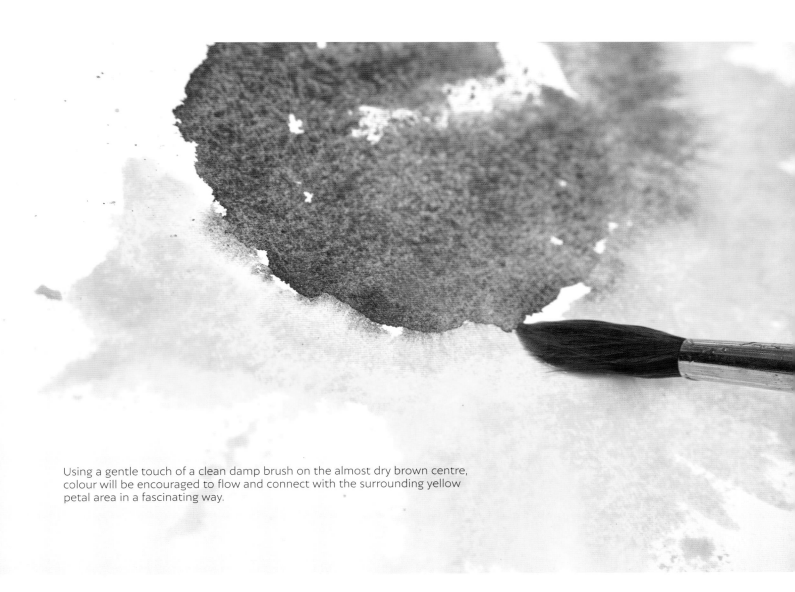

Using a gentle touch of a clean damp brush on the almost dry brown centre, colour will be encouraged to flow and connect with the surrounding yellow petal area in a fascinating way.

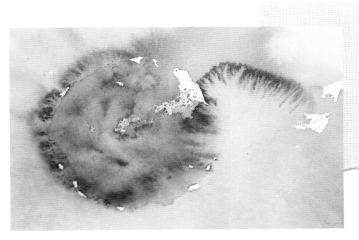

Happy Accidents

While the demonstration piece was drying, a gorgeous watermark appeared. You may panic when you see these happy accidents but I think they are beautiful and they certainly add drama to any result. I usually add detail working around a watermark to show it off.

Building up colour

7 Once my first wash is dry I can add detail using my rigger brush and dark brown pigments such as quinacridone burnt scarlet; a warm glowing colour which adds depth and always enriches a painting.

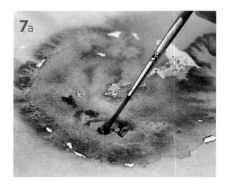

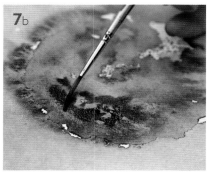

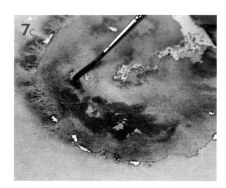

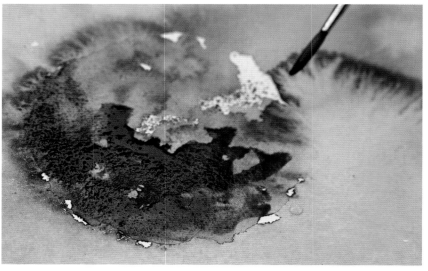

Building up the strength of a sunflower centre is an enjoyable experience. You can see clearly in this image how I have worked around that wonderful watermark.

8 Once the centre is looking good to me, I move on towards painting the outer edges of the petals. I create the definition by painting strong detail with quinacridone gold.

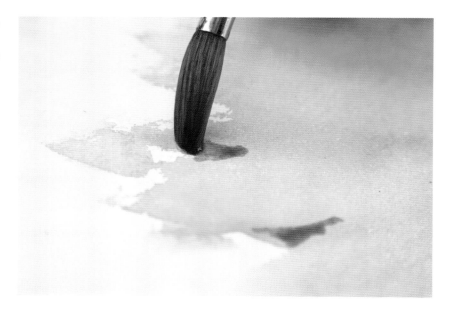

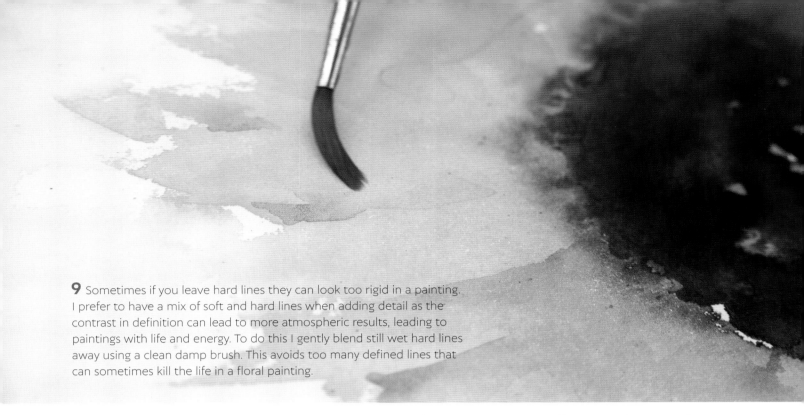

9 Sometimes if you leave hard lines they can look too rigid in a painting. I prefer to have a mix of soft and hard lines when adding detail as the contrast in definition can lead to more atmospheric results, leading to paintings with life and energy. To do this I gently blend still wet hard lines away using a clean damp brush. This avoids too many defined lines that can sometimes kill the life in a floral painting.

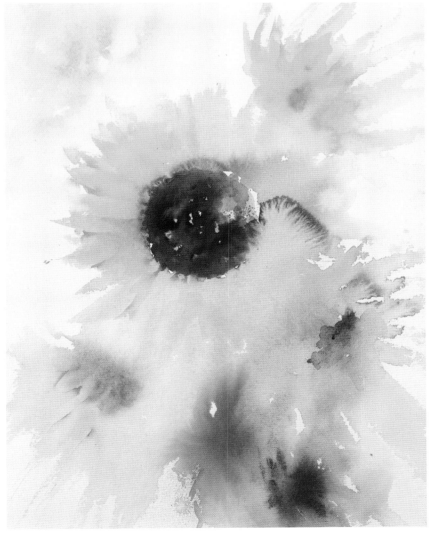

Once my flower was almost complete, I began to paint the outer sections of my white paper around it to create a pleasing composition. I used cascade green as a shade to paint the green foliage and when I added detail to it later. I deliberately chose to keep defined information to a minimum so as not to destroy the energy I yearned for in this painting.

This is a very simple step-by-step but you can make your paintings more complicated with extra texture effects in the centre and more petal details if you wish. Bear in mind when you paint, your creation is how you want to paint. This merely gives you an idea on how to paint sunflowers and is a starting point as a demonstration for you to grow from.

Adding interest

"What you leave out of a composition tells as much of the story as what you put in."

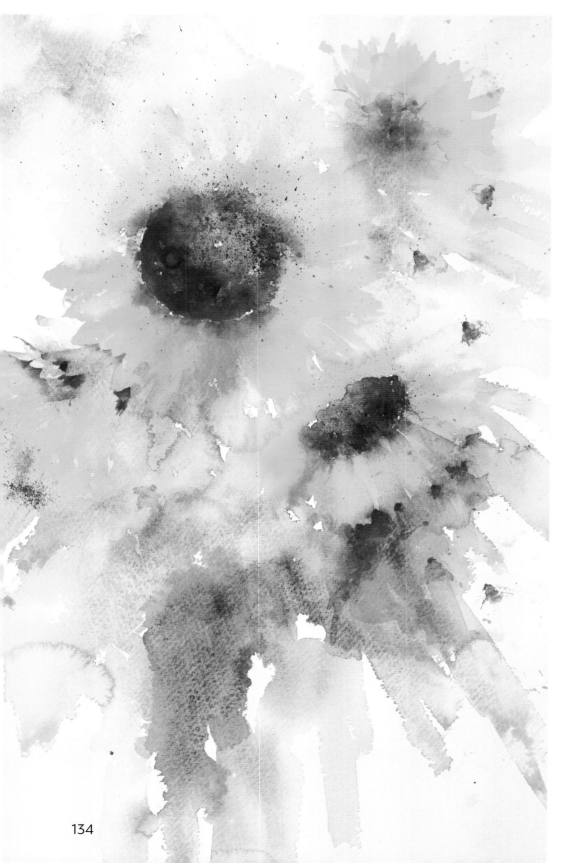

To make my composition more interesting and add a touch of life to my work, I painted a new sunflower composition including bees which are a lovely addition to any floral piece, bringing with them a touch of energy and interest. Adding wildlife in the form of insects or birds really can bring such a great sense of movement to an otherwise still life, and with a painting of sunflowers you have the additional bonus of being able to use the same colours as in your subject for the bees.

Imagine this painting of a sunflower minus the bees hovering around it. It wouldn't be quite as interesting. The feeling of movement comes from their imagined flight and activity around the flower. This is achieved in my painting by adding very little detail for their wings or even the bees themselves. These insects are merely hinted at in this piece through placement of colour and brushwork.

Soft edges give the illusion of movement of a bee in flight in the same way that lost edges on a petal give the illusion of light hitting it.

Sunflower and Bees
38 x 58cm (15 x 22½in)

Practise painting bees

Like other insects, practising painting bees is a great fun project and often these studies can turn into sweet little paintings in their own right. The bees in my study here were painted on top of a scrap of paper that I was originally going to throw away. It already had colour on it, so I had nothing to lose by playing and experimenting with creating bees in flight in watercolour. Soon there was a whole row of bees that almost seemed to be buzzing in the oblong composition.

To paint bees, try painting small yellow shapes for their bodies first, then add a few dark stripes on top. I create wings by blurring colour away from the body while the pigment there is still wet. I use my fingertip rather than a brush, as my movement and touch is softer and my results less tidy this way.

Improving a composition

Think about your composition when adding insects. You might choose to place them at an angle that attractively highlights and brings attention to a flower outline. Alternatively, you might place them at an angle that flatters the direction the flower is growing in. The important thing is that you think about their placement, and don't just put them anywhere in a painting.

"For bees, the flower is the fountain of life. For flowers, the bee is the messenger of love."

Kahlil Gibran

Busy Bees
7 x 35cm (2¾ x 13¾in)

AUTUMN

"Jewels, seen as autumn berries in sunlight, are pure treasure to the artist's eyes."

Autumn is my favourite time of year. I adore painting with reds, golds and orange shades so this is the perfect time to indulge myself by selecting gorgeous vibrant autumnal shades from my palette, such as quinacridone gold, cadmium orange, and perylene maroon, enhanced with beautiful purple shades to act as a stunning colour contrast. Going for a walk becomes an almost playful experience that brings back many childhood memories, when simply kicking leaves in the air brought so much happiness. Simple things in life can be the most beautiful, like a single ripe berry found in sunlight on a autumnal branch.

This is a time to celebrate as farmers harvest their crops. It is also a great time for us as artists to harvest all the knowledge we have gained in the year; and perhaps it is a time to combine all our previously-mastered painting skills and techniques to pull them into new work in a new way. Learning new skills as an artist is a pleasure that can be repeated time and time again. Only by repetition, by constant practice, can we grow as artists; consistently learning and improving as we do so.

Autumn is a time for strong warm golden hues. The best of the summer flowers has long past but the foliage of trees takes on a whole new look as green disappears and rusts, red and gold come into play.

Autumn harvest.

Fruit, berries and seeds

Berries are a delight to paint. When seen growing naturally, fabulous compositions appear right before your eyes. The richness of colour, and direction of the berries tumbling in sunlight highlights the autumnal hues of reds and gold. These are treasure for the artist who is keen on learning from nature.

Tumbling Berries
24 x 38cm (9½ x 15in)
Rich gold shades bring small berries to life with hardly any detail whatsoever.

More than brown

Adding colour for impact

This isn't a time of year to just paint in brown shades, although I think that can be a temptation to the new artist. We perhaps see less variety of shades at this time of year, but that doesn't mean our art should become boring. In fact, this is the best time to learn how to add drama and impact to our work by exciting use of colour.

Combining stunning pigment shades, energy, brushwork and textural techniques can lead to stunning results. With inspiration from nature I can paint constantly at this time of year, not only by taking in what I am seeing in the countryside around me, but also using what I have learned from painting summer flowers over the previous few months, as seen in the previous chapters of my book.

The hare below was created in brown shades, allowing the water to run through and break the pigment in places while it was still wet. White paper is still evident in both the subject and the composition which aids the sense of life in the piece.

The use of similar shades in the painting of reeds seen on the opposite page shows how strongly directional brushstrokes can play a part in our art. Purely by the echo of direction throughout the composition, a sense of movement is achieved as if the reeds are hit by a breeze. Soft and hard edges bring energy to an otherwise ordinary sight.

Opposite:
Reeds in Autumn
28 x 38cm (11 x 15in)
Texture adds interest to an almost monochrome painting.

Running Hare
57 x 38cm (22½ x 15in)

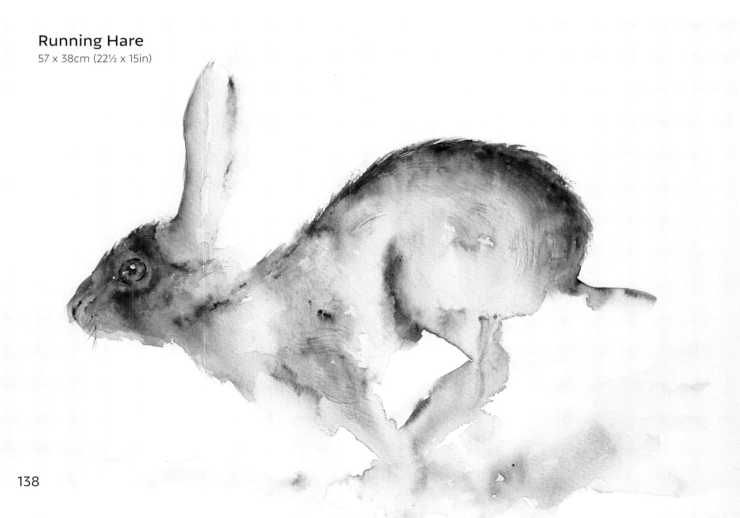

Colour and atmosphere

Compare the watermarks of the vibrant, colourful paintings of blackberries shown here with the monochrome painting of reeds on the previous page. My painting of reeds from nature is capturing what I see in reality whilst the blackberry painting on this page has a very exaggerated colour selection.

This piece includes gorgeous colours: perylene red and perylene maroon for strength, quinacridone gold and cadmium yellow for warmth, and amethyst genuine and French ultramarine to add a few darks. The energy in this piece mainly comes from the colours I selected, but also from allowing water to simply run through the pigment as it is drying. This technique leads to watermarks and patterns that are unique and dramatic, giving great atmosphere to my work.

Blackberries

38 x 57cm (15 x 22in)

The energy in this piece is mainly from the selected colours but allowing water to simply run through the pigment as it is drying leads to watermarks and patterns that are unique and dramatic, giving great atmosphere to my work.

Tumbling Blackberries

38 x 57cm (15 x 22in)

Learning through the seasons

I bring treasures inside to paint throughout the year, and never more so than in autumn as the weather changes, making it at times too difficult to paint outside. What is fascinating to me at this time of year is the flowers going to seed, forming beautiful dried plants that make great subjects to paint, and bringing with them structural challenges.

For example, hydrangea seed heads make fabulous subjects to paint. When you first look at them you may see only brown shades but on closer examination there are far more colours than initially observed.

Try holding subjects like these seed heads in differing lights to see as many colour changes as you can and place them on white paper to see what shapes they make by shadow alone. These tricks can help you when painting them.

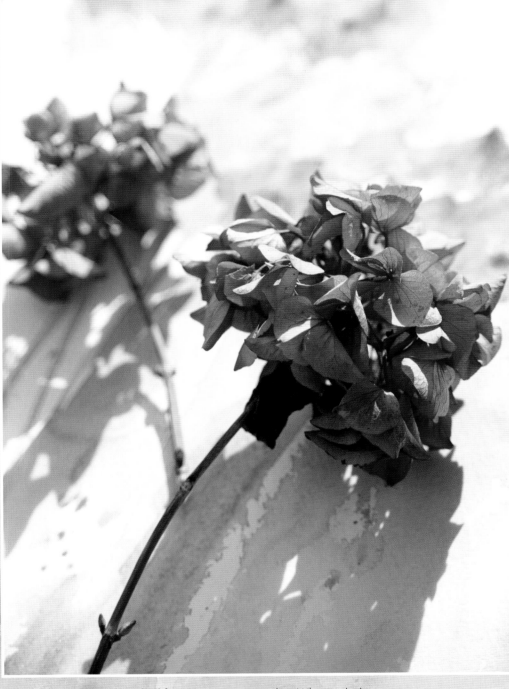

Hydrangea seed heads picked from my cottage garden. When painting any subject I always aim to make it far more interesting by my use of colour selection. In this case I added cobalt turquoise, which acted as a fantastic contrast to my choice of quinacridone gold and amethyst violet.

Painting shapes with blocks of colour

Hydrangea
57 x 38cm (22½ x 15in)

When painting floral subjects where a mass of similar colour can be seen, I often paint a block or outline shape in suitable shades to depict the flower I am working on. The painting of hydrangea seed heads above has been created by painting an interesting colour wash of the outline I can see. Centres have been added when the wash was dry along with hints of stems. In fact, the stems were created by allowing colour to run downwards on the paper, as I worked at an angle on this piece.

Looking at my real subject, I may have opted for a variety of brown shades, but hints of turquoise were far more attractive to me when added here in a very subtle way. Colour is there in this painting of dry seed heads, but not obviously. In fact, if I restrict myself to painting only in monochrome tones now and then, I learn so much about where to add dark shades, or a few warm tones to liven things up.

In the early autumnal mornings there is often a mist, so all of these fabulous structural shapes are not seen quite so clearly. It is this sense of atmosphere I wish to bring into my work. I paint far less detail in an autumnal piece than at any other time of year. In fact, by doing so, I realised I love my paintings with less detail in them and this has contributed to my style. I am learning from each season but taking what I love from one to the other in my paintings.

Opposite:
Hydrangea seed head
28 x 38cm (7½ x 11in)
I added definition to the flower centres in this study, developing the detail once my piece was completed.

WINTER

"Winter for me is a time when I can reflect on my art and plan the year ahead, making it even more exciting than the past."

Some people dread winter but I love it. I am so active outdoors all year long, either gardening or by painting outside. Now the elements change making painting *en plein air* less appealing. In the same way that we can overwork a painting, I strongly believe we can push ourselves too much and overwork as artists.

Recharging our artistic batteries

Taking a break to take stock of where we are in our art journey and looking at how far we have come is as important to the most successful of artists as to those just beginning by taking up their brushes for the first time. Just as plants lie dormant from one season to the next, we too need to recharge our batteries. A rest is really good for the artist's soul and for the mind. In fact, after a break I find my need to paint is even stronger than before.

Winter for me is a time during which I can reflect on all that has happened throughout the past year, leading me into the year ahead. I can plan how I am going to approach a whole new twelve months, making them better in that my art will have to have improved.

Now is the time to take stock of all we have learned from nature, from spring through to winter. While there are of course fewer flowers to be found growing naturally, florists still stock them and it is possible to paint from photographs that we have taken throughout the year.

Whilst colour may disappear from view, evergreens like this ivy still provide wonderful subjects to paint in winter.

Opposite:
In Full Song
19 x 28cm (7½ x 11in)
Robin in watercolour.

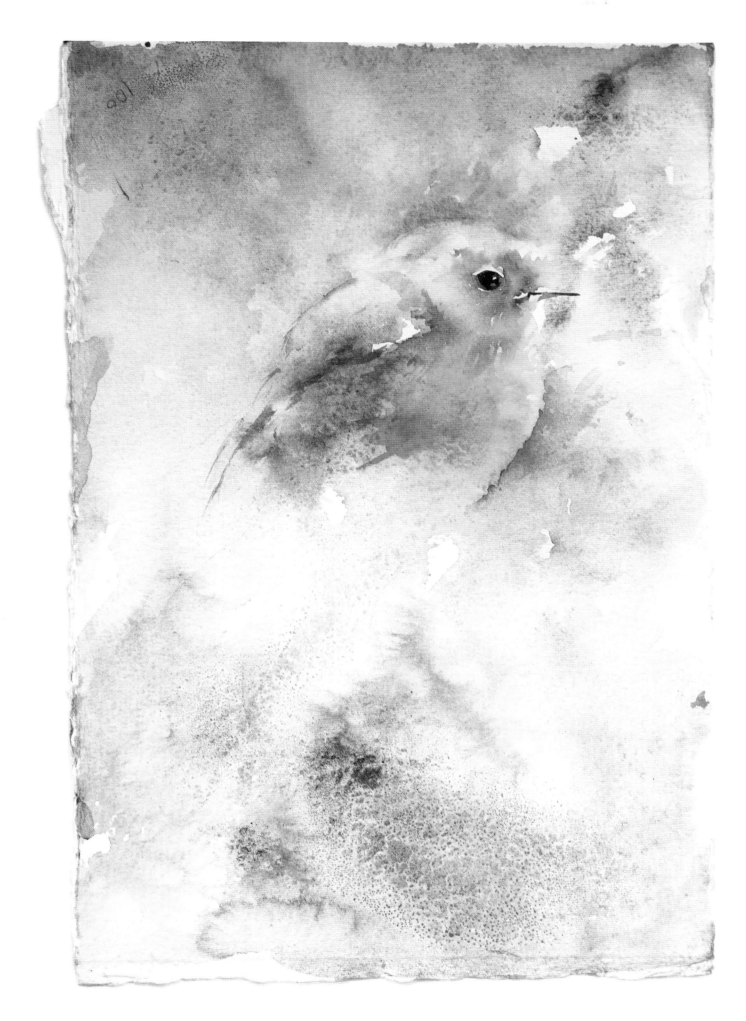

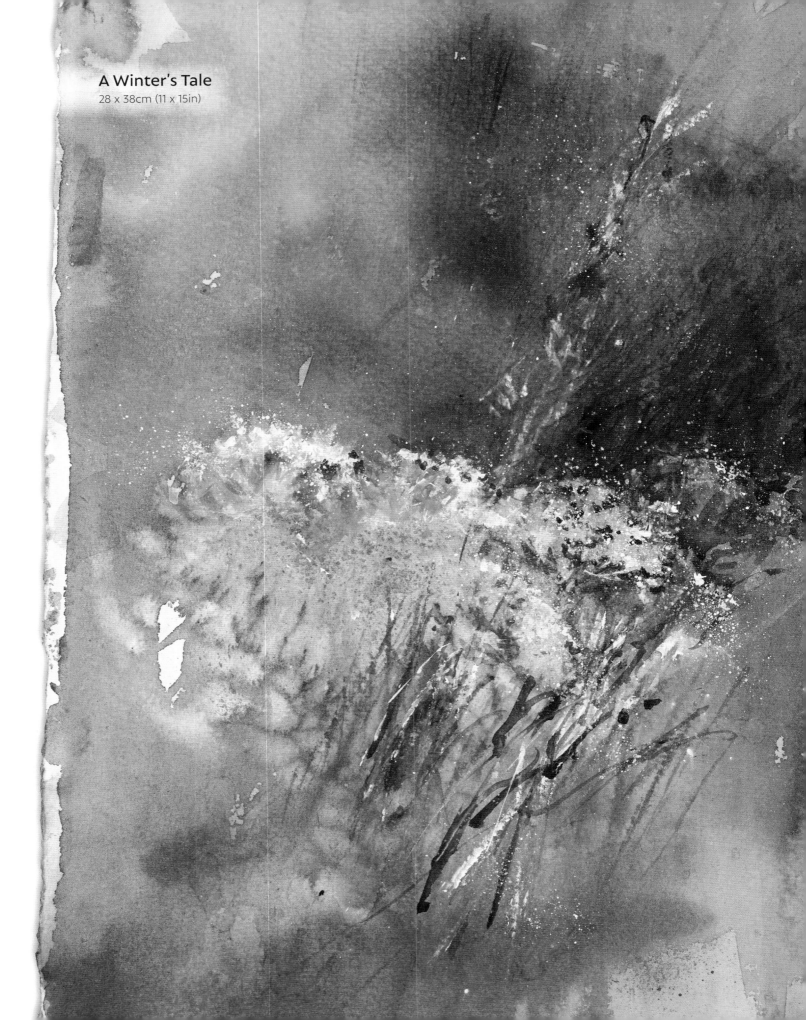

A Winter's Tale
28 x 38cm (11 x 15in)

Simplify complicated painting challenges

Although flowers may be few and far between, this is a time of year when the structural shapes of plants are exposed, making them a sheer delight to paint.

I love Queen Anne's lace, a plant I call hogweed. Throughout the year its frothy white flowers look stunning along the canal banks near where I live, but in winter their seed heads, covered in frost, are absolutely beautiful. They look dramatic and so tempting to paint.

How do you paint such complex formations? By simplifying the task. There are several ways to approach this subject but I like to imagine cold winds blowing when I paint the backgrounds to them.

I begin by creating a first wash in cool colours. I paint around a negative outline with my colour application to begin, then add tiny brush marks with the same background colour inside the white space to create the stems and lace effect. I gain a sense of movement in my work by directional colour placement behind my subject. Allowing water to run through the background colour in a directional flow easily breaks up the pigment, leaving fabulous patterns. This adds to the wonderful atmosphere and sense of movement in my painting.

There are painting tips you can use to make this effect even more beautiful. For example, you can use designer's white gouache to add definition to the many tiny seeds and structural flower heads, to suggest they are covered in frost. If you wish, you can splatter gouache all over your finished work to give the impression of snow, which will change the look instantly, making it seem more wintry.

The darker the background the more dramatic the lace effect with be as seen in my painting *A Winter's Tale*, opposite.

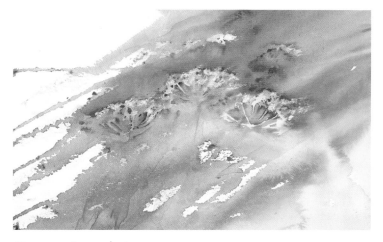

Queen Anne's Lace
38 x 28cm (15 x 11in)

Seed heads act as beautiful subjects in winter for the artist who loves a challenge. Negative edge work brings the Queen Anne's lace into sight in a dramatic and atmospheric way.

Tip

Simple painting tips for complex floral structures:

1 *Place an overall wash first, in a suitable colour, for the background.*

2 *Use careful negative edge work to bring the shape of your subject to life in the first wash.*

3 *Finally, add colour in the inner spaces where needed, to make the subject look more realistic.*

Creative use of splattering techniques

Using gouache effectively

Paintings completed by splattering with white gouache on top can look wonderful, and this technique is a great way to achieve the look of snowfall. However, white colour application can be far more effective when used in other ways. Rather than by simply splattering it all over your work with a toothbrush, white gouache can also be applied in unique ways that are extremely creative, adding intrigue to an otherwise simple painting.

Panel effects of colour

If you observe the painting *Christmas Roses* on the opposite page, you should notice that there is a middle panel that is brighter than the colour on the outer edges. Not only does this bring the full focus of attention to the central flowers, but it also raises the question of how this composition was created.

It started out as a simple painting of Christmas roses from my garden, painted using the negative edge technique. I painted around the flower shapes with green shades, leaving white paper for the flowers. I added centre detail to these at a later stage. When the piece was finished I decided that I would like to add a snow effect. This would be done by applying a fine spray of white gouache over my work. But I wanted this painting to look more unique and so I carried out two very different applications of white gouache.

Protected sections of a painting

The first application of white gouache was made lightly over the whole painting. When dry, I covered the central section with tissue to protect it and then applied a much bolder second application of white gouache to the outer edges of my painting only. Due to the placement of the tissue, these were now exposed. When the white gouache was completely dry I removed the tissue, and the lovely effect seen in my painting on the opposite page appeared.

Enhancing a painting

This technique of covering sections with tissue to apply colour is a fabulous way to enhance a painting. I only discovered the idea by experimenting because it was too cold to paint outside.

This time of year is perfect for doing just this. Get all your pigments out and experiment on scraps of paper. Perhaps you might look at older paintings you don't like and play with ideas like this to see how you could improve them.

This idea definitely worked well on my Christmas roses, which leads me to wonder what else could I come up with as a technique for applying gouache, or other colours. There is only one way to find out, and that is to paint!

Picking up dilute gouache on the toothbrush.

Drawing your finger across the loaded toothbrush will flick the paint off as the bristles spring back.

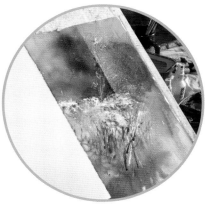

You can use spare paper or card to protect areas from splattering, as shown here.

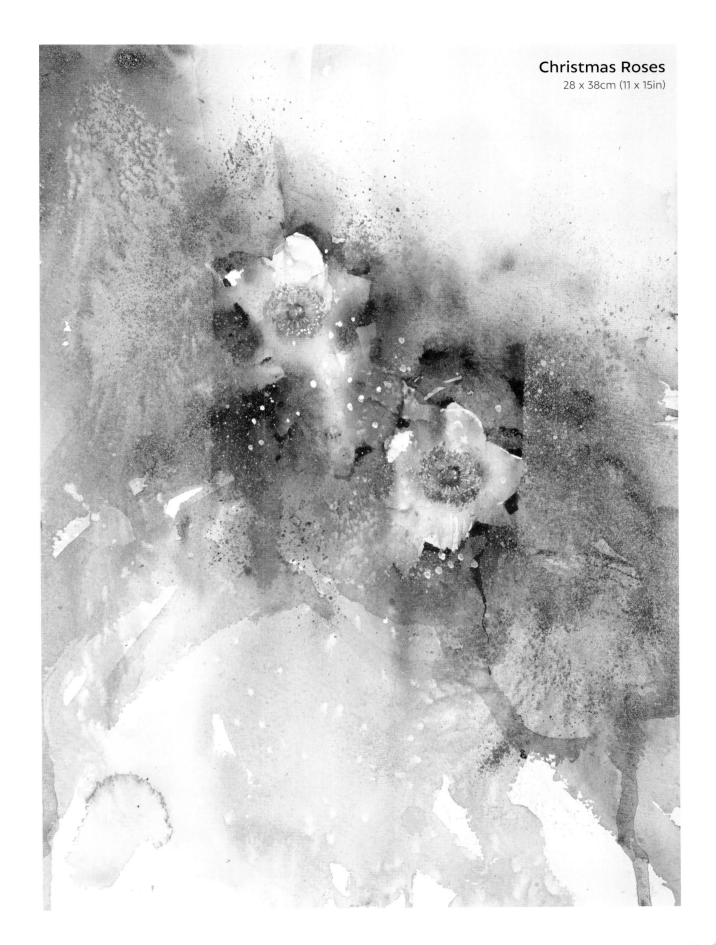

Winter Greens
28 x 38cm (11 x 15in)

Winter greenery

There is no better time for learning to paint foliage than winter. Why? Because the exposed branches of bare trees lets us observe their form, while evergreen foliage is given a chance to shine and now comes to life. The abundance of leaf shapes, interesting shadows and contrasting colour makes this time of year a brilliant source of inspiration.

This is a season to improve painting techniques or to discover new ones. For example, we can improve our negative edge work on leaf shapes, or experiment using different products. Leaving white space on paper for snowfall is an option regularly used in winter landscape paintings, but it also adds oxygen to your work.

Winter is possibly the best time to explore new green shades rather than continue using the same colours; especially when new greens can dramatically add interest and excitement to your colour washes.

Exciting techniques

If you study my painting of holly on this page you will notice some unusual patterns, which have been created through the use of rubbing alcohol. They are more obvious in the lower part of my painting. I only use rubbing alcohol occasionally, but it is fascinating to play with due to the unpredictable effects you achieve when using it with watercolour. I always apply rubbing alcohol with an old brush. I either drop it into a still-wet surface by splattering the liquid on top, or I apply it directly where I want it with deliberate brush work. A word of caution: do use rubbing alcohol minimally.

What is interesting about this painting is that I've also used a product called a distress spray, which is the source of the fabulous vibrant green splatter effect seen here. At times I will cover sections of my paintings so that the spray application of colour only hits an area of my work where it is needed.

When my painting was completely dry, I splattered white gouache (albeit minimally) over the whole painting just to add a feeling of soft snow. You can see how I created this painting by following the simple step-by-step on the opposite page.

There are many ways to bring winter foliage to life and so many products to experiment with. I find when the weather is cold outside, the temptation to play with painting ideas is at an all-time high, making me actually enjoy any bad weather that keeps me in my studio!

Step-by-step Holly and berries

Simple winter foliage

For this simple step-by-step you will need some branches with green leaves. Try finding an interesting one from which you can observe shape and colour. In this simple step by step I have used holly leaves and added wonderful red berries. As always, we need to match colour so try placing your chosen leaves against your palette or tubes of colour to find just the right shade to paint with.

Materials

Watercolour paper, 300gsm (140lb) weight

Size 10 round brush, rigger

Watercolour paints: serpentine green, cascade green, phthalo turquoise, cadmium yellow, permanent red deep

White gouache and toothbrush

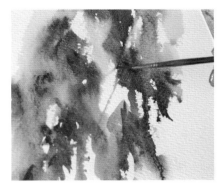

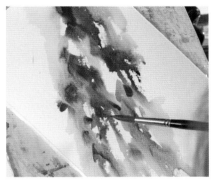

1 I apply a variety of my chosen green shades in a diagonal direction across my paper, allowing the colours to merge together freely. I make a point of leaving gaps of white paper where I will later connect the leaves using fine lines to represent twigs. These white spaces add a feeling of space and light to my finished piece.

2 Using my rigger brush I then created fine lines in the white spaces between the green sections of my wash. These act as twigs between the leaves in the background, and form a feeling of connection, joining one section to another. Painting both lighter and darker lines will create a wonderful feeling of twigs both nearer to you and further in the background.

3 When this first wash is dry I begin to find leaves by painting negative edges on top of the first wash. Take your time and observe the leaf shape to do this. Using a darker pigment for the outer leaf edge and then bleeding it into the background underneath creates a beautiful shadow effect, making the lighter leaf above stand out.

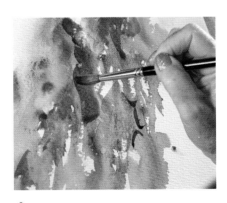

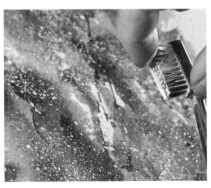

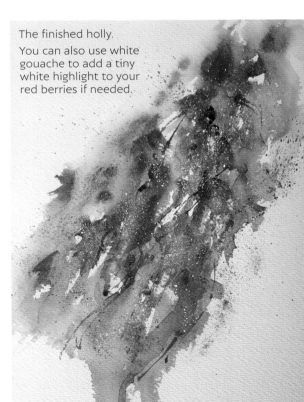

The finished holly.

You can also use white gouache to add a tiny white highlight to your red berries if needed.

4 Next I added a few berries with a stunning deep red shade which really brings this simple painting to life. Be careful in ensuring you create the correct size berries so that they aren't larger than the leaves. Also avoid adding too many.

5 When the painting is completely dry, you can add the winter snow effect by splattering white gouache on top with an old toothbrush. Try splattering in a direction for added interest, perhaps following the original diagonal green wash colour.

Wintry foliage

If you look at my painting on this page you will see I have combined the techniques on the previous pages to create a winter scene. A robin perched on a snow-laden branch adds interest. The snow has been added with white gouache and background texture has been added by the use of cling wrap. Have fun experimenting.

Robin and Holly
28 x 38cm (11 x 15in)

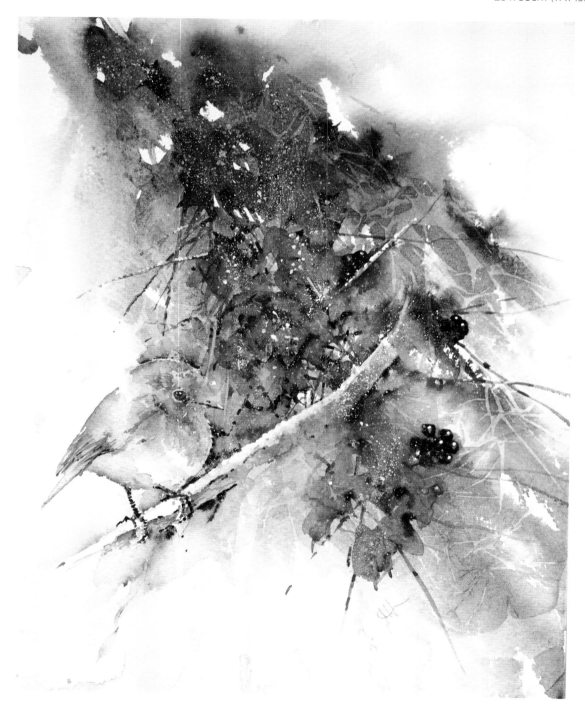

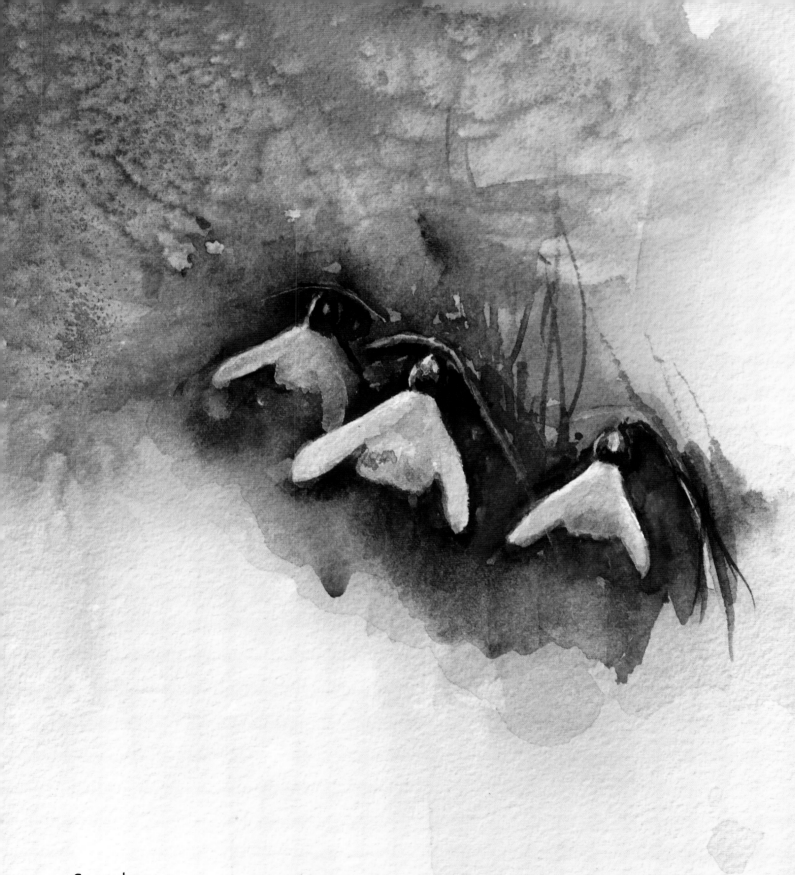

Snowdrops
28 x 38cm (11 x 15in)
Snowdrops herald the beginning of
spring and the seasons begin again.

153

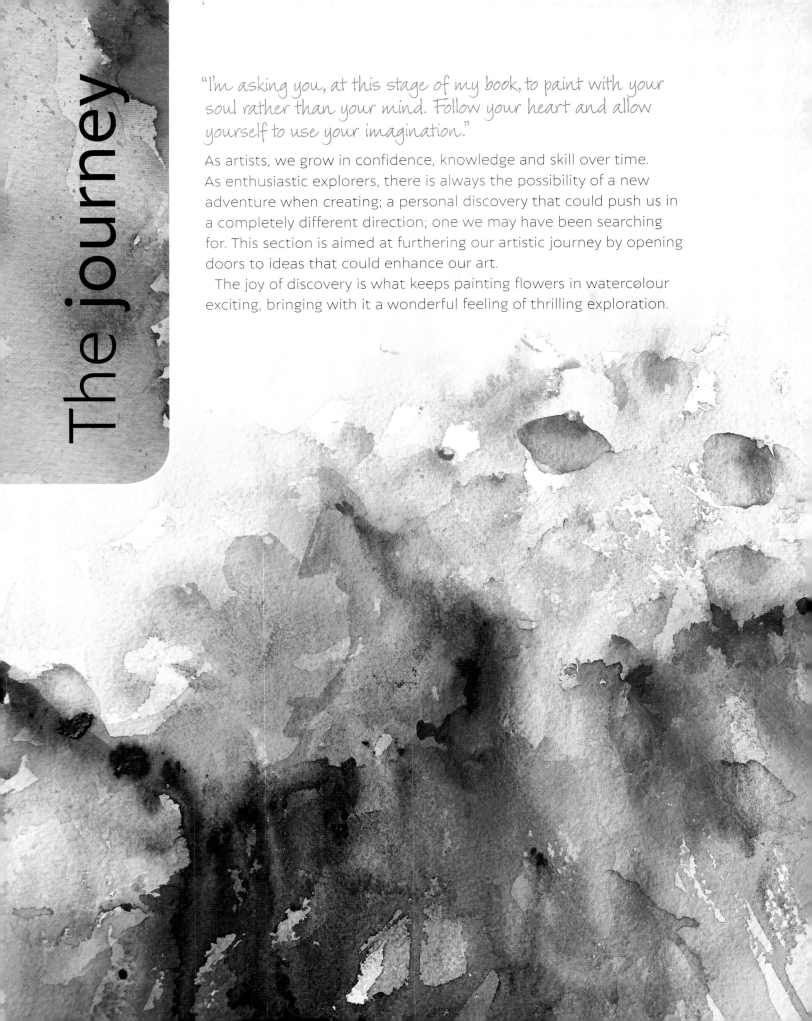

The journey

"I'm asking you, at this stage of my book, to paint with your soul rather than your mind. Follow your heart and allow yourself to use your imagination."

As artists, we grow in confidence, knowledge and skill over time. As enthusiastic explorers, there is always the possibility of a new adventure when creating; a personal discovery that could push us in a completely different direction; one we may have been searching for. This section is aimed at furthering our artistic journey by opening doors to ideas that could enhance our art.

The joy of discovery is what keeps painting flowers in watercolour exciting, bringing with it a wonderful feeling of thrilling exploration.

Using our imagination

"The power of beauty in nature combined with art is hard to ignore."

As seen in previous chapters of my book, I find tremendous joy in the process of learning and experimenting while painting. In the same way that no two plants ever look totally identical, paintings of flowers in watercolour can also carry that wonderful individuality. This is not solely because watercolour as a medium reacts differently each time you use it, but because there are so many options in style we can choose from: botanical, realistic, impressionistic or even abstract.

By painting regularly I eventually reached a point where I no longer needed to paint exactly what I saw. I preferred painting my interpretation of what I was seeing. My painting style has evolved as my art changed dramatically over the years.

Our personal art journeys allow us to grow in skill but the paths we follow as artists can lead us in many different directions. We may find our own style and be happy to stay with it. We may yearn to keep learning and improving, or we can be led into a completely different direction altogether to the one we first thought we were heading for. For example, I know many professional artists who once painted realistically but over time gradually moved to a more abstract style. I started my art life as a botanical artist and yet my work is anything but botanical now.

The main theme throughout any art journey is always colour and the use of it. Whilst how we interpret what we are seeing or feeling in art varies tremendously, learning to paint flowers is a wonderful art journey on a road that has no end as a destination.

Interpretation

Art is simply an interpretation of what we are seeing. We are telling a story in colour. With a loose style of watercolour, that interpretation will not include every single detail. It will capture the essence of the subject and tell the viewer of the finished piece what it is; and hopefully touch an emotion as it does so.

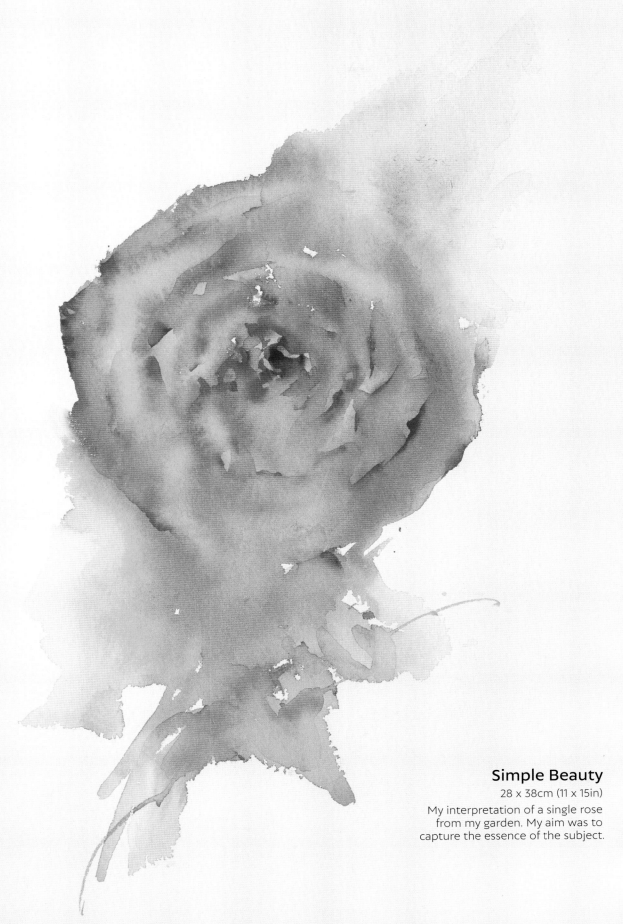

Simple Beauty

28 x 38cm (11 x 15in)

My interpretation of a single rose
from my garden. My aim was to
capture the essence of the subject.

Painting with soul

Painting what we see may lead us to versions of flowers in watercolour that are instantly recognisable; but consider the version of roses in watercolour below: a circular composition which is very different and intriguing.

The whole point of painting in watercolour as a medium is the quality it contains that leads to differing results each time we use it. That magic is well caught when we use our initiative to paint something that may seem ordinary, but in so doing use our imagination to create something that is completely unique.

I'm asking you at this stage of my book to paint with your soul rather than your mind. Follow your heart and allow yourself to use your imagination.

Roses growing naturally in my garden.

Circle of Love

36 x 36cm (14¼ x 14¼in)

Roses forming an unusual painting. White paper behind the flowers allows my blooms to breathe in this circular composition.

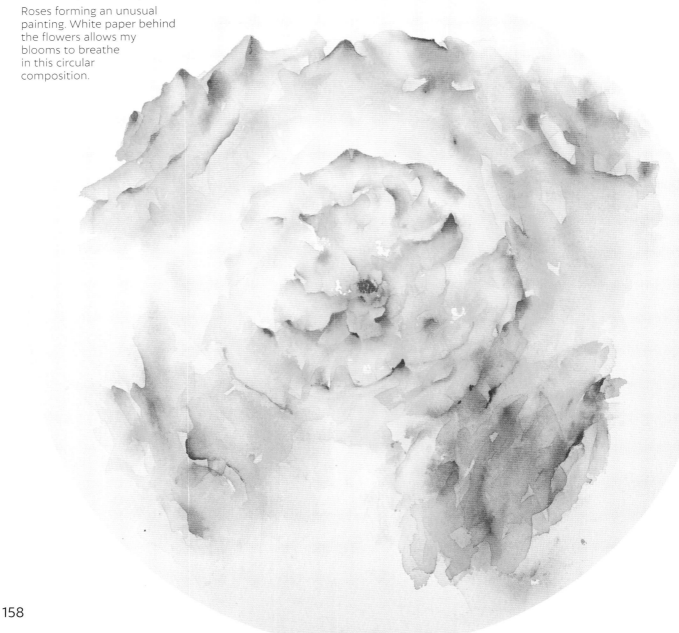

Abstract compositions

Composition alone is a wonderful way to find ways to create superbly unique pieces. Think about square, straight, diagonal, vertical, horizontal, triangular and oblong compositions. The choices are endless. Also, please don't feel glued to painting on the size paper you have bought or are looking at.

Use paper wisely to be a fantastic floral artist, just as the best florists make stunning shapes in their displays. Make your paintings of flowers stunning arrangements that sing with beauty and life. The bottom line here is: don't be boring with your art!

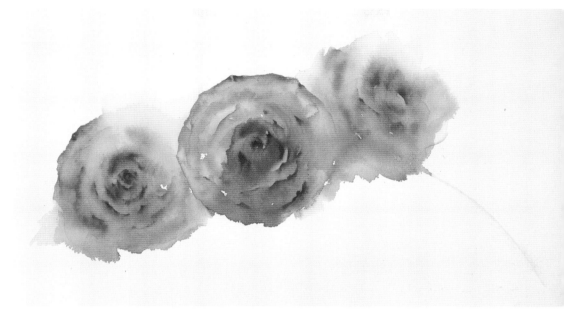

I Love You
57 x 38cm (22½ x 15in)

My interpretation of a cluster of roses from my garden, using my imagination to create a painting that is unique and interesting. This time, my colour is stronger. I believe when we grow in artistic skill, our confidence builds allowing us to attempt more daring paintings.

Painting challenge

Now, take stock of all the tips in this book, and decide how would you paint this camellia. Bear in mind that you don't have to copy the photograph exactly. Use your imagination to create a floral painting that is unique in composition, interesting and beautiful.

What would your favourite interpretation be? Be inspired and think up as many ways to paint this one flower as possible. Try using bold pigment as you do so and perhaps see if working in just one colour will bring this to life, even when painting the foliage.

As you turn the page, we leave this style of painting and leap into another watercolour world altogether.

Camellia from my garden.

A change in direction

"We all have times when painting where we feel our work could be better, but that is the joy in the journey."

I have never been one to sit still in my life and it is the same when it comes to painting. I know that there are many products out there I am yet to try and many techniques I have yet to discover. I can make each painting session as exciting or as relaxing as I wish. However, in this section of my book I hope to show you how exciting painting flowers can be. That is, if you choose to take a slightly different path into a little more abstract work.

Exciting colour work

To create my more abstract paintings, I play with colour alone on paper, working with textural techniques to form patterns randomly. I apply different kinds of salt, place cling wrap in varying ways or even just place drops of water on top of still-wet pigment. All help to create a diverse range of patterns.

Quite often these washes are created with no subject at all in mind. They are part of my art journey; my learning what can be achieved with colour alone. Over time, by doing them daily, I now have an idea of which techniques work best, and for which subjects. I can now start a wash creating texture for individual flowers which aids my results beautifully.

Experimenting with washes

Try growing in this colourful direction by regularly painting experimental washes. Try placing a selection of colours on paper and allowing them to merge at will. On the large colourful wash you see on the facing page, I have used cadmium yellow, phthalo blue, cascade green and quinacridone gold. When the pigment was still wet I applied some salt to my wash and allowed it to dry. When removed it had forced incredible patterns to emerge.

It is important to note that I used brown Himalayan salt as well as white rock salt on this wash. This is why you can see tiny brown dots of colour where the salt had lain, even after the salt was removed from the dry wash.

An exciting experimental colour wash.

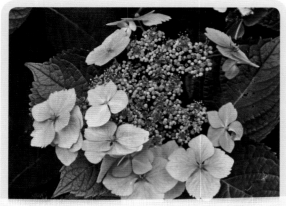

Flower meaning: *Hydrangea*

There are many meanings for this flower but I love that it was once given as a gift, showing gratefulness from the giver to another for their understanding. In the Victorian period, its many blooms were seen to represent boastfulness. In today's gardens this splendid flower will show off its blooms for long periods. It is well worth admiring.

The value of experimental washes

You may wonder where the value in these experimental washes lies. They give me ideas for creating unique paintings. For example, by looking at the experimental wash shown below, I gained an idea on how to use this idea of colour placement to create a new watercolour of lacecap hydrangea: I could paint on top of this wash or begin the experiment again, with the flowers in mind from the start, as a painting to be completed.

I repeated my colour experiment on scraps of paper but this time knowing what my subject would be, which meant I could select shades accordingly. At first the colours I chose seemed too light: the flowers in my garden were vibrantly blue and violet. My initial interpretation didn't seem to scream the dramatic colour or excitement of these flowers seen in the sunshine, so I knew my next attempt would have to be far bolder. My second wash began like the colourful experimental wash seen on page 151. It was so much more exciting that I felt I could add detail on it to bring my subject to life.

The contrast between the beginnings of these two paintings was huge, yet this feeling of learning and being on a journey ignited my artist soul to advance further with even more new adventures in colour and technique. We all have times when painting when we feel our work could be better, but that is the joy in the journey; knowing we have somewhere to go in our learning process. In fact, I think the journey may be far more exciting than actually reaching the destination – just as it so often is in life!

First wash experiment.

Opposite:
Hydrangea Blues
28 x 38cm (11 x 15in)

From here the journey changes in direction, because although the interpretation of a hydrangea seen to the right is stunningly bold in colour, it is still possible to understand what the plant is. As we turn the page we are heading towards a more abstract work; taking an exciting detour from reality.

Abstract impressions

"Abstract painting is not only refreshing; it is energising, freeing and lifts the soul!"

Practising colour washes leads us to discover ways to paint all kinds and shapes of flowers. Over time our selection of colour, whether it be bold or quiet, tells the story of both the bloom and the season enriching a floral painting. I find when working in an abstract style all painting rules seem to fly out of the window – because now only enjoyment in creating exists.

When creating an abstract, we aren't attempting to paint reality. It is possible to beautify without limits, embolden colour choices, be completely dramatic or, if we wish, we can even be way over the top, allowing our imagination to run wild. I love this area of painting as there is a freedom with abstract work that no other style possesses. Your inner artist can shine. That is, if you have the courage, confidence and will to let them out.

Forget-me-not flowers are a complex subject that work perfectly in an abstract style of painting using a textural first wash, as in the example below.

Starting small

Think about all those tiny flowers that are so complicated to paint in a realistic style. In an abstract style we can approach painting them with little care for each individual flower, as they can be created in a simple textural wash. The example wash shown to the left here is all blue, with the application of salt to create patterns that can later be worked on in a negative edge way to form tiny flowers; not realistically, but purely as a guide to form an interesting painting of small flowers.

Blue wash, suitable for small flowers, created with salt.

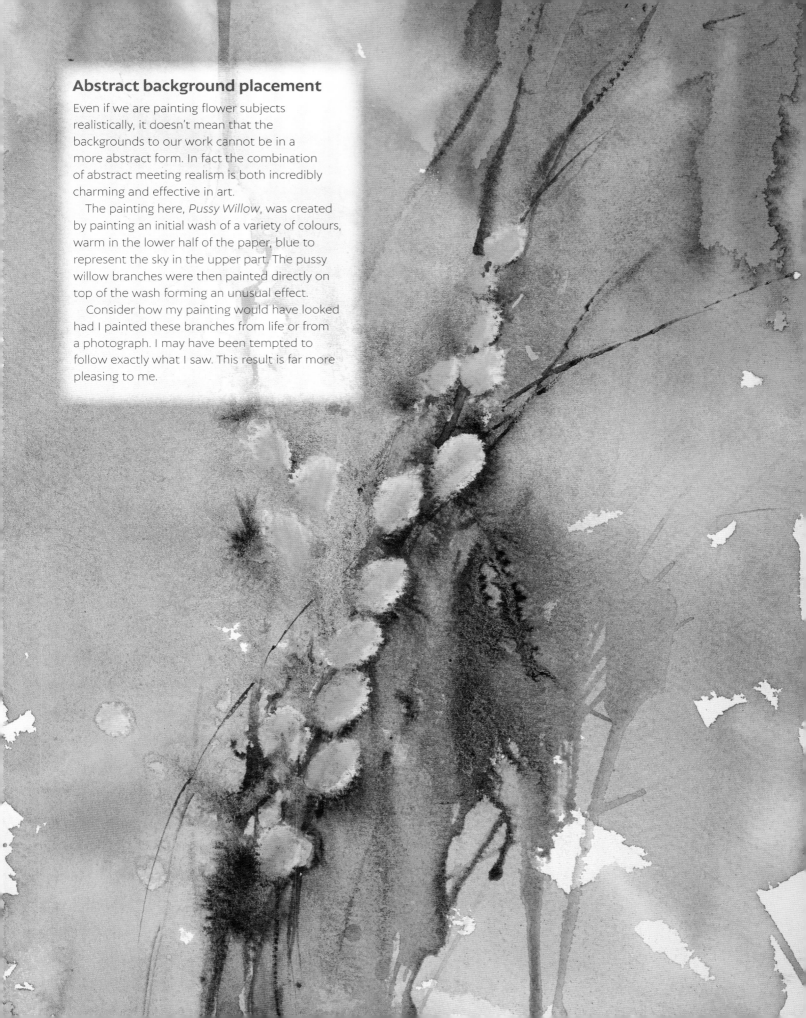

Abstract background placement

Even if we are painting flower subjects realistically, it doesn't mean that the backgrounds to our work cannot be in a more abstract form. In fact the combination of abstract meeting realism is both incredibly charming and effective in art.

The painting here, *Pussy Willow*, was created by painting an initial wash of a variety of colours, warm in the lower half of the paper, blue to represent the sky in the upper part. The pussy willow branches were then painted directly on top of the wash forming an unusual effect.

Consider how my painting would have looked had I painted these branches from life or from a photograph. I may have been tempted to follow exactly what I saw. This result is far more pleasing to me.

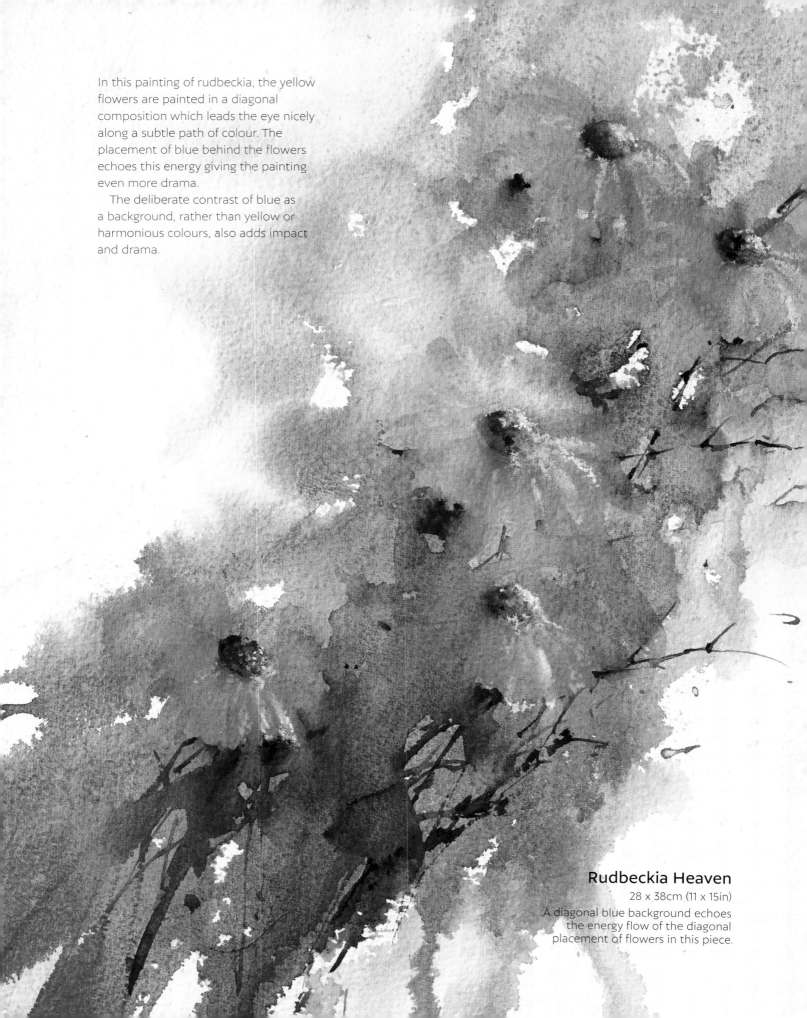

In this painting of rudbeckia, the yellow flowers are painted in a diagonal composition which leads the eye nicely along a subtle path of colour. The placement of blue behind the flowers echoes this energy giving the painting even more drama.

The deliberate contrast of blue as a background, rather than yellow or harmonious colours, also adds impact and drama.

Rudbeckia Heaven
28 x 38cm (11 x 15in)
A diagonal blue background echoes the energy flow of the diagonal placement of flowers in this piece.

Energetic brushwork in abstracts

Consider this painting; look at all the directional lines in red which form the energy in this piece. There is very little detail. We know what the flower is purely by colour and the deliberate arrangement of brushwork.

After a while, as our style develops, the concept of needing a subject can be lost altogether. Painting flowers created in many different ways from our own imagination can be the golden opportunity to be as expressive, impressionistic and as abstract as we wish.

This style of painting brings the artist in you, the one who wishes to be extremely unique, to the forefront of your chosen painting style. After years of working almost botanically, I find this way of painting is not only refreshing, but also energising and freeing. It lifts my soul.

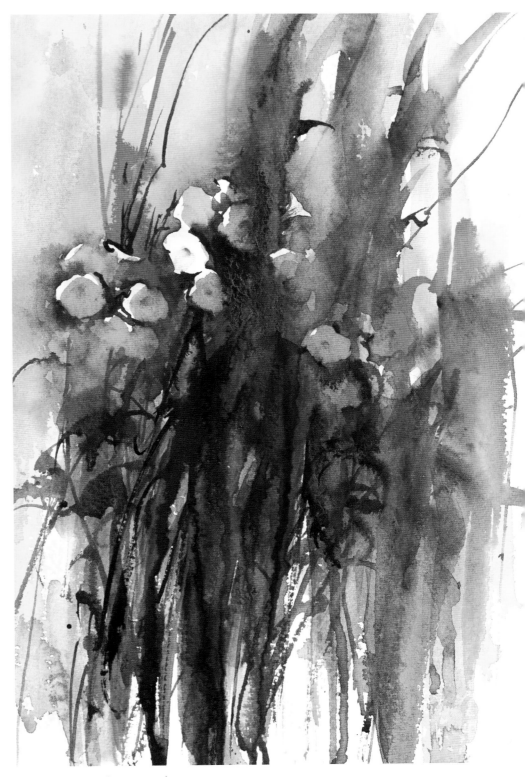

Imaginary Flower Abstract
28 x 38cm (11 x 15in)

Going for gold

"A change wakes up our inner artist, helping us to see things in a new way."

When you embark on a new journey or direction in art, it is almost inevitable that you become fascinated with trying new painting products. As much as I adore painting in pure watercolour, my own art journey began in China where I used to paint with gold on antique silk rather than paper. The effect of weeping willow leaves painted in this way was so stunning, especially when the work was framed. I have often remembered the gold powder I used at that time in my career and thought about how I could use that technique in my work today – and I do.

I now use gold powder on paintings where the subject is suitable. The gold effect achieved ensures that my results are slightly more unusual. The thrill of any art journey is how exciting we can make it; and here we are literally going for gold.

Marguerites

Look for something different

Every subject can be painted in so many ways. Take the marguerite daisy at the top of the page, which grows in my cottage garden. The intricacy of the centre intrigued me and led me to wanting to paint it, so I placed my focus on the detail around the centre and the many tiny petals here. I took time with my rigger brush to paint them almost accurately rather than in an abstract style, and enjoyed the process of doing so.

As always, I think of backgrounds, and where once upon a time I would mix my green shades by using a yellow and blue colour I now use ready-bought green shades such as cascade green, undersea green, green appetite genuine and jadeite green, which are all fantastic colours and give me a vast variety of choice. This helps make decisions on what to use for painting great backgrounds for white floral subjects far easier.

I cannot recommend highly enough the value in researching shade charts of watercolour ranges so you can find new colours that bring your own work stunningly to life.

Flower meaning:

Marguerites

Marguerite was named after the Latin word *margaritaceus*, which means pearl, because the flower petals can be white and cream like the gem. Folklore has it that a daisy chain connected in a circle and placed around a baby would prevent fairies from stealing the child. This beautiful flower represents purity.

Close-up of a marguerite in my garden.

Detail or abstract: a personal choice

I look for sections in a flower that are delightful to paint in full detail. Then my loose, atmospheric colour application and brushwork can surround this complex area. Doing this leads the viewer's focus to what you consider to be the best part of your finished painting.

The abstract background acts as a backing group to the star of the show, the focal point. Even if your work is not totally abstract in itself, having an abstract quality in sections of a painting can make your detail sections look even more beautiful.

My interpretation of the detail on my marguerite painting.

Comparing my painting with the real thing.

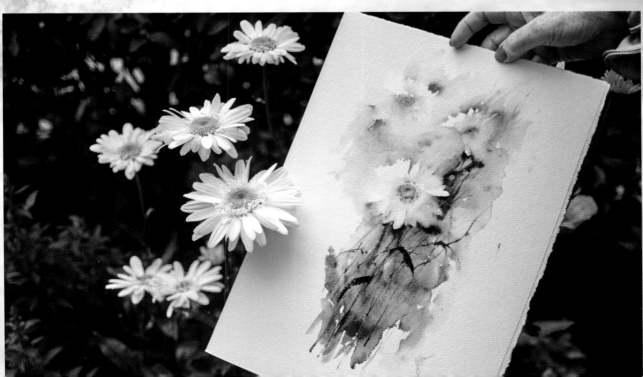

A touch of gold

My first painting of a marguerite (seen on the previous page) is beautiful and the use of the white paper within the composition makes it look fresh – as fresh as a daisy, in fact! But each successful art journey should lead you towards the next adventure or white piece of paper. Which this did.

Having completed the earlier painting, I realised I could paint the daisies growing wild in a field near where I live, with the addition of gold. I imagined adding the gold powder to the daisy centres and grasses around them.

Abstract and detail combination

This new work is a little more abstract than my first painting of a marguerite. The flowers themselves are different; a wild flower compared to a garden variety. It also has more of a sense of movement in it. There is a suggestion of light where detail is missing in the upper half of the painting. Blurred red shapes hint at butterflies hovering over the flowers. It is an impressionistic painting that says more about the atmosphere than the flowers themselves.

Where white paper was lost for the daisy petals, I applied white designer pigment to bring the flowers back to life. I mixed the gold poster powder with a little water and rolled my size 10 brush gently over the painting in the foreground to ensure the gold touched the paper in a random fashion, rather than being too rigidly applied – this was so I would not lose my feeling of freedom in the piece; working like this feels more natural, carrying energy and life within the composition. I also used my rigger to apply a few touches of gold to the flower centres. This addition of gold powder is very subtle so that the shimmer doesn't detract from this piece being a watercolour painting.

When we start painting we may feel we simply want to paint something that is recognisable. We may yearn to discover what our style is. By being adventurous and experimenting with new ideas we can discover what our true potential as an artist is. Taking a leap into a whole new painting direction now and then, whether it be by use of different products or by painting in a new way, is good for us. A change wakes up our inner artist, helping us to see things in a new way.

My advice is: don't sit still on your art journey. Keep travelling by learning and growing and going for gold. Try using gold or silver poster powder on your paintings and when you lose the white in a composition, work with designer white gouache. It works!

Gold powder

Gold powder suitable for using with watercolour can add attractive effects to a painting. Place it on a small dish to work from, then pick it up with a fine wet brush and place it directly on your painting where you feel it is needed. Use minimally and practise application on scraps of paper first.

The gold powder can be picked up with a wet brush.

Applying the gold.

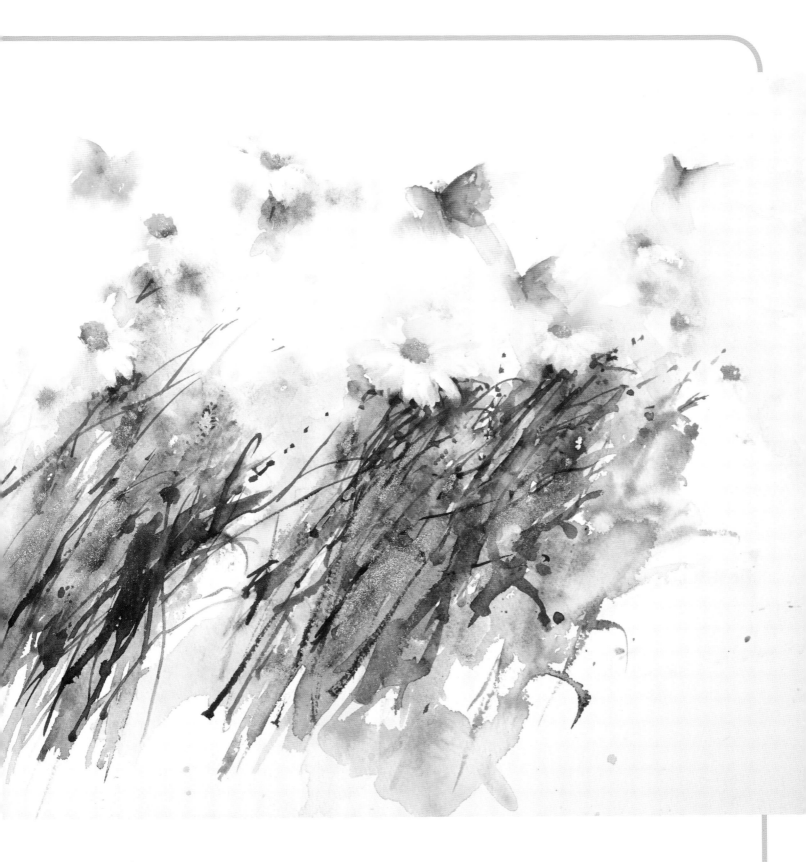

Field of Dreams

57 x 38cm (22½ x 15in)

This painting is an example of using gold powder and white gouache
to experiment for different and exciting results.

Thinking outside the box

"There are no limits when it comes to painting flowers in watercolour."

When we think of watercolour, we can often assume that work in this medium has to be created on watercolour paper. However, with the many products available to us, we can paint on all manner of surfaces; including canvas, wood and board – in fact, on just about anything at all.

Alternative surface options

When I opt to paint on something other than watercolour paper, I prepare my favourite alternative painting surfaces by placing a layer of Daniel Smith Watercolour Ground over them in advance.

I love painting on canvas as it gives me a fabulous feeling of working in between two art worlds. I then have the joy of using my favourite medium, watercolour, but combined with the pleasure gained from working on canvas as when painting in oil. It leads me to very different results.

I can show you what I mean with this atmospheric *Autumnal Scene*. While it is quite abstract with very little detail added, it captures the essence of a misty morning really well. There is a feeling of fog in front of the hedgerow hiding the berries, seen almost floating in mid-air. It feels timeless; and yet the sheen on the berries adds to their existence and reality.

Autumnal Scene
40 x 56cm (15¾ x 22in)
Painted on canvas that has been prepared beforehand with watercolour ground.

Using a surface preparation product

Brushes or card can be used to cover the canvas with the watercolour ground (I find the qualities of Daniel Smith Watercolour Ground suit me best). I apply the preparatory product with directional brush work to enhance and echo the subject that will later be painted on top with watercolour pigment.

Because I apply a thick layer of watercolour ground I often leave the prepared surfaces for up to forty-eight hours, in order for it to completely dry. Once dry, the effects I then achieve with watercolour pigment painted on top are very atmospheric and fascinating.

This area of painting takes us into the realms of working in another medium. Now nothing is out of bounds as a surface to paint on, and our textural effects can be far greater; and in turn, much more interesting.

What we need to fully comprehend as artists is that there are no rules when we create. Restrictions can limit our artistic ability and influence how we develop in our art journey. Thinking outside of the box when we approach a subject or way of painting it can lead to many incredible results, and as many happy hours creating. There are no limits when it comes to painting flowers in watercolour.

Tip

Bear in mind that brushes have to be cleaned thoroughly after use. Choosing old brushes, or a piece of card or heavy weight watercolour paper, as shown here, for applying watercolour ground or other surface preparation products, is wiser.

I deliberately avoid applying the preparatory product smoothly as the textural effects achieved by its application aid my results greatly.

Patterns seen on the canvas surface are created and enhanced by the use of a surface preparation application like a watercolour ground.

This close-up shows the textural effects achieved by painting on top of a very rough texturized surface.

Watercolour ground can be applied to areas of paintings you may wish to correct. Once dry, you can rework the area, giving you a second chance at the section. It can also be used to add texture to a painting that needs more excitement.

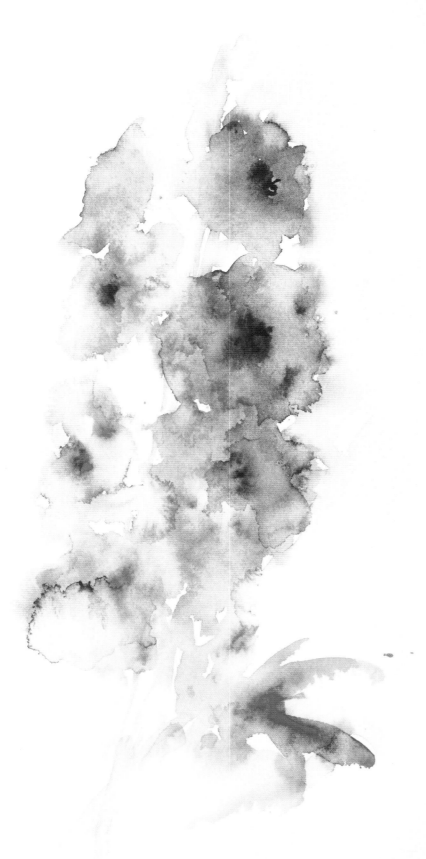

Delphinium Blue
20 x 35cm (8 x 13¾in)

Dear Reader,

I HAVE ABSOLUTELY LOVED writing this book. Each day during its creation I have eagerly raced to my studio to either paint, experiment or write. It has been an amazing time as my own enthusiasm has grown with each new chapter and subject. As this particular journey in sharing my passion for creating floral paintings comes to a close, I am thinking of you, the reader, hoping that you will feel so inspired that you will never look at a flower again without imagining how you can paint it or considering which techniques you would use to bring it to life in watercolour.

As each season arrives, I hope you feel the need to change the colours on your palette and I hope you see new challenges in the buds, plants and flowers that appear throughout the year; and not forgetting, of course, the wonderful wildlife that can enhance your compositions.

I believe that in each of us is an inner artist that we still hold back in some way, no matter who we are or level of skill we possess. It is our individual drive and personal sense of yearning to learn and improve that should keep us motivated enough to see where we wish to be as a floral artist; so that we can take that wonderful leap to reach our goal, whatever it may be.

I honestly cannot pick up a leaf, twig or flower and not think of a zillion ways to paint it. My book could only allow me to show you a few of my favourite ways of painting floral treasures but I truly hope you enjoyed the journey in reading it.

For now, my wish is that you paint many fabulous flowers in watercolour, in many wonderful ways with many fabulous results. And while you are painting them, I hope you shine to your full potential as an artist, growing each time you pick up your brush.

Happy painting,

Jean Haines.

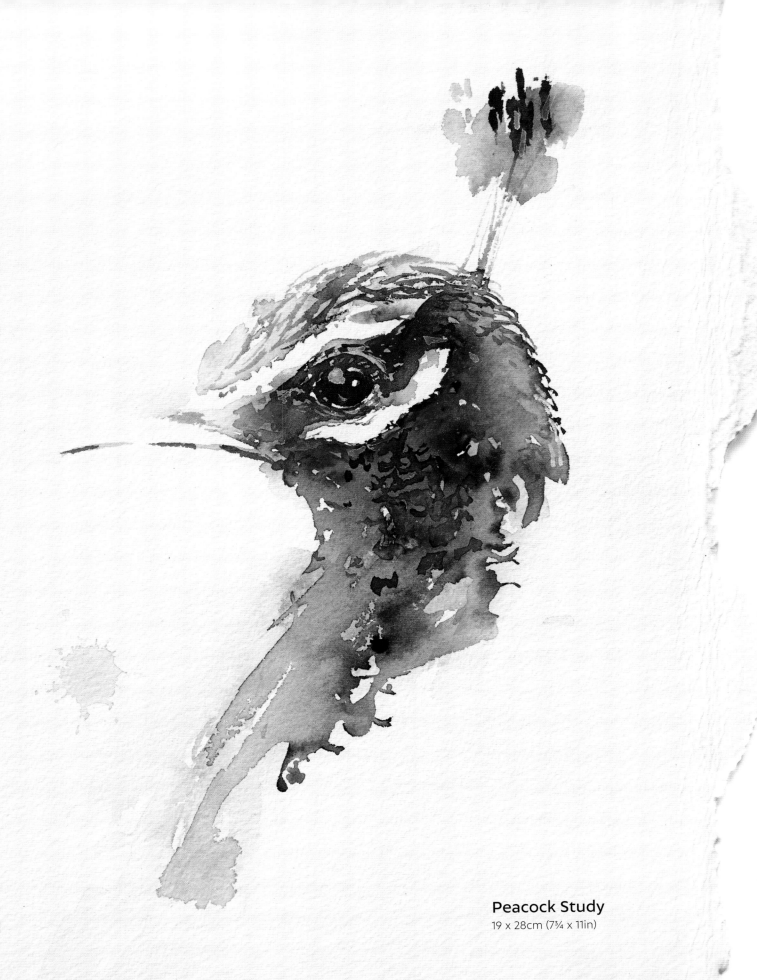

Peacock Study
19 x 28cm (7¾ x 11in)

Index